Aspects of American Printmaking, 1800–1950

Aspects of American Printmaking, 1800–1950

Edited by
JAMES F. O'GORMAN

Syracuse University Press

Copyright © 1988 by Syracuse University Press
Syracuse, New York 13244-5160

First published 1988

First Edition
95 94 93 92 91 90 89 88 5 4 3 2 1

The paper used in this publication meets the minimum requirements of American National Standard for Information Sciences—Permanence of Paper for Printed Library Materials, ANSI Z39.48-1984. ∞™

Library of Congress Cataloging-in-Publication Data

Aspects of American printmaking, 1800–1950.

Includes index.
Revised papers from the seventeenth North American Print Conference, Boston, April, 1985.
1. Prints, American—Congresses. 2. Prints—19th century—United States—Congresses. 3. Prints—20th century—United States—Congresses. I. O'Gorman, James F. II. North American Print Conference (17th : 1985 : Boston, Mass.)
NE507.A87 1988 769.973 88-2291
ISBN 0-8156-2427-1 (alk. paper)

Manufactured in the United States of America

꧁

CONTENTS

❧

CONTRIBUTORS

CLINTON ADAMS is Professor Emeritus of Art at the University of New Mexico, Albuquerque, Director Emeritus of the Tamarind Institute, and editor of the *Tamarind Papers*. He is the author of *American Lithographers, 1900–1960* (1983) and many other works.

RICHARD COX, Professor of Art History at Louisiana State University, Baton Rouge, is the author of several studies of twentieth-century American printmakers, including Wanda Gag, Art Young, Caroline Durieux, and Adolf Dehn.

BARBARA FRANCO is Assistant Director of the Scottish Rite Masonic Museum of Our National Heritage in Lexington, Massachusetts. She is the author of several catalogues of masonic and fraternal symbolism published by the Museum.

ELTON W. HALL, Director of Development for the Tabor Academy, Marion, Massachusetts, collects and writes about American prints and printmakers. He edited *American Maritime Prints* (1985), the proceedings of the eighth North American Print Conference.

SINCLAIR HITCHINGS is Keeper of Prints at the Boston Public Library, and a major influence on the study of American graphic arts. His list of credits includes exhibitions, catalogues, books, and essays on most aspects of American printmaking.

LUNA LAMBERT LEVINSON received her doctorate from George Washington University with a dissertation on "The Seasonal Trade: Gift Cards and Chromolithography in America" (1980). She has been a Guest Curator at the Library of Congress.

JAMES F. O'GORMAN is Grace Slack McNeil Professor of American Art at Wellesley College, Wellesley, Massachusetts. A former president of the Society of Architectural Historians, he is the author of *The Architecture of Frank Furness* (1973), *H. H. Richardson* (1987), and other books and articles on American architecture and illustration.

SALLY PIERCE has been Curator of Prints and Photographs at the Boston Athenaeum since 1981. She is the author of *Citizens in Conflict* (1981), and *Whipple and Black* (1987).

DAVID TATHAM, Professor of the History of Art at Syracuse University, is an authority on the graphic art of Winslow Homer. He is the author or editor of numerous works on nineteenth-century American art, including *The Lure of the Striped Pig* (1973) and *Prints and Printmakers of New York State* (1986).

❧

PREFACE

The seventeenth North American Print Conference met in Boston in April, 1985. It was one of a series of scholarly meetings that have convened annually since 1970 in various sites in the United States and Canada to report new research in the history of the pictorial graphic arts in North America. The 1985 conference was organized jointly by the Scottish Rite Masonic Museum of Our National Heritage, Lexington, Massachusetts, and the Grace Slack McNeil Program in American Art at Wellesley College. Cooperating institutions were the Boston Athenaeum, the Boston Public Library, and the Museum of Fine Arts, Boston. In addition to the conference's program of scholarly papers, five exhibitions were mounted for the occasion: "Boston Harbor" at the Boston Athenaeum; "American Master Prints, 1910–1940" at the Wiggin Gallery of the Boston Public Library; "American Prints 1914–1941" at the Museum of Fine Arts; and "A Decade of Collecting: Maps" and "Fraternally Yours" (the museum's unique collection of decorative art objects with symbols of fraternal organizations including paintings, portraits, and drawings) at the Museum of Our National Heritage.

The conference program was built on two premises. The first of these held that there is a need for a close examination of the dual traditions of printed pictorial communication in North America—the practical and the fine—from the middle of the nineteenth to the middle of the twentieth century, the period of greatest interplay between them. The second premise held that the increasing methodological diversity in recent research in the history of the graphic arts in North America was itself important enough to serve as an organizing concept for the conference.

ix

Accordingly, the papers selected for presentation, and published here in revised form, illuminate the emergence of a tradition of fine art printmaking from a diverse and vigorous tradition of practical and popular pictorial printing. As a group, the conference papers both define and bridge these traditions through the sharply focused examination of special topics. The first five essays are studies in the history of prints allied with popular culture; the remaining four are concerned with the development of the concept of the fine print and the cultivated audience that supported it. A recurring motif throughout this collection is that the two traditions were never wholly independent of each other. The roots of the tendency to turn prints into art objects run deep in nineteenth-century popular culture. The fine printmakers of the early decades of the twentieth century never freed themselves from the older, popular notion that a print ought to be comprehensible to the public at large.

The essays represent the current methodological diversity of the field. They include iconographical, archival, biographical, cultural, technological, and geographical approaches, each supported with an essential foundation of connoisseurship. The authors demonstrate how rich and serious a subject for study the history of printed images in North America has become.

Publication of this volume is made possible by grants from the Museum of Our National Heritage and the Grace Slack McNeil Program in American Art at Wellesley College, and by contributions from Mr. and Mrs. Sinclair Hitchings, Charles E. Mason, Jr., and The Boston Athenaeum. We are delighted also to record our gratitude to the following institutions and individuals for their contributions to the success of the conference: The Museum of Our National Heritage (Clement M. Silvestro and Barbara Franco); the Grace Slack McNeil Program in Art at Wellesley College (James F. O'Gorman); The Boston Athenaeum (Rodney Armstrong and Sally Pierce); The Museum of Fine Arts, Boston (Jan Fontein, Clifford Ackley, and Sue W. Reed); the Boston Public Library (Sinclair Hitchings); and Elton W. Hall.

1

Masonic Imagery

BARBARA FRANCO

Alan Gowans, author of *Images of American Living,* has stated that in the years between 1775 and 1825, "Masonic imagery seems to permeate American culture almost as Christian symbolism permeated the art of the Middle Ages."[1] This is a strong statement, but one that is borne out in the large number of American objects and images that display Masonic symbolism. How the emblems of this eighteenth-century secret fraternal organization came to figure so prominently in the iconography of American arts is an important segment of American cultural history.

What is Freemasonry? Technically, it is an oath-bound fraternal and benevolent association of men whose purpose is to nurture sound moral and social virtues among its members and society as a whole. Its adherents have described it as a "matchless and almost perfect system of morality taught by symbols." The origins of Freemasonry go back to seventeenth-century England when guilds of working stonemasons began accepting honorary members who were not stonemasons or in any way associated with the building trades. The seventeenth century was a period of declining membership for the once-powerful guilds that had constructed the Gothic cathedrals of England. Even in decline, they retained considerable political and social influence. Many of the men who became "accepted" masons were amateur architects and philosophers. Their interest in the classical architecture of Greece and Rome and in the scientific and mathematical principles of Enlightenment philosophy attracted them to the traditional skills of the stonemasons. The practice of joining stonemasons' lodges for philosophical reasons eventually resulted in a separate "speculative" fraternity of Freemasons which officially organized under the Grand Lodge of London in 1717.

1

Associated with the liberal ideas of the Enlightenment, yet steeped in the ancient traditions of stonemasonry and classical antiquity, Freemasonry was transplanted to America from England in its beginning period of growth and development. By the mid-eighteenth century, Freemasonry had gained wide acceptance in England, America, and the Continent. James Anderson's *Constitutions of Free-masons,* published in London in 1723, was one of the earliest printed explanations of the organization. The frontispiece (Fig. 1.1), engraved by John Pine, was widely copied and appears in later American editions of Anderson's *Constitutions,* such as the one printed by Benjamin Franklin for the Grand Lodge of Pennsylvania in 1734. A still later *Constitutions of the Ancient and Honorable Fraternity of Free and Accepted Masons,* published for the Grand Lodge of Massachusetts by Isaiah Thomas in 1798, continued to use Pine's frontispiece. The borrowing of designs from printed sources and the repetition of specific arrangements of symbols continued to characterize Masonic imagery throughout the eighteenth and nineteenth centuries.

Freemasonry is an eighteenth-century organization whose origins are closely related to the coffee houses, philosophical societies, and clubs of the period where men gathered to discuss philosophy and new ideas. Early lodges in England and America often met in taverns or private homes, where considerations of good food and spirits often competed with philosophical issues. Far from being conservative or exclusive, it was a vigorous new organization that included radicals and free thinkers. In a 1738 engraving titled *Night,* William Hogarth's down-to-earth depiction of the master of a Masonic lodge returning home departs from the purely moral and symbolic to reveal some of the less staid aspects of the early fraternity (Fig. 1.2).

The symbols of Freemasonry, drawn from a wide variety of sources in eighteenth-century Europe, remain an important visual legacy of the organization. The primary symbols are based on the tools and architectural principles used by stonemasons. The trowel, for example, is described as "an instrument made use of by operative masons to spread the cement which unites a building into one common mass, but we, as free and accepted masons, are taught to make use of it for the more noble and glorious purpose of spreading the cement of BROTHERLY LOVE."[2] The building stone or rough ashlar symbolizes man's natural imperfect state. The perfect or hewn ashlar symbolizes the state of perfection arrived at by virtuous education. The square, level, and plumb are the Masonic symbols for virtue, equality, and uprightness.

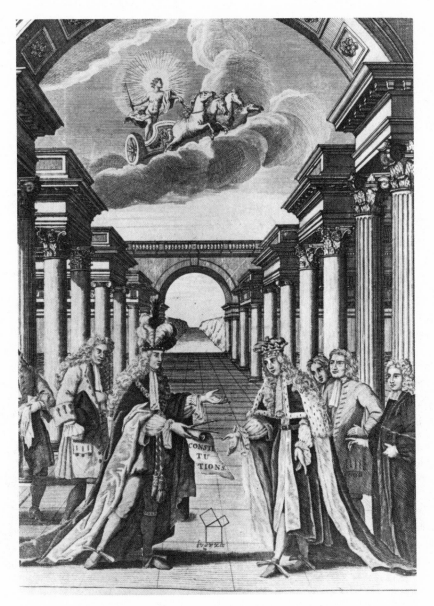

1.1. John Pine, frontispiece to James Anderson, *Constitutions of Free-masons*, London, 1723. Engraving; 8½ × 7¼ in. Courtesy of the Museum of Our National Heritage.

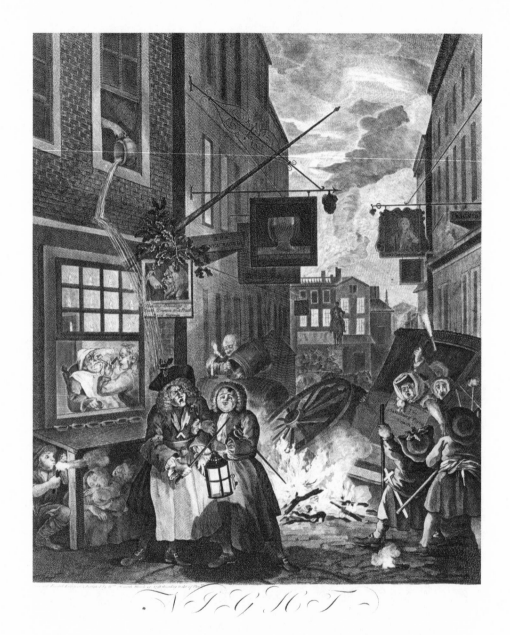

1.2. William Hogarth, *Night*, 1738. Engraving. Courtesy of the Boston Public Library, Print Department.

In combination with the compasses, symbolic of circumscribing passions, the square of virtue is probably the most commonly used and recognized Masonic symbol. Compasses were apparently a well-known symbol associated with a virtuous life in the eighteenth century. Many prints of the period with titles such as "Keep within the Compass and you shall be sure to avoid many troubles that others endure," indicate that the symbolism of compasses was understood by a large public. The earliest documented version of "Keep within the Compass" was engraved by an Englishman, G. Thompson, around 1760 and is in the collection of the Grand Lodge of England in London. Versions of this engraving are found in unsigned prints in the collections of Colonial Williamsburg and the Winterthur Museum. The same design appeared on transfer-printed English ceramics such as plates and pitchers depicting both the male and female versions of the moral tale. The inscription on a version picturing a male reads, "By honest and industrious means, We live a life of ease. Then let the compass be your guide, and go where e'er you please" (Fig. 1.3). The female version reads, "Attend unto this sample fact, as through your life you rove. That virtuous and prudent ways, will gain esteem and love."

The apron worn by Freemasons as part of their regalia is itself symbolic. The apron in Western culture has been the trademark of a craftsman for centuries. In England, "up to the late nineteenth century, the apron was in such general use for all jobs that its name in literature and its appearance in pictures became a sort of generic term or symbolic attribute denoting the 'working man.'"[3] When Freemasons adopted the tools, geometric concepts, and architectural forms associated with operative stonemasons as symbolic images conveying their moral and philosophical teachings, the leather artisan's apron worn by stonemasons became part of Freemasonry's symbolism and ceremonial clothing.

Other symbols are almost universal in Western culture. The beehive of industry and the anchor of hope are not exclusively Masonic. The symbol of charity, consisting of a mother and children, was another popular eighteenth- and nineteenth-century symbol used by Freemasons. Charity appears with Hope and Faith in one of the most common Masonic transfer prints on imported English ceramics, and it remained a popular fraternal symbol in American iconography throughout the nineteenth century, appearing on painted aprons, engraved certificates, and many other decorative arts.

Heraldry was another source for symbols. The compasses appeared on the arms of the Masons Company of London as early as 1472, as well as on the arms of other building trade guilds. John Coles, Sr., a heraldic painter working in

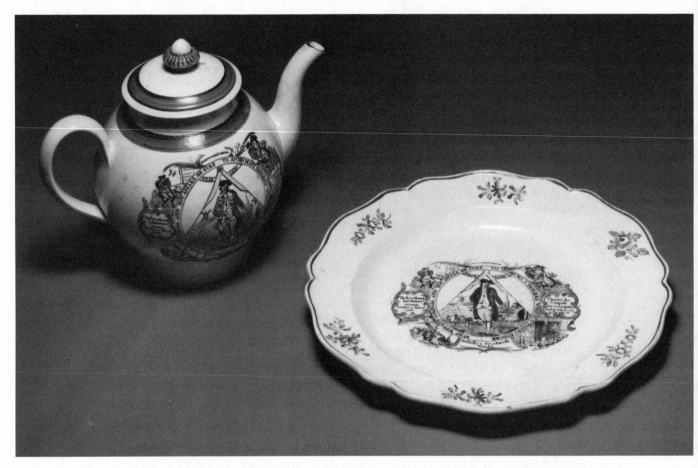

1.3. John Aynesley, teapot and plate, Lane End, Staffordshire, England, 1780–1809. Courtesy of the Museum of Our National Heritage; John Miller photograph.

Boston before 1809, painted several versions of the Freemasons Arms in addition to his paintings of family coats of arms. The versatility of nineteenth-century American artists is well-documented in advertisements offering to paint anything

from a major portrait to signs, furniture, or walls, and many decorative painters in America advertised heraldry painting among their many services. A Masonic apron dating from around 1800, originally owned by William Burr of Providence, Rhode Island, shows the influence of heraldry in the central design of the Mason's arms, crossed sword and pen, and the motto, "Honi Soit Qui Mal Y Pense" (Fig. 1.4). This apron might have been painted by one of several painters, including Davis W. Hoppin and Samuel Brown, who advertised themselves as "portrait and heraldry" painters in Providence during this period.

Of particular importance in Freemasonry are the many symbols dealing with death and immortality. This is a reflection of the widespread preoccupation with death in the eighteenth and nineteenth centuries which was characterized by elaborate funeral and mourning customs. The hourglass, scythe, and coffin used by Freemasons were well-known symbols for death that also appear on American mourning art such as carved gravestones and needlework memorials.

Not surprisingly, architecture plays an important role in Masonic symbolism. The columns, pavement, and steps which are so prominent in Masonic symbolism together represent King Solomon's temple and singly convey individual symbolic meanings. An unattributed engraving dating from about 1800 which belonged to Union Lodge of Dorchester, Massachusetts, shows a view of Solomon's temple that also appears on a number of nineteenth-century decorative artifacts. The same design appears on English ceramics of the 1830s and on an engraved whale panbone of the nineteenth century; Mary Sandiford, aged nine in 1840, chose a similar representation of Solomon's Temple for the design of her sampler (Figs. 1.5–1.6).

Freemasonry's connections with architecture were not always confined to symbolic meanings. The frontispiece to Batty Langley's *The Builder's Jewel*, published in London in 1746, incorporated Masonic symbols as appropriate illustrations for a builder's manual, indicating that early distinctions between working stonemasons and speculative Freemasonry often became blurred. While Masonic symbols were used in an architectural context in the frontispiece designed and engraved by Batty and Thomas Langley, this composition in turn served as the basis for Masonic transfer-printed designs on English ceramics dating around 1830 (Fig. 1.7).

Freemasonry was developing during a period in which classical architecture was being rediscovered by Europeans. Two of the most prominent architects of seventeenth-century England and the leading proponents of neoclassicism, Inigo Jones and Sir Christopher Wren, were also reported to have been

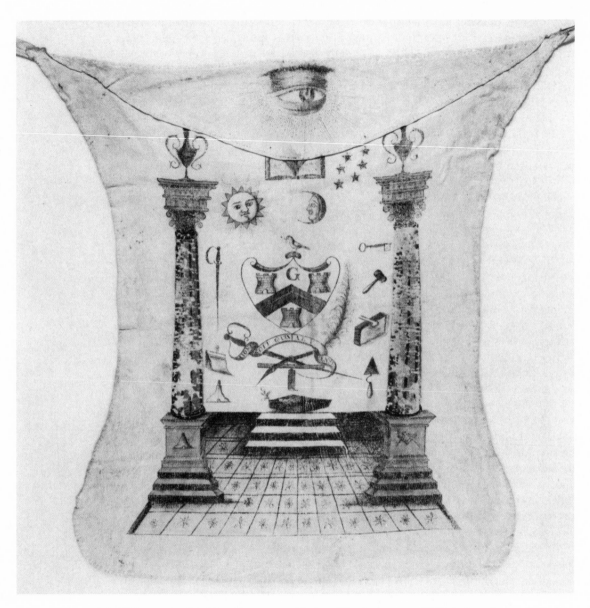

1.4. Unknown artist, Masonic apron with heraldic devices, ca. 1800. Ink and wash on leather; 16 × 13¾ in. Courtesy of the Museum of Our National Heritage.

members of Masonic lodges. In Freemasonry, the Ionic, Doric, and Corinthian orders are symbols for the Masonic attributes of Wisdom, Strength, and Beauty.

Americans were certainly familiar with classical architecture by the end of the eighteenth century. Georgian, Federal, and Greek Revival styles of architecture in America exhibit an increasing interest in and reliance on classical forms that finally culminate in a national style of architecture using Greek temples for public buildings and private dwellings. In fact, the moral significance of classical forms in Masonic imagery and their familiarity to large numbers of Americans may have contributed to the perception that the classical revival in architecture and furnishings was especially appropriate as a national style that could express the ideals of the new nation, much as Freemasonry taught its own moral virtues. When A. J. Downing in his books on architecture and landscape sought to break away from the Grecian style in the 1840s, he mourned the fact that "nine tenths of even the educated believe that the whole circle of architecture is comprised of the five orders or at most that a Greek Temple and a Gothic cathedral are the Alpha and Omega of the art."[4] It is interesting to speculate that the Grecian style in furnishings and architecture retained its tenacious popularity in America partly as a result of Freemasonry's emphasis on classical forms in its teachings.

The ties between Freemasonry and the growing national interest in classical architecture are well documented. The architect William Strickland, one of the major proponents of classical revival architecture in America, was also an active Freemason in Philadelphia. Early in his career, he designed a Masonic apron engraved by William Kneass that emphasizes the symbolism of the same classical columns that became Strickland's architectural trademark (Fig. 1.8).

The widespread use of Masonic emblems as decoration on a variety of objects dates from the last quarter of the eighteenth century and coincides with the American struggle for independence. By 1775, Masonic lodges had been established in each of the thirteen colonies. For Americans, removed from the European centers of learning, Freemasonry served as a vehicle for the popularization and spread of the new ideas—Enlightenment concepts of equality and the existence of natural laws were incorporated into the philosophy of Freemasonry. These radical ideas helped form American arguments favoring revolution and political separation from Great Britain. At least nine signers of the Declaration of Independence were Freemasons, and members of the Lodge of St. Andrew in Boston were involved in the Boston Tea Party incident. (George Washington's Masonic affiliations enhanced his role as the country's military and political leader.)

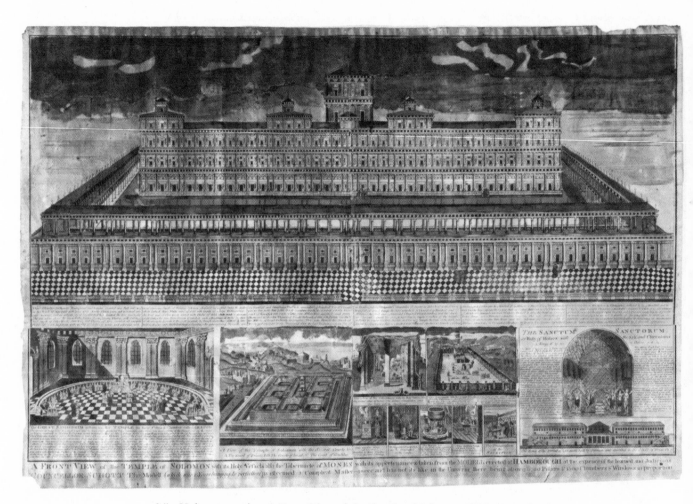

1.5. Unknown artist, *A Front View of the Temple of Solomon*, 1790s. Hand-colored engraving on four joined sheets, probably American; 23¼ × 25¼ in. Courtesy of the Museum of Our National Heritage.

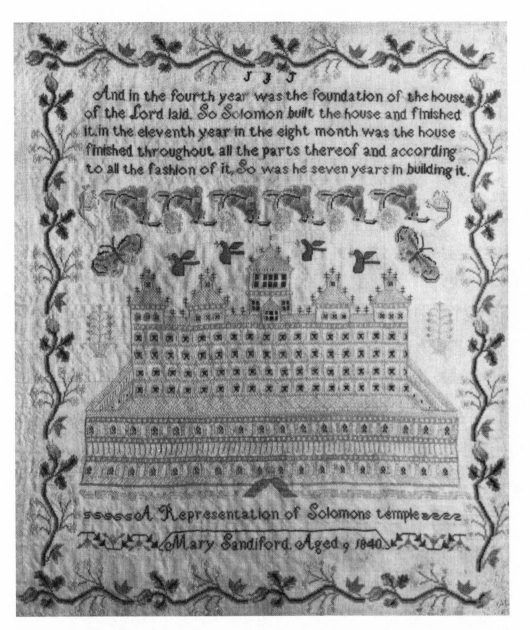

1.6. Mary Sandiford, sampler, 1840. Silk embroidery on linen; 22½ × 19¼ in. Courtesy of the Museum of Our National Heritage; John Miller photograph.

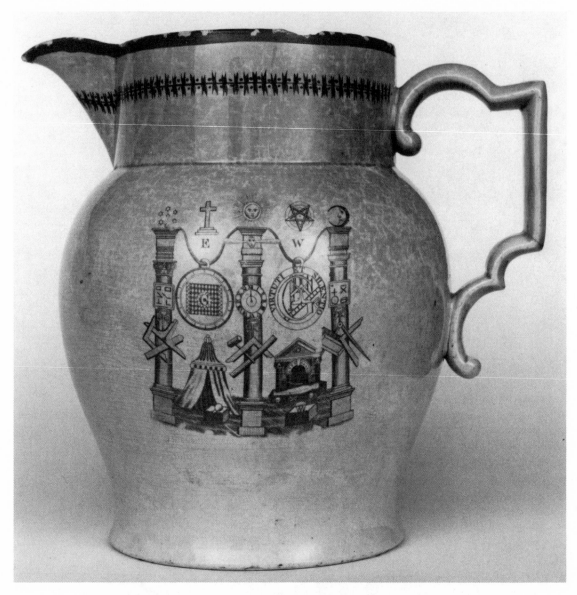

1.7. Unknown artist, earthenware pitcher, Staffordshire, England, ca. 1830. The transfer print is based upon the frontispiece to Batty Langley, *The Builder's Jewel*, London, 1746. Courtesy of the Museum of Our National Heritage.

1.8. William Kneass after a design by William Strickland, Masonic apron, ca. 1804–17. Engraving on silk; 14½ × 14½ in. Private collection; photograph courtesy of the Museum of Our National Heritage.

In attempting to establish a more distinctively American style, American craftsmen could turn to the aesthetic philosophy and symbols of Freemasonry for their models. The "Federal style," which developed in the years following the Revolution, was based on European interpretations of classical designs, but it was often given an American identity by the use of patriotic symbols as decorative motifs. Freemasonry's reverence for classical forms of architecture as embodiments of the moral principles of the fraternity was firmly rooted in eighteenth-century thought that valued art for its literary and symbolic significance. Although more esoteric parallels with the ancient democracies of Greece and Rome also influenced the adoption of a classical style in America, the moral significance of classical forms in Masonic imagery was familiar to large numbers of Americans and made the classical revival in architecture and furniture especially appropriate as a national style expressive of the ideals of the new nation.

It is not surprising then that an extremely close relationship exists between the development of patriotic symbols and the use of Masonic symbols in American decorative arts. The familiarity of American craftsmen with the symbols of Freemasonry and their use in decoration made it natural for them to use national symbols in a similar way. In some cases, the Masonic symbols themselves were considered emblems of patriotism. In the period 1775 to 1830, Masonic symbolism appears on almost every type of decorated object used in America, whether alone or in combination with patriotic symbols like the American eagle, Liberty, or George Washington. Examples of American furniture, glassware, stoneware crocks and jugs, coverlets, tin lanterns, tavern signs, and gravestones all may be found displaying Masonic symbolism.

The accepted relationship between Masonic and patriotic symbolism is clearly shown in a Staffordshire plate made by James and Ralph Clews, Staffordshire, England, in about 1830 (Fig. 1.9). The figure of America holding a portrait of George Washington wears a blindfold of justice and a Masonic apron. An earlier version of this design appeared in the *Sentimental and Masonic Magazine* published by John Jones of Dublin, Ireland, in June 1795. It in turn was based on a frontispiece for *The Freemasons' Magazine* (London, 1793) designed by Mather Brown and engraved by J. Corner. The 1793 version depicts a medallion portrait of H.R.H. the Prince of Wales, Grand Master of Masons in England, instead of George Washington. Freemasons often participated in public ceremonies in full regalia, such as at the laying of the cornerstone for the United States Capitol in 1793, which was later drawn by Benjamin Latrobe. These occasions helped to reinforce the connections between Freemasonry and patriotism in the minds of Americans.

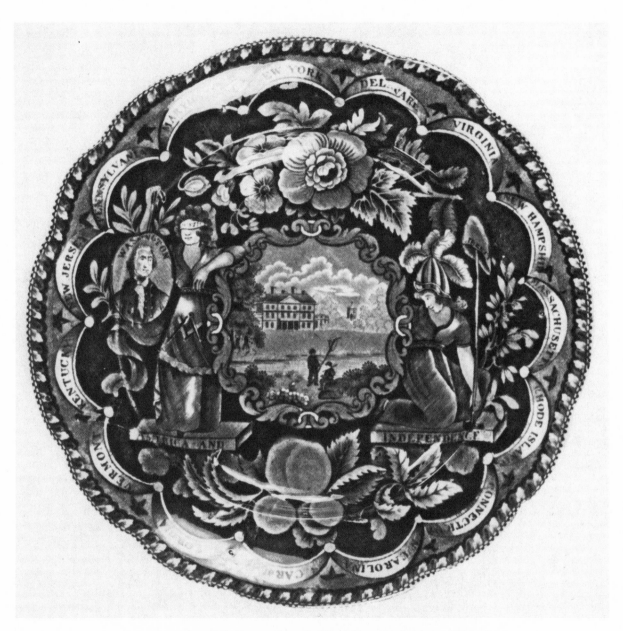

1.9. James and Ralph Clews, plate, Staffordshire, England, ca. 1830. Courtesy of the Museum of Our National Heritage.

A small drawing, dating from about 1800 and signed by C. R. Warren, may be a schoolgirl's effort, but it accurately records American sentiments at the time (Fig. 1.10). At the top of the page Commerce and Agriculture are balanced against each other, just as the young nation saw itself encouraging both types of economic development. The Lord's Prayer is written inside a heart as a reference to religion; surrounding it is the inscription "Is yours a Bacon or a Locke to blame, a Newton's genius or a Milton's flame," referring to some of the major scientists and philosophers of the Enlightenment; below this are the Masonic square and compasses. "Liberty, Justice, and Peace" shown to the left of the page with a reference to the Constitution and "George Washington, September 17, 1787" are balanced by "Love, Honor, and Virtue." At the bottom is Science symbolized by books and a desk, a quote referring to fleeting visions of death, and the inscription, "United we stand, Divided we fall." The Masonic symbol, centrally placed in the design, definitely played a part in America's patriotic and national symbolism at this time.

Following the Revolution, Freemasonry experienced a tremendous growth in membership in America. Political independence also meant that American lodges had to reorganize. They chose to create a system of state Grand Lodges rather than a national grand lodge patterned after the Grand Lodge of England. Many of the same men who had served important roles in the Continental Army appear again as the prime movers in establishing Grand Lodges, chartering new lodges, and serving as officers in their local lodges. The comradeship developed during military service often continued through these Masonic ties.

The immense popularity of Freemasonry following the Revolution corresponded with the development of engraving in America. Engravers were needed to supply the new nation with the necessary broadsides, banknotes, and documents, and to record patriotic subjects and heroes in popular prints. Self-taught American engravers such as Abner Reed and Amos Doolittle helped fill this need and similarly supplied the growing number of Masonic lodges with the necessary printed certificates and aprons that they required. A large number of these early engravers were themselves Freemasons. Some of them were silversmiths like Paul Revere, who made and engraved Masonic jewels of office and also engraved the copper plates for membership certificates and announcements.

The art of the engraver played an important role in the evolution from the rather diverse use of Masonic symbols in the eighteenth century to the more uniform designs that became standard by the mid-nineteenth century. English book illustrations and engravings continued to serve as models, often through

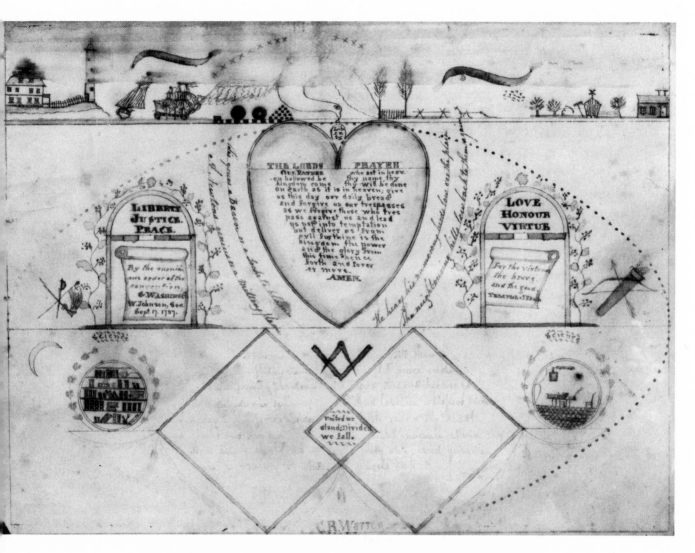

1.10. C. R. Warren, *Symbolic Picture*, ca. 1800. Ink and watercolor on paper; 6 × 8 in. Courtesy of the Museum of Our National Heritage; John Miller photograph.

the medium of transfer-printed designs on imported English ceramics. A transfer-printed pitcher presented to Union Lodge of Dorchester, Massachusetts, by Nehemiah Skillings in 1811, for example, has a design adapted from the frontispiece to Fifield d'Assigny's *Serious and Impartial Inquiry into the Present Decay of Freemasonry in Ireland* published in Dublin in 1744 (Fig. 1.11). In another instance, an engraving by Alexander Slade entitled "A Freemason form'd out of the material of his lodge," published in England in 1754, appears again as a watercolor by Samuel King of Boston in 1763 (Fig. 1.12), and again as a transfer-printed design on an English creamware pitcher of about 1800. Similarly, the design on a transfer-printed Liverpool creamware bowl of about 1790 is used as the design for a hand-painted Masonic apron made for John Rowe of Gloucester in 1791. The original inscription, "Deum Time Regem Honora" (fear God and honor the king), was democratically adapted for American use to read "Time Deum et Patriam Ama" (fear God and love your country).

It is important to remember that Freemasonry was an international organization, and American Freemasons were constantly in touch with brother Masons in other parts of the world. A certificate by J. Hiller and Samuel Hill was issued by Essex Lodge, Salem, Massachusetts, to Samuel Derby, the master of the ship *Margaret,* which was commissioned to sail to Japan for the Dutch in 1800. Addressed "To all Brethren throughout the world," this certificate served as a passport to introduce Captain Derby to Masonic lodges around the world. Signed by the secretary of a lodge in Batavia (Jakarta) in 1801, it documents his participation in a Masonic lodge in Indonesia and the nature of his contact with the Dutch. The symbolism of the certificate is particularly interesting because it uses the standard European symbolism of an American Indian to represent the American continent. Captain Derby's contacts with the Dutch and Japan resulted in the importation of Japanese lacquer wares to America, among them Japanese lacquer boxes with Masonic symbols. Most of these designs were taken from engravings or book illustrations and copied by the Japanese for their European and American customers.

French Masonic designs were brought to America via traders and ship captains as well as by the many emigré artists who came to America following the French Revolution. French Masonic aprons and membership certificates were often quite different from their English prototypes. French designs use distinctively French symbols (the niveau, a French form of level; tassels, ribbons, and a radiant "G"), small temple buildings reminiscent of the Pantheon in Paris, and

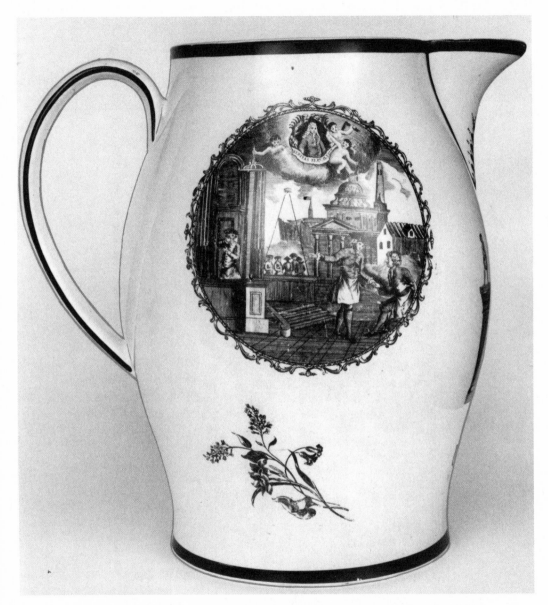

1.11. Unknown artist, English transfer-printed creamware pitcher. One of a pair presented to the Union Lodge of Dorchester, Mass. in 1811. Courtesy of the Museum of Our National Heritage.

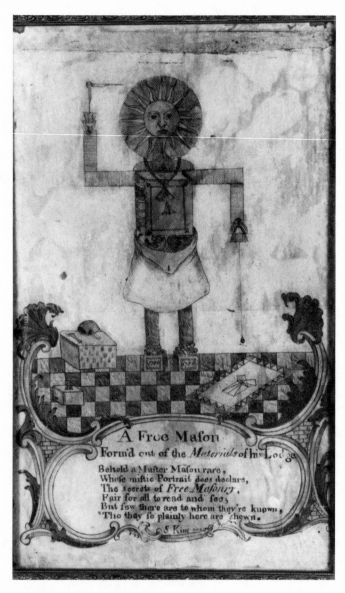

1.12. Samuel King, *A Free Mason Form'd Out of the Materials of his Lodge,* 1763. Ink and watercolor on paper; 13¾ × 8¾ in. Courtesy of St. Andrew's Lodge, A.F. and A.M., Boston, Mass.; photograph courtesy of the Museum of Our National Heritage.

columns topped with pomegranates. Landscape scenes with Egyptian elements, such as sphinxes and obelisks, are also common in French Masonic engravings for aprons and certificates.

Close political ties with France during the American Revolution and continuing emotional ties to French Freemasons, such as the Marquis de Lafayette, who fought in the American Revolution, established links between French and American Freemasons that can be seen in American Masonic designs of the early nineteenth century. A group of Masonic works by the emigré French artist Thomas Bluget de Valdenuit clearly shows that French designs were introduced directly to American Freemasons at this time. A leather apron printed with an engraved design signed "Valdenuit: N York 97" displays a typical French arrangement of symbols (Fig. 1.13). Two nearly identical certificates, one engraved and signed "V*** N. York 1797" and the other hand-drawn and filled out in France in 1798, both appear to be the work of Valdenuit. The engraved certificate represents his work in New York, while the hand-drawn version confirms that he had returned to France by 1798.

By 1800, the influence of American engravers can be seen in the increasingly standardized designs of American Masonic imagery. One of the most important steps toward this standardization was provided by the Masonic designs engraved by Amos Doolittle of Connecticut in collaboration with a Masonic writer, Jeremy Cross. Trained as a silversmith, Doolittle was typical of many self-taught craftsmen who did engraving for the Masonic fraternity. Doolittle was a member of Hiram Lodge in New Haven, and his earliest effort was a membership certificate for the Grand Lodge of Connecticut that was published and distributed in 1799. He also pressed the same engraved design, minus the text, into an apron. In signing the plate "Brother Amos Doolittle," he carefully identified himself as a brother and member of the fraternity. In 1818, Doolittle began his collaboration with Jeremy Cross by producing an apron for the degree of Royal Arch Select Mason in which Cross designed the symbols and Doolittle engraved the plate. When Cross published his book, *The Masonic Chart,* the next year, Doolittle did the engravings (Fig. 1.14). Earlier publications about the ritual, such as William Preston's *Illustrations of Freemasonry* and Thomas Smith Webb's *Freemason's Monitor,* had explained the meanings of the Masonic symbols but provided no description or illustration of their designs. Webb in particular did not approve of the use of emblems to illustrate Masonic works and upheld the greater secrecy characteristic of the early fraternity. Cross, on the other hand, purposely included the illustrations in the hopes that he would correct

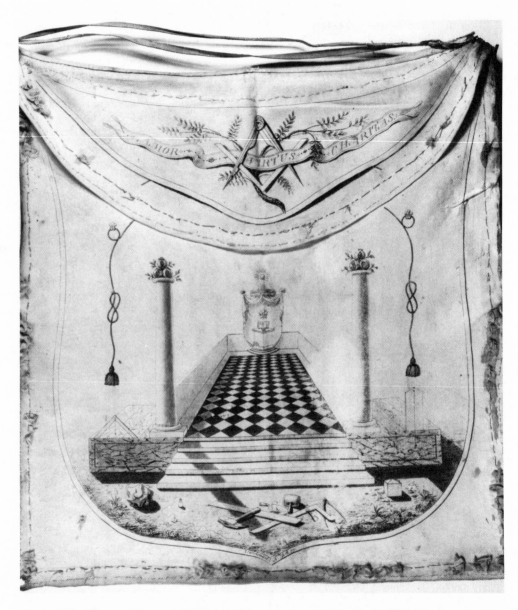

1.13. Thomas Bluget de Valdenuit, Masonic apron, New York, 1797. Engraving on leather; 15¼ × 14½ in. Courtesy of the Museum of Our National Heritage.

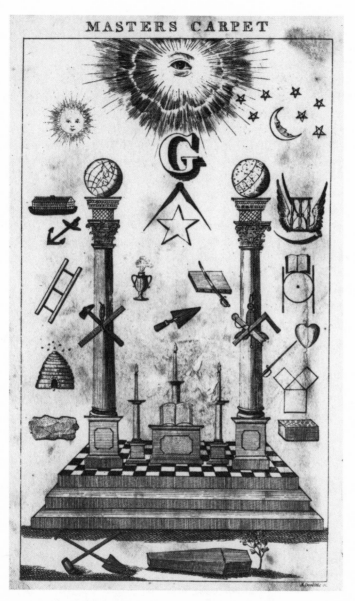

1.14. Amos Doolittle, frontispiece to Jeremy Cross's *Masonic Chart*, New Haven, Conn., 1819. Engraving; 5½ × 3⅛ in. Courtesy of the Museum of Our National Heritage; John Miller photograph.

inaccuracies in the ritual which he had observed in many American lodges during his tours as a Masonic lecturer: "Among these errors, may be mentioned,—the improper classification of masonic emblems; and a difference in the mode of working. To obviate these inaccuracies is the object of this work. It contains a classification of the emblems, together with illustrations that have been approved and adopted by a majority of the Lodges of the United States."[5]

Cross's book became immediately popular, and Doolittle's engravings quickly became the standard designs for American Masonic symbolism. Symbols like the cock or lamb that were found in eighteenth-century American symbolism, but were not included in Cross's *Masonic Chart,* quickly fell out of use in America, although they continue in English Masonic symbolism. The frontispiece in particular became the model for many subsequent designs, including a Currier and Ives lithograph of a Masonic chart published later in the century. The book included one new symbol, a broken column that Cross apparently designed. Other symbols were derived from the engraved designs found on printed ceramics, handkerchiefs, jewels, certificates, and aprons of the period. Cross and Doolittle succeeded in taking these informal but familiar Masonic designs found on objects used in America and publishing them in a standard source for future use and dissemination.

Masonic engravings for certificates and aprons provide some interesting insights into the careers of early nineteenth-century American engravers. Many of these works represent a collaboration between an individual Freemason and an engraver. Cross's diary, now in the collection of the Grand Lodge of Massachusetts, documents his partnership with Amos Doolittle in great detail. On March 28, 1818, Cross noted that he "calld on Comp[anion] Doolittle and agreed with him to engrave a R.A. Aprn which he agreed to do and go halves in the expen[se] and profit."[6] In October of the following year Cross bought out Doolittle's interest in the copyright and became the sole owner: "Bot 10 1/2 of Copper; purchased the one copyright in the Royal Arch Apron and all the stock, debts, etc. belonging to Amos Doolittle and became the sole [owner] gave him fifty dollars for the whole."[7] Other entries in Cross's diary for October and November 1819 mention that he carried some satin to Brother Doolittle for select flaps and assisted in printing aprons which he then sold for two dollars and fifty cents.

A number of collaborations between prominent Freemasons and American engravers produced printed Masonic aprons. Cross later designed another apron in the 1820s in collaboration with the firm of N. & S. S. Jocelyn of New Haven. Connecticut engraver Abner Reed produced three different Masonic apron de-

signs with Sherman Dewey, a Freemason of Willimantic, Connecticut. Each apron they produced together is inscribed, "Engraved by Abner Reed for Bro. S. Dewey." Giles Fonda Yates, a prominent Freemason in Schenectady, New York, designed an apron that was printed by the firm of Balch, Rawdon and Company of Albany in 1821.

The rapid growth of the Masonic fraternity in the first three decades of the nineteenth century created a market for printed certificates and aprons. Publishers and engravers were quick to see the possibilities of marketing Masonic aprons both locally and nationally. Edward Horsman, a Mason in Massachusetts who designed an apron in collaboration with an unidentified engraver, solicited and gained the approval of the Grand Lodge of Massachusetts for his design before successfully selling copies throughout the state. Amos Doolittle's engraved Masonic aprons and certificates are found over a wide geographic area, indicating that he published Masonic engravings in quantity and marketed them as widely as possible. One Doolittle apron carries the legend, "Engraved by Brother Amos Doolittle, New Haven for H. Parmele. The above may be had of Bros. . . . Samuel Maverick, N.York, A. Doolittle, New Haven, and I. W. Clark, Albany." Cooperative arrangements such as this among the many engravers who were Freemasons assured distribution of their work in several states. Many of Doolittle's certificates are multilingual, including French-English-Latin and Spanish-Latin examples, suggesting use as far away as Louisiana, Florida, and the West Indies.

Engraved Masonic aprons can also provide new information about the early work of well-known American engravers. For example, portrait painter, engraver, and inventor Oliver Tarbell Eddy (1799–1868) did engraving for Masonic aprons early in his career. The son of the Vermont printer Isaac Eddy, Oliver Eddy began engraving at the age of fifteen under his father's tutelage. Before he left home for New York City in 1822, young Oliver had engraved two Masonic aprons which were published by Lewis Roberson of Wethersfield, Vermont. Similarly, Charles Cushing Wright, who began as a silversmith's apprentice and later became associated with some of the most important bank note printing firms in America, engraved Masonic aprons and certificates early in his career. In Homer, New York, he did engraving for William B. Whitney, a local Mason who belonged to the same lodge as John Osborn, the silversmith to whom Wright was apprenticed.

Lesser-known engravers are also represented in collections of Masonic aprons and certificates. James T. Porter was a Middletown, Connecticut, engraver whose known work includes a frontispiece to *A Narrative of the Adventures*

and Sufferings of John R. Jewitt (Middletown: Loomis and Richard, 1815) and a juvenile book with eight illustrations printed and sold by J. T. Porter in 1823. During the period that he worked in Middletown, from 1815 to about 1830, Porter also engraved at least three Masonic aprons (Fig. 1.15). One plate is signed "J.T. Porter Middletown" but others are simply signed, "designed and engraved by a brother, Midd." Because he used the same engraving for the flaps of several aprons, this entire group of Masonic engravings can be attributed to him.

Besides being one of the most popular fraternal organizations, the Freemasons also served as a model for many other fraternal organizations. By the mid-nineteenth century, fraternal organizations in America had proliferated. The Independent Order of Odd Fellows was transplanted from England to America in 1815; the Improved Order of Red Men was established in 1834; the Sons of Temperance began in 1842; the Order of United American Mechanics formed in 1845; and a long list continues. Many of these organizations were based on Freemasonry and similarly used symbols to represent and teach values.

The imagery associated with these later organizations reflects the shifts in printing techniques from engraving to lithography and chromolithography. Masonic imagery similarly changed to adapt to current fashions and changing aesthetics. The late nineteenth-century Masonic charts chromolithographed with florid designs and sentimental subjects are a clear departure from the classical restraint of William Strickland (Fig. 1.16).

The sheer quantity of American objects displaying Masonic symbols is tangible evidence of the important role that Freemasonry has played in American life. Whether Freemasonry helped shape American taste through its architectural and classical symbolism, or simply reflected current styles, its presence in American culture is significant. Large numbers of Masonic artifacts exist throughout the country in individual lodges, in State Grand Lodges, and in art and history museums. These can be utilized by art historians in their efforts to learn more about American artists and engravers and the various sources they used.

The iconography of Freemasonry goes beyond Masonic symbolism and embraces major themes in American art. Freemasonry's basic symbols—the square, compasses, other stonemasons' tools, the sun, moon, stars, and all-seeing eye—consistently appear in Masonic design, but the eclectic symbolism of Freemasonry also includes other familiar symbols associated with religion and patriotism. Faith, Hope, and Charity, represented by the figures of a mother and

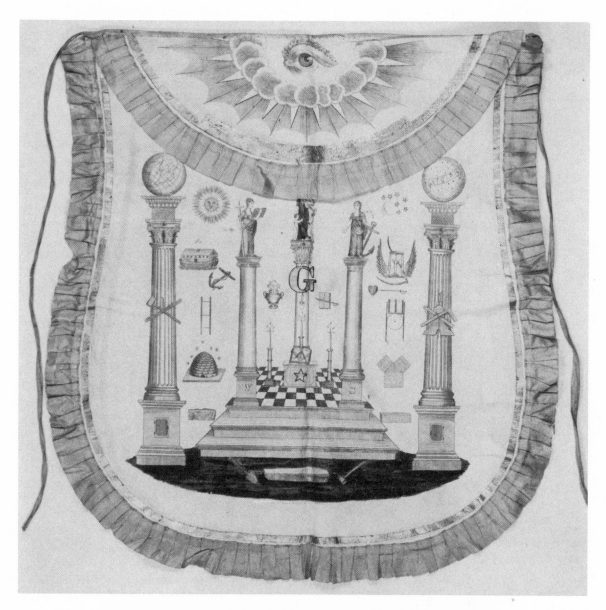

1.15. James T. Porter, Masonic apron, Middletown, Conn., ca. 1810–1830. Engraving on leather; 16½ × 16 in. Courtesy of the Museum of Our National Heritage.

1.16. J. H. Buffords Sons, *Masonic Chart*, Boston, 1866. Lithograph; 25½ × 20¼ in. Courtesy of the Museum of Our National Heritage; John Miller photograph.

child, and female figures holding a cross and an anchor, are common to both Masonic imagery and a wide variety of family registers, mourning pictures, and the like. The use of columns and other architectural forms in Masonic designs coincides with the classical revival in America, and Masonic imagery includes some of the most charming examples of the American taste for neoclassical motifs. Symbols of death and eternal life closely link Masonic imagery with the mourning-art tradition in America. Universally recognized mourning motifs on gravestone carvings and mourning pictures of the Federal period, the coffin, willow, branch, and urn, were also widely used to express the ideals and teachings of Freemasonry. Masonic imagery conveyed well-known meanings to contemporaries by combining familiar motifs and symbols of Freemasonry in a wide variety of original designs.

Notes

1. Alan Gowans, "Freemasonry and the Neoclassical Style in America," *Antiques*, February 1960, 172.

2. Jeremy Cross, *The Masonic Chart* (New Haven, 1819), 40.

3. Phyllis Cunnington and Catherine Lucas, *Occupational Costume in England* (London, W. & J. Mackay, 1967), 375.

4. A. J. Downing, *The Architecture of Country Houses* (New York, D. Appleton & Co., 1854), 2.

5. Cross, *Masonic Chart*, 6.

6. Jeremy Cross, unpublished diary, March 28, 1818, Grand Lodge of Massachusetts Collection.

7. Ibid., October 11, 1819.

2

The Poet and the Illustrator

Longfellow, Billings, and the "Disproportion
Between Their Designs and Their Deeds" in the 1840s

JAMES F. O'GORMAN

For most literary historians, the 1850s loom large as the decade in which American writing came of age with the appearance of *The Scarlet Letter, Moby Dick, Walden,* and other flowers of the "American Renaissance." For most historians of the book—students of form as well as content—it is the previous decade that shines forth. For William Charvat, who focused upon the occupation of authorship in America, the 1840s saw the struggle for birth of the literary profession, led by the promotional skills of James T. Fields of the house of Ticknor and Fields in Boston.[1] For Frank Weitenkampf and Sinclair Hamilton, students of American book illustration, the 1840s marked the era in which "almost overnight" "in a comparatively sudden outburst of production," American illustration "first got into stride, in artistic and professional stature."[2] It was this decade, according to Hamilton, in which engravers became delineators and their dependence upon English models began to diminish.[3]

Such sweeping claims about American illustration ring sonorously in brief historical overviews, but they simplify a rich and complex story. Nor can they be entirely accurate. They exist because there has been little detailed examination of the careers of the illustrators who emerged during the 1840s, with the conspicuous exception of F. O. C. Darley. That Darley deserves the attention he has received on qualitative grounds alone cannot be denied, but as is so often the case, it may prove possible to learn more about an era from the experiences of its average practitioners than from the triumphs of its stars. To pinpoint some general characteristics of this formative decade in the history of American book illustration, this chapter will focus upon one case study, that of the relatively

brief and largely ill-fated relationship between the poet Henry Wadsworth Long-fellow of Cambridge (1807–82) and the illustrator Hammatt Billings of Boston (1818–74). Although available evidence stems largely from Longfellow's writings and is therefore one-sided, the story emerges in its major outlines. The historian of the visual arts may question that so little came of an association of more than five years, but it is just such lack of achievement that signals the precarious lot of the American illustrator in this early period. As the poet himself summed it up in 1846, in reference to no specific, discernable event, "authors and art-ists ... have one element of unhappiness in their lot, namely, the disproportion between their designs and their deeds. Even the greatest cannot execute one tenth part of what they conceive."[4] Longfellow seems to suggest that time—or rather, the lack of it—is the cause of this unhappiness, although as we shall see, for Billings this was only one of the problems.

Dramatis Personae

Of the two figures in our story, the poet is as overly familiar as the illustrator is unjustly obscure. It may be well, however, to recall Longfellow's position in the period here considered, the half-decade 1845–50. Born in 1807, Harvard's professor of modern languages had by his mid-thirties traveled thrice to Europe, produced a number of scholarly linguistic studies, two prose works based upon his travels (*Outre-Mer,* 1833, and *Hyperion,* 1839), collections of poetry (*Voices of the Night,* 1839; *Ballads and Other Poems,* 1842; and *Poems on Slavery,* 1842, in-cluding such popular works as "The Wreck of the Hesperus," "The Village Blacksmith," and "The Skeleton in Armor"), and a drama (*The Spanish Student,* 1843). In 1845 appeared *The Waif, The Belfrey of Bruges, The Poets and Poetry of Europe,* and *Poems,* the last two published in illustrated editions by Carey and Hart of Philadelphia. His major publication during the five years under dis-cussion here, and our main focus, was his first long narrative poem, *Evangeline* (1847).[5] That the poet continued to produce on a regular basis until his death in 1882 is beyond our immediate interest. As William Charvat has emphasized, it was during the 1840s, one of his most productive periods, that Longfellow "established his reputation and popularity as a poet."[6]

If, by 1845, Longfellow was a firmly established scholar and bard, well on his way to making his name synonymous with versifying, Hammatt Billings, a decade younger and scion of a less distinguished heritage, was just beginning

to establish a toe-hold on the precarious profession of graphic design.[7] In the 1830s he left Boston's English High School without graduating to begin a duel apprenticeship, first as an illustrator under Abel Bowen, and then as an architect under Asher Benjamin and Ammi B. Young. His career as architect got off to a promising start in 1845 when, in partnership with his brother, Joseph, he was commissioned by Moses Kimball to design the Boston Museum, a combined theater and exhibition hall that once stood on Tremont Street north of King's Chapel. In the same year appeared his first significant piece of book illustration, Munroe and Francis's *Chimes, Rhymes and Jingles: or, Mother Goose's Songs,* with some 135 large and small wood-engraved vignettes distributed throughout the text. The title page claims these as "original pictures, designed by Billings, and engraved by [Alonzo] Hartwell," but the production is markedly uneven, perhaps because it reflects a wide variety of ill-digested English and other foreign sources. Between the mid-1840s and his death in 1874, Billings was to toil ceaselessly at all aspects of design, distinguishing himself as an architect with such works as the original buildings of Wellesley College (1869–75), and as an illustrator of books by, among many others, Hawthorne (*The Wonder Book,* 1852), Stowe (*Uncle Tom's Cabin,* 1852 and 1853), Whittier (*Sabbath Scene,* 1854), Scott (*Waverly Novels,* 1858), "Grace Greenwood" (*Stories from Famous Ballads,* 1859), Tennyson (*Poems,* 1866), Alcott (*Little Women,* 1869), Dickens (*A Child's Dream of a Star,* 1870), and Longfellow's brother-in-law, T. G. Appleton (*Faded Leaves,* 1872). Although he is now remembered, if at all, primarily as an illustrator of juvenile texts, in 1845 Hammatt Billings had the entire world of design to conquer.

The Poet and his First Illustrator

Illustrated editions of Longfellow's writings first appeared in 1845, published by Carey and Hart of Philadelphia: *The Poets and Poetry of Europe,* an anthology, and the *Poems,* a collection of original verse. For *The Poets,* the publishers supplied a frontispiece (a mezzotint portrait of Schiller) and a steel-engraved title page framed by a series of small European scenes (Fig. 2.1). The latter, following what was then standard practice, appears to have been adapted from a design "lying about the shop" and was not created specifically for the work. Longfellow's reaction was as incredulous as it was naive, and Abraham Hart's response to Longfellow is revealing of the relationship between writer, publisher, and illus-

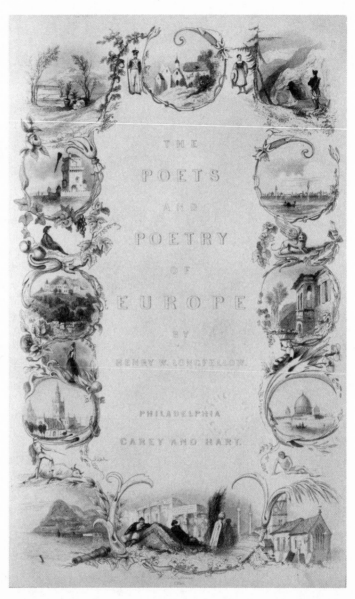

2.1. Unknown artist, title page to H. W. Longfellow, *The Poets and Poetry of Europe*, Philadelphia: Carey and Hart, 1845. Steel engraving. By permission of the Houghton Library, Harvard University.

tration in the mid-1840s. When he received his copy, the poet, who, incidentally, was himself a draftsman of some talent, felt "bound to protest" the title page as "very bad."[8] Had he seen it in advance, he would "never have consented to its going in." Writing as "the responsible person in the public eye," he felt nothing should have been done about the book "without my consent." The reason he disliked the page was not just that it was bad, which even by the standards of the time it undoubtedly is, but, as he expressed it in an earlier letter, "engravings which have no connection with the subjects in the book—would be to me a deformity and not a beauty."[9]

That the poet was mistaken in thinking he or any other author had control of the appearance of a book contracted to the Philadelphia publishers in the mid-1840s was made clear by Abraham Hart's reply. Carey and Hart, he wrote in July 1845, "consider ourselves at liberty to select the parties to make the designs and engrave the plates, feeling satisfied that we are better acquainted with the public in that department."[10] Longfellow's first illustrated work thus provided him with a disappointing lesson in the ways of book production.

His second book with Carey and Hart proved a little more satisfactory, as the publishers secured the services of an artist of standing, Daniel Huntington, to provide illustrations inspired by Longfellow's poetry. It was in April 1844 that the poet contracted with the publishers to produce an illustrated edition of his verse.[11] Edward Carey, an important patron of American artists, had recently purchased Huntington's major work, *The Dream of Mercy* (1842), had it engraved, and used it in various publications of his firm.[12] He also commissioned of Huntington, who was in Europe during this period, eight illustrations and an engraved title page for Carey and Hart's edition of Longfellow. The illustrated *Poems* of 1845 is an example of the quality of which the Philadelphia house was capable when it made the effort. It was generally well received in the press, one unidentified clipping collected by the poet providing two important references for the historian: "the mechanical execution," it reads, "rivals the workmanship of London"; and—to the reviewer's surprise, it would seem—"the illustrations ... unlike most illustrations of American books ... really do adorn the volume."[13] As this so clearly demonstrates, American book illustration in the mid-1840s was judged by English standards.

The poet's reaction to Huntington's efforts was, apparently, cautious. He was puzzled in April 1845 by a proof of the artist's rendering of "The Old Cathedral" (Fig. 2.2), which he thought represented a misunderstanding of the verse[14] and wished that Hart "had sent me all the illustrations before they went

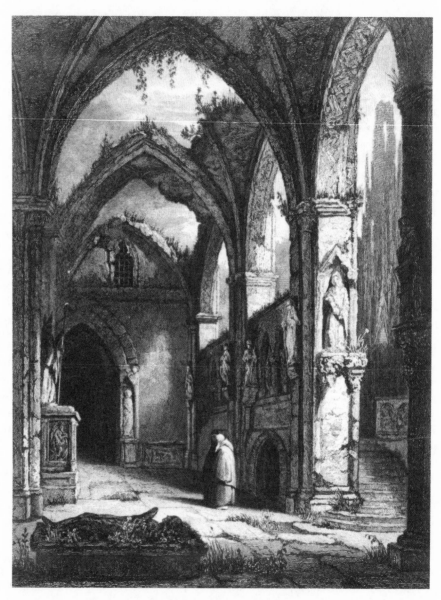

2.2. After Daniel Huntington, *The Old Cathedral,* from H. W. Longfellow, *Poems,* Philadelphia: Carey and Hart, 1845. Wood engraving. By permission of the Houghton Library, Harvard University.

into the engraver's hands."[15] This, we remember, predates the publisher's chastising letter of July about responsibility for illustrations, when Longfellow still assumed he had a say in the matter. Eventually the poet found some satisfaction in Huntington's work, remarking to Hart that he found "Nuremberg," "Preciosa," and "most of the others excellent," although he thought the maiden in "The Wreck of the Hesperus" (Fig. 2.3) "too like a Roman peasant" and the fisherman rather unlike "a Marble-head fellow."[16] Longfellow dimly recognized the problem inherent in the scene, with its maiden a distant echo of Giorgione's Dresden Venus, which is itself based upon an ancient Ariadne. He clearly thought Huntington's long residence in Italy a corrupting influence upon his handling of American subjects. Just as clearly, as later events show, Longfellow was somewhat dissatisfied dealing with both an illustrator and a publisher who were in every way beyond his control.

Longfellow, Billings, and Evangeline

During the winter of 1844–45, with Carey and Hart working on illustrated editions of *Poets* and *Poems*, Longfellow thought of reissuing *Hyperion*, then five years old, with illustrations. In December he asked the Philadelphia publishers how "a new edition ... with vignettes [would] succeed" and returned to the idea in a letter of March 1845, in which we first learn of his interest in Hammatt Billings.[17] "Have you thought anything more of 'Hyperion,' " he writes. "I think one [edition] with wood-cuts *[sic]* intermingled with the text, like the French Gil Blas, would have a fine effect, because the whole *scenery* of the book is highly picturesque. There is a young artist by the name of Billings in Boston, who has the talent for such designs." Nothing came of the poet's first attempt to employ the local illustrator, however.

By the end of 1845 the writer was at work on a long narrative poem dealing with the eighteenth-century dispersal of the Acadians. He noted in his "Journal" in December that he was undecided about its title. "Shall it be 'Gabrielle,' or 'Celestine,' or 'Evangeline,' " he wrote.[18] Through the entire next year he worked at his epic, announcing in his "Journal" in February 1847 that "Evangeline is ended."[19] It was published in October of the same year[20] by William D. Ticknor and Company of Boston.

Such a simple recital of the facts hides the more complicated history of the book which emerges from scattered documents. Longfellow's experience with

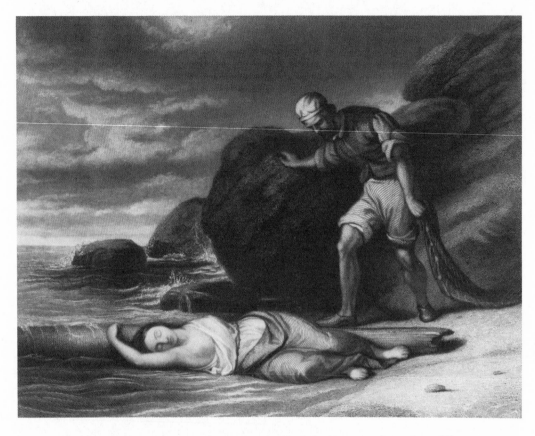

2.3. After Daniel Huntington, *The Wreck of the Hesperus*, from Longfellow, *Poems*, 1845. Wood engraving. By permission of the Houghton Library, Harvard University.

Carey and Hart apparently in part led him to seek control over his publications by having his verse set in type at his own expense, then selling the printed sheets to a local publisher for binding and distribution.[21] It also led him to seek a local artist to embellish his work, for Longfellow intended to issue *Evangeline* in two editions, one illustrated, and one in "cheaper" format.

With the writing of the epic well toward completion in the early days of 1847, Longfellow began to think of its published appearance. On 9 January he went to Boston to see Billings "about illustrating 'Evangeline.['] I want to have an illustrated edition at the same time with a cheaper one."[22] Billings reacted favorably to the idea, as well he might given the relative reputations of the two men. In his "Journal," and presumably to the artist as well, the poet briefly outlined his ideas for the proper embellishment of his work. "I shall have margins from American subjects such as Indian corn, hops, muscadine vines, amid festoons of evergreens and the mournful pines," he recorded. He wanted American subjects to enrich an American saga, not Renaissance Ariadnes sprawled upon North Shore granite, as the Italophile Huntington had provided for "The Wreck of the Hesperus." For this generation, the desire to create an American art—verbal as well as visual—was supreme, even if the means of its accomplishment were in doubt.

Billings quickly followed Longfellow's visit by visits of his own to Craigie House in Cambridge. On the afternoon of the eleventh of January, the artist came to tell the poet he desired to do the illustrations, "and enters warmly into the plan." Longfellow adds that he is a "charming fellow ... and altogether the best illustrator of books we have yet had in the country."[23] On the eighteenth Billings came again "to hear some passages in Evangeline, previous to making designs."[24] But here the matter rested. When, a month later, Longfellow stopped by Billings's place in the city, he found that the artist had "not got anything done for me in the way of illustrations. At this rate it will be long work."[25] The unillustrated edition of *Evangeline* appeared in October; in January of the next year, with the sixth edition already in print, Longfellow, in the city to see Billings, cannot find him.[26] Thereafter, all is silence in the "Journal" regarding Billings and the epic, although we know that the poet and the illustrator continued communication about other matters for a number of years. No edition of *Evangeline* was ever published with illustrations by Hammatt Billings.

Before we ask the obvious question why there occurred this "disproportion between their designs and their deeds" regarding *Evangeline,* we might take cognizance of the fact that Billings did produce at least one drawing for the epic. The Hammatt Billings Collection in the Wellesley College library recently acquired a copy of the sixth edition of *Evangeline* with the artist's calligraphic signature at the top of the title page (Fig. 2.4), and a soft pencil sketch of the "forest primeval" at the beginning of the text (Fig. 2.5).[27] As we know, the sixth edition appeared in January 1848, but this particular copy has bound in front

EVANGELINE,

A

TALE OF ACADIE.

BY

HENRY WADSWORTH LONGFELLOW.

SIXTH EDITION.

BOSTON:
WILLIAM D. TICKNOR & COMPANY.
1848.

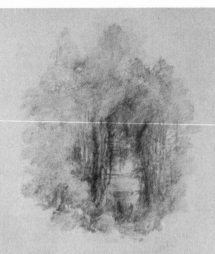

THIS is the forest primeval. The murmuring
 pines and the hemlocks,
Bearded with moss, and in garments green, indis-
 tinct in the twilight,
Stand like Druids of eld, with voices sad and
 prophetic,
Stand like harpers hoar, with beards that rest on
 their bosoms.
Loud from its rocky caverns, the deep-voiced
 neighbouring ocean

2.4. (*Left*) Title page to H. W. Longfellow, *Evangeline, a Tale of Acadie,* Boston: William D. Ticknor and Company, 6th ed., 1848, with signature of Hammatt Billings. Courtesy of the Book Arts Collection, Wellesley College Library; Robert W. Chalue photograph.

2.5. (*Right*) Hammatt Billings, *The Forest Primeval,* ca. 1849. Pencil drawing in Longfellow, *Evangeline,* 6th ed., 1848; 3⅛ × 2½ in. Courtesy of the Book Arts Collection, Wellesley College Library; Robert W. Chalue photograph.

a list of books recently published by Ticknor dated 1 May 1848. Since Billings's sketch cannot predate that list, it is apparent that he still had in mind illustrating *Evangeline* at least until the late spring or early summer of 1848.

What happened to thwart Billings's plans after this date is not now and may never be known. There was no falling out between the poet and the artist, as a host of documentation proves.[28] Certainly Billings was preoccupied with other matters, both professional and personal, which drained his energy. We know, for example that in April 1846 Billings signed a contract to construct the Church of Our Saviour in Bedford Street, Boston, from his own design at a price of $33,000. When the church was dedicated in November 1847, it had cost more than twice that amount, and Billings had begun a scramble for money that was to plague him throughout his career.[29] Yet, Billings did other illustrations during this period, and the main reason for the lack of his illustrated edition of *Evangeline* lies not within the biography of either poet or artist. It lies in the precarious position of American illustration in this, its formative decade.

Enter the English

What prevented Billings from providing sketches for *Evangeline* between the summer of 1848 and the autumn of 1849 is unknown. What is known is that the poet rejoiced to a correspondent in November of the latter year "that an illustrated edition of Evangeline is in press in England,"[30] even though this pirated work thwarted his desire to have an American illustrate his poem. By then the book was nearly released, for Longfellow had a copy in his hands by the end of January 1850.[31] Assuming a year to produce drawings, engravings, and finished books, the idea of this first illustrated edition of *Evangeline* must have been broached in the winter of 1848–49, not long after Billings's last known stab at the project. The publisher was David Bogue of London; the illustrators were Jane E. Benham, Birket Foster, and John Gilbert, the latter two among the busiest English draftsmen of the period. All this suggests that the efficiency of the English bumped the emerging—and, in truth, dilatory—American artist from the project, that the established competition from abroad was too much for the native neophite, that the beginning in the 1840s of the "great development in American book illustration" went not quite so smoothly as Sinclair Hamilton would have us believe.[32]

The English combination of Birket Foster and John Gilbert, the former working for Bogue (and his successor, Kent), the latter, after *Evangeline,* moving

to Routledge, went on in the 1850s to produce illustrated edition after illustrated edition of Longfellow's works.[33] A quick perusal of *The National Union Catalogue* shows London issues of *Poems, Poetical Works, Prose Works, Hiawatha, The Golden Legend, Hyperion, Kavanagh,* and *The Courtship of Miles Standish* embellished by Foster or Gilbert or both before 1858. Since Bogue sold sheets of his illustrated editions to Ticknor and Fields for reissue in the U.S., and they continued to produce new editions of his unillustrated versions of Longfellow's works,[34] it would seem that the poet's plan to have both illustrated and cheap editions of *Evangeline* was, willy-nilly, extended to his other works, with the illustrations supplied by English rather than native artists. In the case of Longfellow, at least, the callow American illustrators lost an important client to their established and prestigious English cousins. It was not until 1866 that *Evangeline* appeared with American illustrations, and then they were the work of F. O. C. Darley.[35]

And what did Longfellow think of these foreign illustrations of his American theme? The copy of *Evangeline* he received in January 1850 he thought "very beautiful,—the landscapes in particular. But alas! Evangeline herself fares poorly with her limner."[36] The heroine was depicted by Jane Benham, whose work, at least here, is weaker than that of her male colleagues (Fig. 2.6). On the other hand, the landscapes reflect the labor of Birket Foster, master of the rustic vignette, whose opening view of the "forest primeval" (Fig. 2.7) is reminiscent of Billings's unpublished sketch (see Fig. 2.5), and may perhaps take precedence in time, although it frames the text rather than balances above it, and lacks a clear depiction of "the hemlocks, Bearded with moss" which characterizes the Billings design. We cannot argue with Longfellow's appreciation here, but what of other landscapes? How could the poet who once thought to ornament his American epic with American flora accept Foster's view of the lowly Ozarks, whose highest points are but 2300 feet above sea level, as snow-covered Alpine peaks towering above diminutive Gabriel (Fig. 2.8)? The answer is, probably, that Longfellow like Foster had never been to the Missouri highlands; to both of them the Swiss peaks alone represented mountainous terrain. But the poet had been to Philadelphia and must surely have recognized its transformation into a medieval English village in Foster's depiction of the watchman espying Evangeline's nightly candle (Fig. 2.9). That Longfellow could express delight in these alien scenes suggests an unconscious anglophilia, for he might have justly said of them, as he had written in 1845 of the title page of Carey and Hart's *Poets and Poetry of Europe*, that "engravings which have no connection with the subjects in the book—would be ... a deformity and not a beauty." But

Shone on her face and encircled her form, when, after confession,
Homeward serenely she walked with God's benediction upon her.

When she had passed, it seemed like the ceasing of exquisite music.
Firmly builded with rafters of oak, the house of the farmer
Stood on the side of a hill commanding the sea; and a shady
Sycamore grew by the door, with a woodbine wreathing around it.
Rudely carved was the porch, with seats beneath; and a footpath

2.6. After Jane E. Benham, *Evangeline*, from H. W. Longfellow, *Evangeline,* London: David Bogue, 1850. Wood engraving. Courtesy of the Book Arts Collection, Wellesley College Library; Robert W. Chalue photograph.

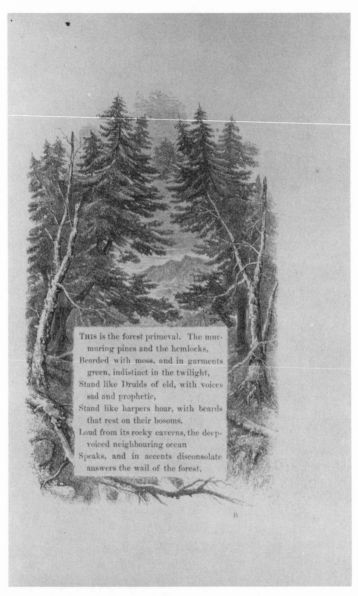

THIS is the forest primeval. The murmuring pines and the hemlocks,
 Bearded with moss, and in garments
 green, indistinct in the twilight,
Stand like Druids of eld, with voices
 sad and prophetic,
Stand like harpers hoar, with beards
 that rest on their bosoms,
Loud from its rocky caverns, the deep-
 voiced neighbouring ocean
Speaks, and in accents disconsolate
 answers the wail of the forest.

2.7. After Birket Foster, *The Forest Primeval,* from Longfellow, *Evangeline,* 1850. Wood engraving. Courtesy of the Book Arts Collection, Wellesley College Library; Robert W. Chalue photograph.

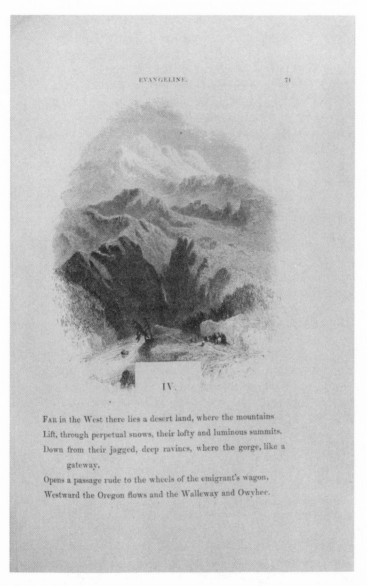

2.8. After Birket Foster, *Into this wonderful land, at the base of the Ozark Mountains, Gabriel far had entered*, from Longfellow, *Evangeline*, 1850. Wood engraving. Courtesy of the Book Arts Collection, Wellesley College Library; Robert W. Chalue photograph.

Other hope had she none, nor wish in life, but to follow

Meekly, with reverent steps, the sacred feet of her Saviour.

Thus many years she lived as a Sister of Mercy; frequenting

Lonely and wretched roofs in the crowded lanes of the city,

Where distress and want concealed themselves from the sunlight,

Where disease and sorrow in garrets languished neglected.

Night after night, when the world was asleep, as the watchman
 repeated

Loud, through the gusty streets, that all was well in the city,

High at some lonely window he saw the light of her taper.

2.9. After Birket Foster, *Night after night ... the watchman ... saw the light of her taper,* from Longfellow, *Evangeline,* 1850. Courtesy of the Book Arts Collection, Wellesley College Library; Robert W. Chalue photograph.

he did not, and in his silence is the ultimate disproportion between designs and deeds that marks this tale of unfulfilled hope. When it came to illustrating books, the new world would still bow to the old, even as it struggled to assert its cultural independence.

In 1856, *Ballou's Pictorial Drawing Room Companion* ran a brief article on Billings, who was by then its leading artist and an established book illustrator. In it he is described as without rival in this country and equalled only by John Gilbert among the English in versatility of talent.[37] Judgment by English references had not ended with the 1840s any more than Billings had ceased to rely from time to time upon English models for his illustrations. As late as 1855, for example, he came near copying line for line a Richard Doyle rendering of "The Southwest Wind Esq." from Ruskin's *King of the Golden River* for a book of fairy tales published by Ticknor and Fields.[38] And the relative positions of English and American illustrators is suggested by the case of *Uncle Tom's Cabin*. When it first appeared in Boston in 1852, with six boxwood engravings after designs by Billings, there was no mention of the artist, although he was given last-name credit on the title page of the illustrated edition of the next year. In contrast, the pirated edition embellished by George Cruikshank displayed the artist's name on the title page in type larger than that used for Harriet Beecher Stowe.[39] By 1852–53, Billings had matured as an illustrator, and his scenes for Mrs. Stowe's novel are markedly distinct in style from those of Cruikshank, but, in his case at least, the dominance of English illustration was undiminished even after the 1840s. Even in the 1850s a prized and productive American designer found it difficult to break free of British hegemony in the art of illustration.[40]

Epilogue

Was, then, the association between Longfellow and Billings devoid of visual results, other than an isolated sketch in a maverick copy of *Evangeline*? The answer is no; there are published designs by Billings associated with the poet, but the harvest is meager indeed, compared with the promise sown in the 1840s. The first issue of the *Bulletin of The New England Art Union* (1852) contains a composite image by Billings inspired by two stanzas of Longfellow's "Skeleton in Armor," apparently the only published remnant of a series of drawings begun in 1847 (or 1849) and finished at least by early 1851 (Fig. 2.10).[41] Secondly, the *Homes of American Authors*, published by Putnam in New York in 1853, includes

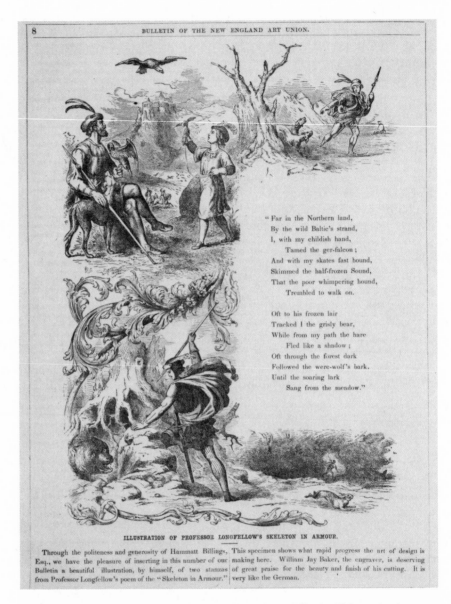

2.10. After Hammatt Billings, scenes from Longfellow's *Skeleton in Armor*, from the *Bulletin of the New England Art Union*, 1852. By permission of the Boston Athenaeum.

a steel-engraved view of Craigie House after a drawing by Billings made in late May 1852.[42] We know of other unpublished and now unlocated drawings illustrating Longfellow, but this seems to be the extent of published results of Billings's work for the poet.[43] Such was the gap between "their designs and their deeds."

Notes

1. William Charvat, "James T. Fields and the Beginning of Book Promotion, 1840–1855," in his *The Profession of Authorship in America, 1800–1870*, ed. Matthew J. Bruccoli (Columbus, Ohio: Ohio State University Press 1968), 172.

2. Frank Weitenkampf, "The Emergence of the American Illustrator," *The Art Quarterly* 18 (Winter 1955):394–402.

3. Sinclair Hamilton, *Early American Book Illustrators and Wood Engravers 1670–1870* (Princeton: Princeton University Press, 1968), 1:xxxvii.

4. Samuel Longfellow, *Life of Henry Wadsworth Longfellow* (Boston and New York: Ticknor and Co. 1886), 2:47, 25 June 1846. Samuel Longfellow published only excerpts of the poet's "Journal," the manuscript of which is now at the Houghton Library, Harvard University (see note 22).

5. Jacob C. Chamberlain and Luther S. Livingston, *A Bibliography . . . of the Writings of Henry Wadsworth Longfellow* (New York: The De Vinne Press 1908).

6. Charvat, "Longfellow's Income from his Writings, 1840–1852," in *The Profession of Authorship,* 156.

7. James F. O'Gorman, "H. and J. E. Billings of Boston," *Journal of the Society of Architectural Historians* 42 (March 1983):54–73; idem, *A Billings Bookshelf. An Annotated Bibliography of Works Illustrated by Hammatt Billings,* rev. ed. (Wellesley, Mass., 1986); idem, "War, Slavery, and Intemperance in the Book Illustrations of Hammatt Billings," *Imprint* 10 (Spring 1985):2–10.

8. Andrew Hilen, ed., *The Letters of Henry Wadsworth Longfellow,* Cambridge, Mass.: Harvard University Press, 1966–1982), 3:80, 28 June 1845. Hilen published some of the poet's sketches; others are to be found among Longfellow's papers at the Houghton Library, Harvard University.

9. Hilen, *Letters,* 3:57, 2 March 1845.

10. Hilen, *Letters,* 3:80, n. 2, 21 July 1845.

11. Hilen, *Letters,* 3:101; Longfellow to Hart, 13 February 1846.

12. William H. Gerdts, "Daniel Huntington's *Mercy's Dream,*" *Winterthur Portfolio* 14 (Summer 1979):182.

13. The undated clipping is found among the Longfellow Papers at the Houghton Library, Harvard University, in "Scrapbook—Criticisms 1839–50" (MS Am 1340 [221]), 64.

14. Hilen, *Letters,* 3:62–63, 3 April 1845.

15. Hilen, *Letters,* 3:66, 22 April 1845.

16. Hilen, *Letters,* 3:89, 18 October 1845. In a letter of 24 November (p. 91), he includes the Raphaelesque "Maidenhood" among the best.

(Longfellow may have had reservations about Huntington's depiction of "The Wreck of the Hesperus," but Winslow Homer found it a useful model for his "The Wreck of the 'Atlantic'—Cast Up by the Sea," a wood engraving which appeared in *Harper's Weekly,* 26 April 1873.)

17. Hilen, *Letters,* 3:48, 3 December 1844; p. 59, 17 March 1845.

18. Samuel Longfellow, *Life,* 2:26, 7 December 1845.

19. S. Longfellow, *Life,* 2:81, 27 February 1847.

20. S. Longfellow, *Life,* 2:96, 30 October 1847.

21. For Longfellow's business acumen see Hilen's edition of the *Letters, passim,* and William Charvat's "Longfellow," and "Longfellow's Income from His Writings, 1840–1852," in Bruccoli, ed., *The Profession of Authorship.*

22. Longfellow's "Journal" (Houghton Library, Harvard University: MS Am 1340) 9 January 1847 (hereafter cited as "Journal"). All but one reference to Billings, that of 18 January 1847, were omitted from Samuel Longfellow's edition of the "Journal" (see note 4).

23. "Journal," 11 January 1847.

24. S. Longfellow, *Life,* 2:75, 18 January 1847.

25. "Journal," 9 February 1847.

26. "Journal," 18 January 1848.

27. My thanks to Ms. Anne Anninger, Special Collections Librarian at Wellesley College, for cooperation.

28. See the epilogue to this chapter.

29. O'Gorman, "H. and J. E. Billings," 60.

30. Hilen, *Letters,* 3:226, 18 November 1849; Clarence Gohdes, "Longfellow and his Authorized British Publishers," *PMLA* 55 (December 1940):1168 (Hilen revises Gohdes's dates slightly).

31. S. Longfellow, *Life,* 2:169, 28 January 1850.

32. Hamilton, *Illustrators,* 1:xxxvii.

33. On 9 January 1852 Bogue wrote the poet of his intentions to issue an illustrated *Hyperion* (it appeared in 1853), and that Foster would be sent to Europe to make sketches "on the spot." On 16 February Longfellow answered that "it could not possibly be in better hands (Hilen, *Letters,* 3:329–30). The next year the poet received from England the original drawings ("Journal," 12 March and 7 September 1853). Five Birket Foster sketches are among the Longfellow papers at Houghton Library, Harvard University. For the poet's appreciation of Gilbert, see the "Journal," 21 March 1852.

34. W. S. Tryon and William Charvat, eds., *The Cost Books of Ticknor and Fields* (New York, 1949), 167.

35. See the "Journal," 2 June 1866. Earlier, Longfellow had found Darley's outline illustrations to Rip van Winkle "meager and insufficient" ("Journal," 19 April 1849), but by the mid-1860s, the illustrator had married into the polite society of Cambridge and become a visitor at the poet's hospitable table ("Journal," *passim*).

In 1859 Rudd & Carleton in New York issued *Illustrations to Longfellow's Courtship of Miles Standish . . . , Photographed from The Original Drawings* [by John W. Ehninger] *by Brady*. See the "Journal," 28 November 1858.

36. "Journal," 28 January 1850.

37. *Ballou's* 10 (1856):252, with a portrait engraved by A. Hill after a daguerreotype by Whipple and Black (present location unknown).

38. *Curious Stories about Fairies, and other Funny People* (Boston: Ticknor and Fields, 1856). Hamilton, *Illustrators*, Cat. 420; O'Gorman, *Bookshelf*, Cat. 63.

The frontispiece derives from Doyle's illustration in the first edition (not later, where it was altered) of Ruskin's *King*, London, 1851. See Rodney Engen, *Richard Doyle* (Straud, Gloucester, England: Catalpa Press, 1983), 93–94, 184–85, 196, and O'Gorman, "War, Slavery, and Intemperance."

39. J. F. O'Gorman, "Billings, Cruikshank, and *Uncle Tom's Cabin*," *Imprint* 13 (Spring 1988).

40. In truth, Hammatt never completely freed himself from English influence. His illustrations to Oliver Goldsmith's *The Deserted Village* (Boston: J. E. Tilton and Company, 1866) owe much to the London edition (Sampson, Low, Son & Co., 1861) illustrated by members of the Etching Club (O'Gorman, *Bookshelf*, Cat. 111).

41. Longfellow was a vice-president of the New England Art Union. The project is mentioned in a letter from Billings to Longfellow dated 13 July 184? (the final digit being either a 7 or a 9) (Houghton Library, Harvard University, MS Am 1340.2 [527]): "The designs for the 'Skeleton in Armor' have not progressed so rapidly as I anticipated, but are now so far advanced that I shall be able soon to present them for your inspection." Before September 1847 Billings borrowed Longfellow's copy of Esaias Tegnér's *Frithiof's Saga* while working on his illustrations (MS Am 1340 [149]: "Memorandum of Books 1835–67," p. 98). In a letter of 8 February 1851 Billings again mentions his "series of designs from the 'Skeleton in Armor.'" He seeks the poet's permission to have them engraved for a gift book he hopes Ticknor will publish in 1852 (MS Am 1340.2 [527]). I know of no such publication.

42. Longfellow had hoped the engraving could be made from a daguerreotype, but was foiled by the sudden appearance of foliage (Hilen, *Letters* 3:339, 346, 30 May 1852). Billings, he reports to George Putnam, "is desirous of making also the drawings on wood for the engraver. . . . I suppose you know Mr. Billings, and how skilful [*sic*] he is." See also Billings to Longfellow, 26 May 1852 (MS Am 1340.2 [527]), and The "Journal," 29 May 1852.

43. Evidence for other drawings by Billings related to Longfellow includes a "Journal" entry 11 February 1849 mentioning a sketch of "The Luck of Edenhall," which the poet remarks he much coveted, and a letter from the artist to the poet dated 18 January 1853 (MS Am 1340.2 [527]) asking him "to select some poem from which you would like a design for yourself, and let me do my best, which I hope is much better than anything you have yet seen by me." There is no identifiable Billings drawing in either the Longfellow collection at the Houghton Library or in Longfellow House, according to Kathleen M. Catalano, formerly the curator.

3

The Railroad in the Pasture
Industrial Development and the New England Landscape

SALLY PIERCE

In his book *The Machine in the Garden,* Leo Marx chronicles the pervasiveness of the pastoral ideal of America as a nation of self-sufficient farmers. He also discusses the contradictory urge of the inhabitants of the United States to dominate the virgin landscape and develop it in the interests of commerce and manufacture. Marx identifies an area of compromise between the two forces, which he calls the middle state or middle landscape, defined as "a happy balance of art and nature." Because it is an area of compromise, the middle landscape does not have a fixed description or definition. It must be able to fit the needs of ever-changing situations, but its purpose remains the reconciliation of the pastoral ideal with the forces of change and development. As Marx says, the middle state became an "expression of the national preference for having it both ways" that "enabled the nation to continue defining its purpose as the pursuit of rural happiness while devoting itself to productivity, wealth, and power."[1] Marx explores the dynamic interaction of these forces in American literature. I propose to show how the contending forces are depicted and reconciled in New England topographical prints from the 1820s through the 1850s.

The lithographic views cited as examples here were printed and published as commercial commodities. Town views appealed to the civic pride and historical consciousness of residents and property owners. They were intended for display in homes and public places. Other topographical prints fulfilled a more specific purpose. They served to commemorate a feat of engineering, advertise

a product, or promote a cause. In all cases, the printmaker maximized appeal by utilizing accurate and detailed rendering, moderate to large size, and color when possible.

A view of Manchester, N.H., seen from Rock Raymond in 1847 (Fig. 3.1), provides a good illustration of the middle landscape. The fifteen-year-old artist, Uriah Smith,[2] has drawn in the forces which were to change dramatically the economy of his region, but the compositional device of dividing the picture plane into a series of horizontal bands, with the sky taking up half the area, assures an impression of tranquility and stasis. In this simple landscape open pasture and woodland are peacefully and symmetrically bisected by the two main agents for change in New England, the railroad and the textile mill, which not only dramatically altered the economy, but also literally changed the face of the landscape.

Whether viewed as a force for good or for evil, the railroad was *the* symbol of progress in the early nineteenth century. For many artists and writers it was a precursor of destructive change. For the businessman and his supporters the railroad forging through the countryside carried the promise of opportunity, improvement, and prosperity. The railroad of commerce led to a promised land on earth, a Calvinist paradise where one worked industriously, did not waste talents or opportunities, and thus served God the better. Nathaniel Hawthorne wrote an essay entitled "The Celestial Railroad" satirizing the unlimited faith for good and progress which people projected onto the new invention. Conversely, there was a widely used temperance image known as the Black Valley Railroad, illustrated here in an 1863 chromolithographed version by Emile Ackermann, printed by Charles H. Crosby (Fig. 3.2). It shows a train hauling the slaves of drink through a nightmare landscape on the road to perdition. The message of both allusions was the same. The railroad had the power to obliterate time and physical boundaries. Wherever you wanted to go, the railroad could take you there.

One of the first railroads in America was the Quincy Railway, originally chartered as the Granite Railway. Built in 1826 by Thomas Handasyd Perkins, it carried granite from his quarry in Quincy, Mass., to a wharf on the Neponset River, where the blocks were loaded onto boats and taken to Charlestown to be used in the construction of the Bunker Hill Monument. Perkins was also a member of the monument's building committee. Thus the railroad was employed in the cause of patriotism as well as monetary gain.

VIEW of MANCHESTER CITY N.H. from ROCK RAYMOND, 1847.

3.1. Sharp, Pierce and Co. Lithographers, after Uriah Smith, *View of Manchester City N.H. From Rock Raymond,* 1847. Hand-colored lithograph; 12⅞ × 20 in. Courtesy of the Boston Athenaeum.

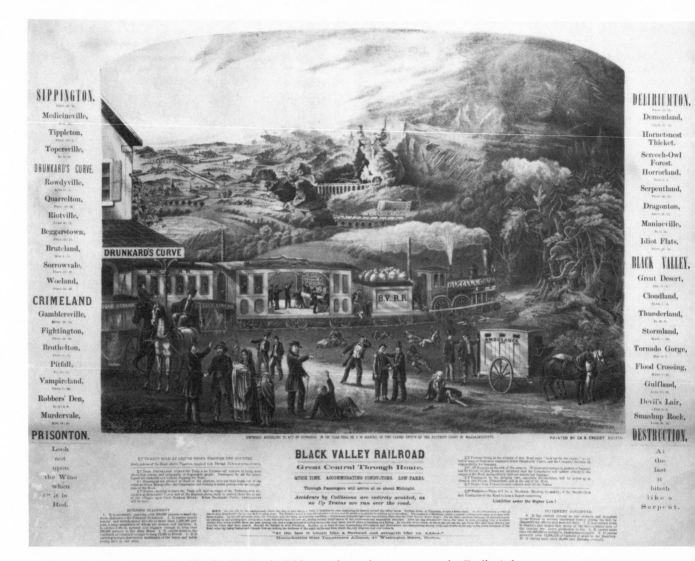

3.2. Charles H. Crosby Lithographers, drawn on stone by Emile Ackermann, *Black Valley Railroad*, 1863. Chromolithograph; 17 × 22⅞ in. Courtesy of the Boston Athenaeum.

On this early railroad, the cars were drawn by horses. Steam locomotives still had to be imported, along with men to run them, and no facilities existed in the United States to repair or maintain them. David Claypoole Johnston recorded the novel new development in an 1826 lithograph printed by the Pendleton firm of Boston (Fig. 3.3). Another Pendleton print shows the Quincy Railway House, drawn by Moses Swett, and a map of the route, drawn on stone by James Eddy. The three-mile stretch of track supplied granite to Boston and other parts until 1870.

One of the great engineering feats of New England railroad construction was the Canton viaduct. Two views of the structure were drawn by Joel Baker and lithographed by E. W. Bouvé (Figs. 3.4 and 3.5). In them we see the main components of the New England industrial scene: the locomotive with its plume of smoke, the mill pond or water power source, the textile mill, and the cow. Cows seem to represent the pastoral life, and they appear repeatedly in the foregrounds of industrial views.

The Canton viaduct was built to carry the Boston and Providence Railroad across the valley of the Neponset River. Completed in 1835, it is still in use today as part of the Amtrak northeast corridor, carrying loads of up to fifty times those originally expected. The foundations run to bedrock and the structure is hollow so that it can be entered for inspection. The stone was quarried in Canton and cut by Scottish stonemasons. Scottish Rite Masonic insignias were cut into some of the blocks.[3] The engineers for the project were William Gibbs McNeill and George Washington Whistler, both graduates of West Point.[4] Gibbs and Whistler supervised the location and construction of most of the railroads built in the East, beginning with their work on the Baltimore and Ohio in 1828.

Press reaction to the Canton viaduct was positive and expressed the assurance of the age. An account in the June 6, 1835, *Providence Journal* of an excursion made over part of the newly opened Boston and Providence line reported: "The viaduct at Canton, though yet unfinished, is a stupendous work. ... The excavations and embankments in Canton are also worthy of minute attention; they testify in strong language to man's dominion over nature, and his ability to overcome any obstacle to any undertaking that is not morally or physically absurd."[5]

The railroad, by this time employing steam locomotives, was immediately accepted as a quicker and more convenient way to transport goods and passengers. The use of stagecoaches, one of which is seen at the right of Figure

3.3. Pendelton Lithographers, drawn on stone by D. C. Johnston, *Quincy Rail-Way*, 1826. Lithograph; 10¼ × 16¾ in. Courtesy of the Boston Athenaeum.

3.4 where an arch of the viaduct has been enlarged to accommodate the passage of the road underneath, declined, and many of the taverns catering to the coaching trade failed.

Leo Marx's claim that "no one needs to spell out the idea of progress to Americans"[6] is born out by the story of Enos Withington, the best teamster be-

tween Canton and Boston. In the days before the railroad, Enos had made a daily round trip hauling goods by horse in good weather and by ox in bad. Enos quickly discovered that it was smoother going to run his wagon over the railroad bed than over the highways, so he used to hitch up his horse and follow the morning train from Canton to Boston. One morning he got behind a train carrying the directors of the line and caught up with them when they stopped to inspect a bridge. The irate directors told Enos he had no right to use their road and had his cart thrown off the tracks.[7]

Alvin Adams was another enterprising man who saw the railway as a path to wealth and turned it to his own advantage. It had become common for people to go to the railroad stations and search for passengers willing to take charge of parcels and deliver them to destinations along the line. Adams seized upon the need and founded the firm which later became known as the Adams Express Co.[8] He began by purchasing two season tickets and contracting to deliver valuables and small parcels. In an autobiographical sketch, Adams described the initial operation of his company: "I gave one ticket to my partner, and with trunks and valises, we went back and forth daily, one leaving Boston, the other New York, every P.M. ... My first way bill amounted to $3.75."[9] Adams's company gradually acquired a monopoly of all the express business on the Atlantic coast. The Civil War put the seal on his fortune. The company made huge profits shipping arms, ammunition, government supplies, and all government money and securities. In addition, Adams Express delivered parcels to soldiers at the front and in hospital and sent employees to the front to receive pay and messages from the soldiers for delivery to their families and friends back home.

In 1860 Alvin Adams purchased one of the most beautiful estates in Watertown, Mass. Called Fountain Hill, the property had been owned by Charles Davenport, who built the first cars for the Erie Railroad. Adams enlarged the property and built, on the site of a pasture, a new house called Fairlawn, shown in two views drawn by J. P. Newell and printed by John H. Bufford. They are titled *The Lodge and Residence of Alvin Adams, Watertown, Mass.* and *Residence of Alvin Adams, Watertown.* The house contained a picture gallery which was frequently open to the public, and the grounds were open to the public one day a week. Up the road was a barn with marble walls built to house a herd of Jersey cows.[10] Thus Adams, who had left his family homestead at the age of sixteen "dissatisfied with the slow, plodding farm-life," assumed the trappings of a country squire and gentleman farmer.[11]

As people lived away from the land, residing in cities, spending their days in shops, offices, and factories, they increasingly saw the outdoor life as an ideal-

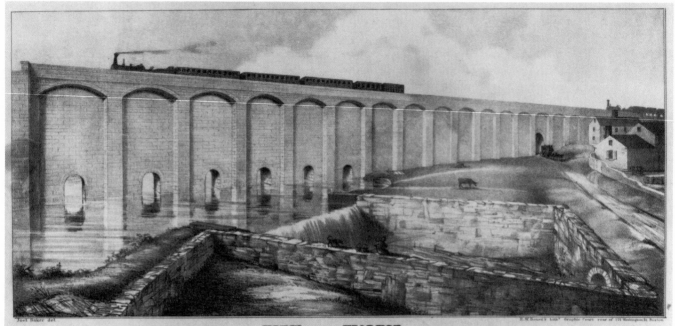

VIEW OF THE VIADUCT
over the Mill Pond of the Stone Factory in West Village, Canton, Mass.

The Superstructure consists of two Walls extending the whole length of the VIADUCT (615 feet) connected at intervals by Buttresses 5½ ft. thick extending transversly across the walls and projecting 4 feet beyond their faces; their elevation is crowned by Segment Arches that support the coping, which is surmounted by a parapet wall 3 ft. 8 in.² high, the top of the parapet wall is 60 feet above the surface of the water. The whole structure is considered the most elegant structure of rustic masonry in the United States. *Erected by the Boston & Providence Rail Road Company.*

Wm. Gibbs McᶜNiell *Engineer*
Dodd & Baldwin *Builders*

3.4. E. W. Bouvé Lithographers, after Joel Baker, *View of the Viaduct Over the Mill Pond of the Stone Factory in West Village, Canton, Mass.*, ca. 1839. Lithograph; 10⅛ × 17 in. Courtesy of the Boston Athenaeum.

ized state. Nature was not taken seriously enough to let consideration of it interfere with the course of progress, but it continued as a popular aesthetic and cultural icon. In urban areas the creation of parks and landscaped estates like Adams's "Fairlawn" represented not just pride and wealth but a desire for the freedom, health, peace of mind, and communication with the divine spirit that

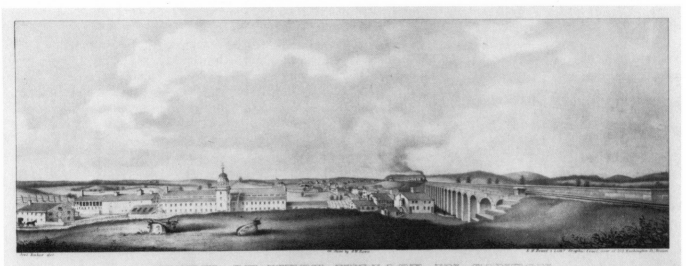

VIEW OF WEST VILLAGE IN CANTON.

Representing

The Neponset Company's Factories, The Viaduct and a section of the B & P.R.Road.

3.5. E. W. Bouvé Lithographers, drawn on stone by Samuel Worcester Rowse after Joel Baker, *View of West Village in Canton. Representing the Neponset Company's Factories, the Viaduct and a Section of the B. and P. R. Road,* ca. 1839. Lithograph; 8¾ × 18½ in. Courtesy of the Boston Athenaeum.

were associated with closeness to nature. The age-old and continuing belief in the revitalizing properties of natural remedies is witnessed by an 1868 advertisement for Green Mountain Balm of Gilead and Cedar Plaster, manufactured in Windsor, Vermont, at the base of Mount Ascutney. The Forbes & Co. tinted lithograph uses W. A. King's view of Ascutney mountain as the selling point.

Although the railroad was perceived by its opponents as scarring the earth and disturbing the tranquility of wilderness, it did, paradoxically, grant access to nature. It functioned as a bridge between town and country and in this capacity its proponents saw it as a link in the middle landscape. As nature became relegated to the leisure side of life, the railroads became heavily involved in the

resort trade. In an 1865 summer timetable lithographed by J. H. Bufford, vignettes of the natural wonders of the White Mountains alternate with views of hotels owned and operated by the railway. The Pemigewasset House in Plymouth, N.H., was one such hotel. North- and south-bound trains stopped there once a day at lunch time, and the dining room was filled with holiday travelers. The chromolithographed view of the Pemigewasset House used in the bottom center vignette of the timetable was also issued by Bufford as a large advertising print. It shows the train stopped between the hotel and an adjacent park. Visitors ascend the stairs to the imposing white building.

The bucolic was the desired state for many urban residents seeking a summer change of scene. A tinted lithograph by L. H. Bradford & Co. advertising "E. Putnam's Private Boarding Establishment, Phillips Point, Swampscott, Mass." (c. 1857) features pleasant cottages and individual bathhouses. A garden is prominent in the right foreground, implying fresh, home-grown vegetables for the table. Gentlemen engage in sporting activities. Two men carrying fishing poles pass two others squiring a comely young woman. The comforting cow roams freely among the guests.

Another print inspired by the urban dweller's desire for rural reconstitution is the J. H. Bufford tinted lithograph *View Near the Laurels, Newbury* (Fig. 3.6). "The Laurels" was a natural grove on the north side of Moulton Hill. During the flowering season visitors were admitted by the landowner for a small fee. Also in the flowering season the Curzons, a prominent local family, held an annual picnic there for literary friends from Boston, Concord, and Salem. What is interesting is that the buildings and land in the foreground belong to Arrowhead Farm, an embodiment of the Jeffersonian ideal of the independent family homestead. The farm has been owned by the same family for over three hundred years and continues in operation today. None of the Moultons ever went to work for the textile factories, but they did supplement their agricultural income by doing piecework for nearby shoe factories. Additional income was also obtained by hauling dories, selling lumber to shipyards, and taking in sewing and summer boarders. It is important to remember that the Moultons did not commission the lithograph. As Pauline (Polly) Chase Harrell, present-day descendent and chronicler of the farm's history says, "We were just the peasants in the foreground."[12] In the distance is the Chain Bridge over the Merrimack River, the town of Newburyport, and a railroad bridge. Polly Harrell thinks that the appearance of the train in this 1847 view may be a trifle premature—something added in anticipation of the railroad's coming so that the view would not become out of date.

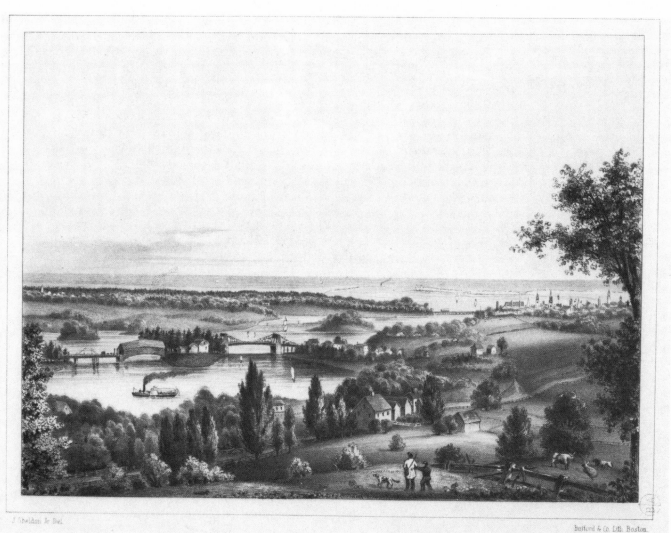

3.6. Bufford and Co. Lithographers, after J. Sheldon, Jr., *View Near the Laurels, Newbury,* 1847. Tinted lithograph; 9¾ × 12¼ in. Courtesy of the Boston Athenaeum.

Just as the railroad was the symbol of progress, the textile mill was New England's embodiment of industry. The textile mills were New England's most important vehicle for early industrial development and population distribution. Most mills depended on water power and waterfalls were prime sources. Natural power sources were often located in isolated, sparsely inhabited places. If a mill was to be operated in such a spot a work force had to be enticed there, housed, provided with a store and eventually with a school and a church. Communities sprouted in the wilderness along the rivers. Jacques Milbert's view drawn for the 1828 *Itineraire Pittoresque du Fleuve Hudson* shows the falls at Pawtucket, R.I., scene of some of the earliest mill development in the United States. A J. L. Giles & Co. lithograph of "Vergennes Falls, Vermont" (c. 1860) shows a variety of manufactories clustered around the natural power source on Otter Creek near Lake Champlain. Their products included wagon and carriage spokes, doors, window shashes, blinds, wood shingles, furniture, woolens, and tanned leather. The Island Mills in the center of the falls ground flour and feed. Another mill was occupied by the publisher of this print, S. M. Southard, manufacturer of frames for paintings, photographs, and looking glasses.

A small advertisement for the sale of water privileges and property at Great Falls on the Westfield River in Russell, Mass., (Fig. 3.7) describes the landscape solely in terms of its suitability for development. The selling points are: proximity to the major commercial centers of Boston, Albany, and New York; rapid communication via the Western Railroad which passed within a few rods of the falls; enough water power to run three large cotton mills; river banks "composed of white coarse grained granite, and slate rock" providing solid foundations so that the mills could carry heavy loads and withstand the continuous vibration of machinery. The seller was Cyrus West Field, who later achieved fame as a promoter and backer of the Atlantic Telegraph Cable. At the time of this advertisement, 1844 or 1845, Field was a wholesale paper dealer in New York. He had purchased the water privileges at Great Falls as an investment. When friends failed to take an interest, Field chartered a Western Railroad locomotive to transport prospective buyers to the spot and included a free meal as part of his inducement.[13] The landscape lithographed on Field's advertisement is a direct copy of a view by H. J. Van Lennep which appeared in Edward Hitchcock's *Final Report on the Geology of Massachusetts* published in 1841.

In the 1837 "View of Ware Village, Mass." (Fig. 3.8) by Peder Anderson, all the components of progress are represented. The power sources are water, the Ware River on the right, and wood, being clear-cut from the hillsides. Trans-

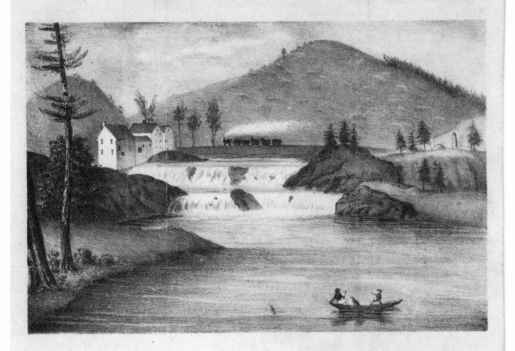

THE GREAT FALLS ON WESTFIELD RIVER.

The above is a view of the Great Falls on Westfield River, in the town of Russell, Massachusetts, twenty miles west of Springfield, and within four hours travel of Albany, six of Boston, and nine of New York. The Western Railroad runs within a few rods of the Falls.

The water Power at this place is very great, there being a fall of from thirty to forty feet, and all of the water sufficient for three largest class Cotton Mills, can be used for manufacturing purposes.

The bed and banks of the river here, are composed of white coarse grained granite, and slate rock, and large mills could be built on solid rock foundation.

The whole of the water power including a Grist Mill, Dwelling House, and about 180 acres of land for sale on favorable terms, by

CYRUS W. FIELD,
No. 9 Burling Slip,
NEW YORK

3.7. Unknown artist, *The Great Falls on Westfield River,* ca. 1844. Lithograph; 9⅞ × 8¾ in. Courtesy of the Boston Athenaeum.

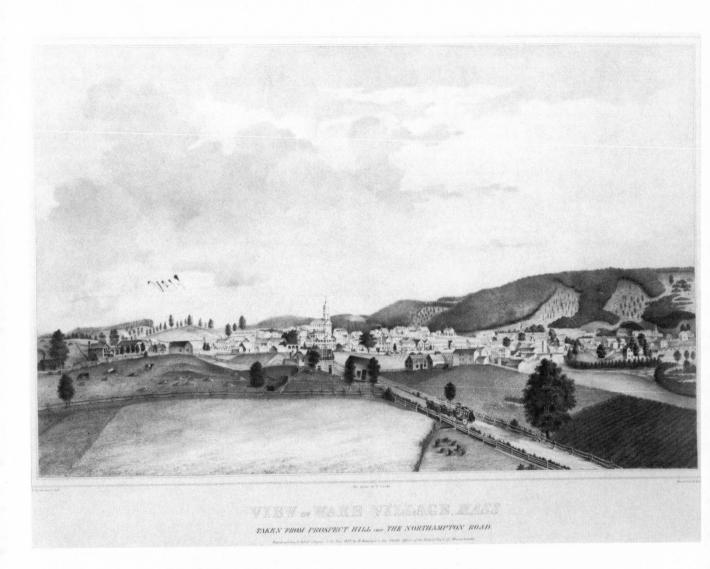

VIEW OF WARE VILLAGE, MASS.

TAKEN FROM PROSPECT HILL near THE NORTHAMPTON ROAD

3.8. T. Moore Lithographers, drawn on stone by Robert Cooke after Peder Anderson, *View of Ware Village, Mass. Taken from Prospect Hill near the Northampton Road*, 1837. Lithograph; 23⅞ × 33⅛ in. Courtesy of the Boston Athenaeum.

portation and communication take place via river and road. (Note the many stagecoaches.) Growth is ongoing as witnessed by the two buildings under construction. Strips of cloth are bleaching in a field. Mills line the river bank. In the foreground are seven stumps, the work of the implacable axe. But the stumps are flanked by planted fields, and more fields and pastures merge into the town from the left and provide the transition to the softly rolling hills on the horizon. The sky occupies more than half the picture area. It is a settler's vision of a new land being transformed from wilderness to productivity, a land large enough and rich enough to offer seemingly limitless opportunity. Countryside surrounds the small town and beyond those hills, under the same vast sky, is the frontier.

Peder Anderson, a Norwegian immigrant, turned to illustrating when the woolen factory where he worked as a bookkeeper went bankrupt in the financial crisis of 1837. A resident of Ware, Anderson put his artistic talent to work, drew the view, and sent it to T. Moore's Lithography in Boston, where it was drawn on stone by Robert Cooke. Anderson sold several hundred copies at one dollar each. Friends in Worcester were impressed and took up a subscription to encourage him to produce a "View of Worcester Mass., Taken from Union Hill."[14]

The Worcester view presents a more developed cluster than straggling Ware. The Blackstone Canal, opened in 1828, provided transport by barge and powered eight woolen mills. In Anderson's print, roads enter the town from the right and left, as do three railroad lines. As in the Ware view, fenced fields surround the town and the sky occupies half the picture. The foreground is a band of wildflowers and grasses, and the two stumps have a rustic rather than a mutilated appearance.

Anderson used the proceeds from the sale of his views to go to Washington, D.C., and realize his dream to hear the debates in Congress and to draw a view of the capital of his adopted country. The 1838 "View of the City of Washington ... Taken from Arlington House" was drawn on stone by F. H. Lane and lithographed at Moore's. Anderson reported that he made $1400 from the sales and paid $600 for the lithography.[15]

After the Washington trip Anderson went to Lowell, where he became bookkeeper and cashier in a wool factory. He eventually became part owner of a factory and treasurer of the Baldwin Manufacturing Company in Lawrence. Anderson's career followed the development of the textile industry from the small Rhode Island–system mills typical of the Blackstone River Valley, where Worcester and Uxbridge were located, to the huge mill cities like Lowell and Lawrence based on the Waltham system of joint stock company ownership.[16]

The Crown and Eagle Mills at North Uxbridge, Mass., (Fig. 3.9) are a fine example of the Rhode Island system. They followed a pattern established by Samuel Slater, an Englishman who brought the secret of the Arkwright water-powered spinning machines to the United States in 1790. Slater was employed by a Rhode Island Quaker named Moses Brown who was active in the anti-slavery and anti-poverty movements and believed that the establishment of manufacturing might alleviate the seasonal poverty of agrarian life. Brown's desire to combine a financially successful factory system with improved living conditions for the workers was a theme of early mill-town development. American businessmen who traveled to England and Europe were horrified by the poverty of workers there. They hoped that organization and strict paternalistic control would prevent the formation of a degraded working class in America.

Rhode Island—system mill villages were financed by families or partnerships and tended to be small in scale. They were managed by a resident owner. At Uxbridge, Roger Rogerson built two mills, the Crown (left, with tower) in 1825 and the Eagle (left of center, with tower and cupola) in 1829, naming them in honor of England and America. Rogerson probably lived in the house at the far left. Housing for worker families was clustered around the mill pond on the right. In this lithograph, drawn by James Kidder and printed by the Senefelder Co. in about 1830, the village appears as if at the moment of its completion. A workman in the foreground is just putting on his coat. There are shovels, wheelbarrows, and scattered blocks of stone. The oxcart is hauling away debris. As with the clear-cutting in the Ware view, there is no reticence about showing an assault on the natural environment, although of course neither the delineators nor the patrons of these views would have thought in terms of destruction. Waste ground was being utilized. The twin mills and the wide curve of the millrace and pond bring harmony and order to the scene. The cow and the small figure sitting on the stone bank beside the falls in the right foreground add a note of serenity and contemplation.

The same feeling of calm and harmony is conveyed by the 1834 "View of Lowell, Mass." (Fig. 3.10) by E. A. Farrar, lithographed by Pendleton. The mills lining the Merrimack River form orderly, repetitive units of harmonious proportion. This is obviously a planned city. Even though the extent of the development is massive compared to the previous views, it is still softened by the pastoral foreground and the open spaces and plantings within the city itself.

Lowell was the most successful representative of the Waltham system. Organized by a joint stock company of wealthy Bostonians, Lowell was designed

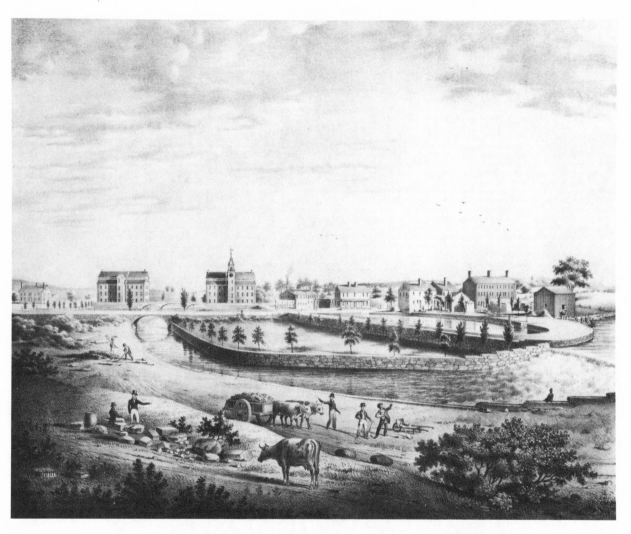

3.9. Senefelder Lithographers, after James Kidder, *Crown & Eagle Mills, Uxbridge, Mass.*, ca. 1830. Hand colored lithograph; 16¾ × 20¾ in. Courtesy of the Boston Athenaeum.

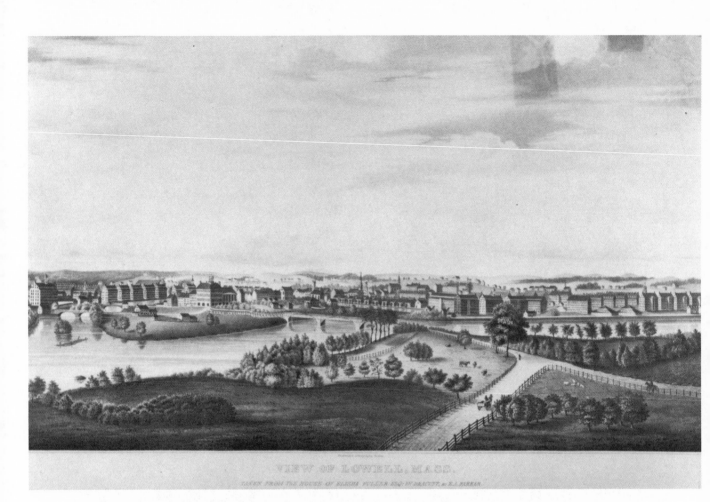

3.10. Pendleton Lithographers, after E. A. Farrar, *View of Lowell, Mass. Taken from the House of Elisha Fuller Esq. in Dracutt*, 1834. Tinted lithograph; 17⅝ × 20¾ in. Courtesy of the Boston Athenaeum; George M. Cushing photograph.

and controlled by a resident agent, Kirk Boott. In order to take full advantage of the water power potential of the Pawtucket Falls and to increase the number of mills that could be built on the site, seven canals were dug to distribute the water power. The factory operatives were mostly young women recruited from New England farm families. They lived in company-run boarding houses, some of which can be seen above and to the right of the bridge in the center of the picture. The girls were attracted by the promise of regular cash wages and as-surances that their living and working environment would be totally respectable.

Lowell was established in 1822 and for the first ten years enjoyed un-imagined prosperity and expansion. In 1835 the Boston and Lowell Railroad began service. Large capitalization enabled the mills at Lowell to survive the crash of 1837, when many smaller operations, such as the Crown and Eagle, failed. It was a paragon of mill towns, noted in the early days for its prosperity and the ideal conditions enjoyed by its workers. The poet John Greenleaf Whit-tier, who resided there briefly, described Lowell as "dedicated, every square rod of it, to the Divinity of Work. The Gospel of Industry."[17] To Whittier, Lowell seemed a prelude to a "millennium of steam engines and cotton mills."[18]

The astonishing growth of Lowell over a period of twenty years can be seen by comparing the 1834 Farrar view with an 1856 view by John Badger Bachelder (Fig. 3.11), taken from an identical vantage point. The empty land at the confluence of the Concord and Merrimack Rivers has been filled with mills. Housing, civic buildings, and more mills are filling the land beyond the river and subsidiary development has spread to the near bank. It is interesting to note that although the size of the city has dramatically increased, it still oc-cupies the same amount of space in relation to the picture frame as the 1834 city did.

Inspired by the success of Lowell and by a period of prosperity from 1843 to 1847, Abbott Lawrence and a group of investors determined to establish an-other great textile city on the Merrimack twelve miles below Lowell at Bodwell's Falls. The developers expected their city, subsequently named Lawrence, to sur-pass Lowell in size and financial return. To maximize the available water power, they undertook the expense and risk of building the largest dam ever con-structed on the Merrimack. From 1845 to 1849 the basic design was laid out. The developers assumed the continuation of a favorable textile market and a continuous influx of investment, but they had chosen the wrong moment. In 1850 the bottom fell out of the textile market. Coarse cotton sheeting was selling

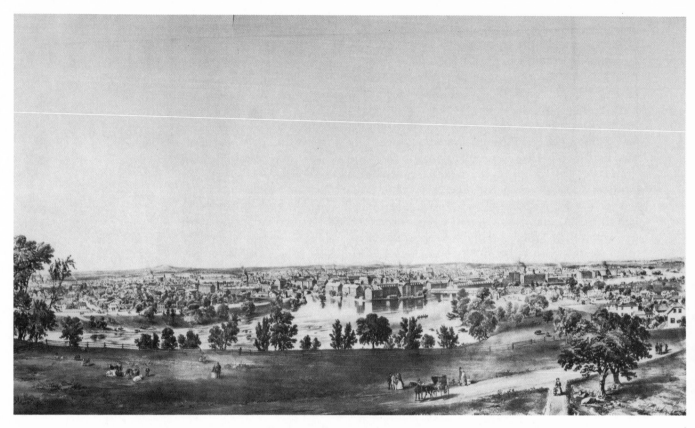

3.11. Endicott and Co. Lithographers, after a painting by John Badger Bach-
elder, *Lowell, Mass. Sketched from the Residence of Thomas L. Tuxbury Esq.*, 1856.
Hand colored lithograph; 25 × 38⅝ in. Courtesy of the Boston Athenaeum;
R. Jackson Smith photograph.

for 7 percent below mass production cost. The investors tried to salvage the
situation by pouring in more money. Abbott Lawrence was forced personally to
underwrite the growth. In the end Lawrence was a $6 million disaster.[19]

None of this is apparent in a view dating from about 1855 which was drawn by Ed. Hoffman and printed by S. W. Chandler & Bro. It features assertive verticals of smokestacks, towers, and flagstaffs, and the high vantage point lets us see the planning and order of this great city of mills, worker housing, public parks, town hall, and churches. The foreground, with the obligatory cow and sightseers, seems a little more contrived than in previous views.

This enthusiastic portrait and the view of the Lawrence Machine Shop, also dating from around 1855 (Fig. 3.12), were part of the effort to attract investment to the failing city. The machine shop was one of the first buildings erected in the city. The 1853–54 *Lawrence Directory* reported that seven hundred hands were employed there, and "every kind of machinery is made from a spindle to a locomotive." The shop went bankrupt in the depression of 1857. However, Lawrence did recover after the Civil War and continued as a great textile mill city until the 1950s.

The L. H. Bradford & Co. lithograph of the Lawrence Machine Shop sums up the owners' pride in the factory and their belief that it was a positive force for the improvement of the community. The machine shop, foundry, and forge were constructed of granite, and a covered railroad track encircled the yard. The park-like setting, featuring a tree-lined canal and balustraded bridge, gives importance to the manufacturing compound and provides a pleasant recreational area. The spacious effect is further enhanced by the soft coloring of the print and by the glimpses of surrounding countryside and farmhouses beyond the town. Economic realities to the contrary, this print expresses faith in industrial development and in its harmonious reconciliation with the natural environment and an agrarian way of life.

John Badger Bachelder's *Album of New England Scenery,* published between 1855 and 1858, marks the final statement of the particular style of landscape of reconciliation which we have been considering. The twenty hand-colored prints which comprise the series, all lithographed by Endicott & Co. of New York, follow the format of a wide rural or marine foreground. The industrial cities named in the titles occupy a thin strip in the middle ground, their size and importance diminished by their distance from the viewer. Foreground figures of farmers, picnickers, and sightseers emphasize the picturesque nature of the scenes. The sky still occupies half the picture plane. The predominance of industry has been accepted, but there is a determination, in compositional terms, to hold the balance between urbanization and the agrarian myth. Indeed, the balance in the Bachelder views seems to be artificially tipped in favor of nature.

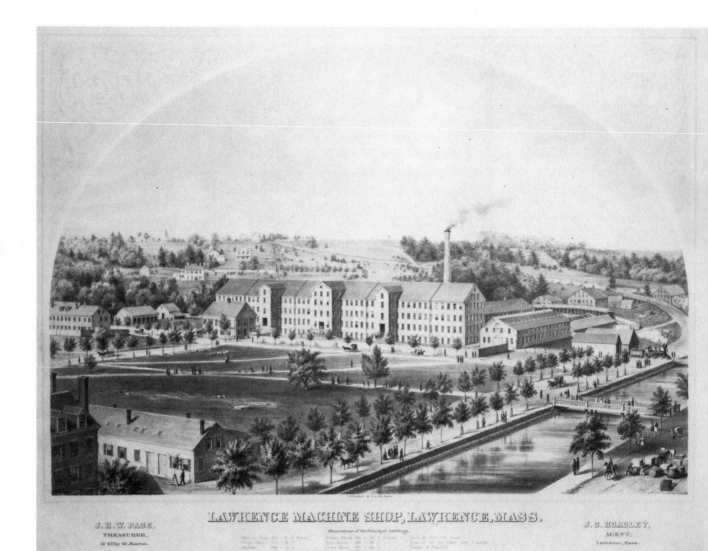

LAWRENCE MACHINE SHOP, LAWRENCE, MASS.

J. H. W. PAGE,
TREASURER,
34 Kilby St. Boston.

J. C. HOADLEY,
AGENT,
Lawrence, Mass.

3.12. L. H. Bradford and Co. Lithographers, *Lawrence Machine Shop, Lawrence, Mass.*, ca. 1855. Hand colored lithograph; 20 × 25⅞ in. Courtesy of the Boston Athenaeum.

The city is safely contained and held at a distance by the surrounding landscape, perhaps because by this date belief in the betterment of society through continued development and industrialization had been shaken by cyclical economic depressions and deteriorating working conditions in the factories.

After the Civil War the bird's-eye view became the dominant format for New England city views, replacing the old horizontal format with the vantage point taken from a slight elevation. The foreground of pasture or outlying homestead is eliminated. Instead we get, full frame so to speak, the extent of urban development. Compare Bachelder's 1856 views of Lynn with the 1879 view drawn and published by O. H. Bailey and J. C. Hazen. Or compare the 1856 Bachelder view of Holyoke and South Hadley Falls (Fig. 3.13) with the 1881 bird's-eye view by Beck & Pauli (Fig. 3.14). Instead of a framework of trees and green fields, we have vignettes of the principal public buildings, residences, and factories. In the bird's-eye view it is clear that the industrial takeoff is over. The impact of factories and urban development on the landscape has grown too large to be ignored or glossed over and is therefore much more nakedly accepted than in the Bachelder view, where we still see a kind of stasis between town and country.

Bachelder's 1856 view of "Lawrence Mass. from the Residence of Wm C Chapin Esq" (Fig. 3.15) presents the perfect middle landscape of the 1850s. One of the greatest industrial cities of the Northeast is smoking on the horizon, while the foreground is occupied by a house and garden plot. Unified and reconciled within a single picture we have represented the pastoral ideal of the independent farmer and the urban manifestation of the national urge toward commerce and profit.[20]

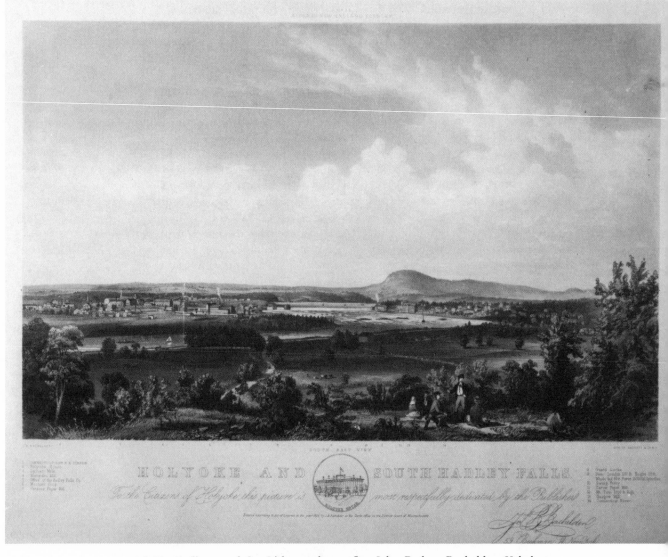

3.13. Endicott and Co. Lithographers, after John Badger Bachelder, *Holyoke and South Hadley Falls,* 1856. Hand colored lithograph; 14 × 18¾ in. Courtesy of the Boston Athenaeum.

3.14. Beck and Pauli Lithographers, on stone by A. F. Poole, *Bird's Eye View of the City of Holyoke and the Village of South Hadley Falls, Mass. Looking North*, 1881. Tinted lithograph; 27¾ × 42 in. Courtesy of the Boston Athenaeum.

3.15. Endicott and Co. Lithographers, after John Badger Bachelder, *Lawrence, Mass. From the Residence of Wm. C. Chapin Esq.*, 1856. Hand colored lithograph; 14 × 18¾ in. Courtesy of the Boston Athenaeum.

Notes

1. Leo Marx, *The Machine in the Garden: Technology and the Pastoral Ideal in America* (London: Oxford University Press, 1964), 226.

2. Uriah Smith (1832–1903) combined evangelical religious fervor with business acumen and a taste for mechanical invention. Having suffered the amputation of his left leg when he was fourteen, Smith, an organizer of the Seventh Day Adventist denomination, invented a wooden leg with a moveable foot to enable him to kneel in prayer. The patent was granted in 1863 *(Dictionary of American Biography)*.

3. Gregory W. Grover, "The Boston & Providence Railroad. An Address to the Canton Historical Society. May 1937" (scrapbook in the collection of the Boston Athenaeum), 3. See also the *Third Annual Report of the Directors of the Boston and Providence Rail Road Corporation, With that of the Agent and Engineer, and Other Documents. June 4, 1834* (Boston, 1834), 59–62, for details of the viaduct's construction.

4. George Washington Whistler married McNeill's sister, Anna Mathilda. One of their sons was the artist James Abbott McNeill Whistler, who spent his youth in St. Petersburg, Russia, while his father worked as consulting engineer for the 420-mile-long railroad between St. Petersburg and Moscow.

5. As quoted by Grover, "The Boston & Providence Railroad," 4.

6. Marx, *Machine in the Garden,* 193.

7. Grover, "The Boston & Providence Railroad," 1 and 4.

8. Thomas C. Quinn, ed., *Massachusetts of To-Day* (Boston: Columbia Publishing Company, 1892), 246.

9. Abby Maria Hemenway, ed., *The Local History of Andover, Vt.* (Chicago, 1886), 60. A letter dated "Boston, May 4, 1870," written by Adams in response to a request for a brief sketch of his life to be included in the history of his natal town, is quoted in its entirety.

10. Maude de Leigh Hodges, *Crossroads on the Charles: A History of Watertown, Massachusetts* (Cannan, N.H.: Phoenix Publishing for the Watertown Free Public Library, 1980), 114.

11. Hemenway, *Local History of Andover, Vt.,* 59.

12. Interview, March 1985. See also Pauline Chase Harrell, Charlotte Moulton Chase, and Richard Chase, *Arrowhead Farm: Three Hundred Years of New England Husbandry and Cooking* (Woodstock, Vt.: Countryman Press, 1983). "The Laurels" is discussed on p. 41.

13. Samuel Carter, III, *Cyrus Field: Man of Two Worlds* (New York: G. P. Putnam's Sons, 1968), 56.

14. Eva L. Haugen and Ingrid Semmingsen, "Peder Anderson of Bergen and Lowell: Artist and Ambassador of Culture," *Americana Norvegica* 4 (offprint, Norwegian Contributions to American Studies, Universitetsforlaget, Oslo, 1973), 5–6.

15. Ibid., 11.

16. See Steve Dunwell, *The Run of the Mill: A Pictorial Narrative of the Expansion, Dominion, Decline and Enduring Impact of the New England Textile Industry* (Boston: David R. Godine, 1978), 52, for a comparison of mill systems. I have relied heavily on Dunwell for an overview.

17. Whittier, *Stranger in Lowell* (Boston: Waite, Pierce & Co., 1845), 10, quoted in Dunwell, *The Run of the Mill*, 46.

18. Whittier, *Stranger in Lowell*, 9, quoted in Dunwell, *The Run of the Mill*, 40.

19. Dunwell, *The Run of the Mill*, 82–85.

20. The Bachelder print also shows the countryside being drawn under the domination of the city. The yard in the foreground belonged to William Chapin, resident agent for the Pacific Mills in Lawrence, while the house with the trellised porch was the home of John Fallon, who succeeded Chapin in 1871 as superintendent of the Lawrence Print Works. See *New City on the Merrimack: Prints of Lawrence, 1845–1876*, Merrimack Valley Textile Museum, Occasional Reports, Number Two, 1974. My thanks to Helena Wright for making me aware of this report and for pointing out some errors in my interpretation of the view of the Lawrence Machine Shop.

4

Images That Sell
Color Advertising and Boston Printmakers, 1850–1900

LUNA LAMBERT LEVINSON

Practical Lithographers and Show Cards

The application of art to practical things evolved routinely for Boston lithographers printing color show cards from 1850 to 1900. Closely associated in both size and imagery to chromolithographs designed for home decoration, show cards accelerated the growing commercialism in the practice of lithography. There were fixed formulas for images to sell commodities, some stock printed images ready for speedy service and others tailor-made to obscure the ubiquity of the medium. The artists' talent for switching quickly from copying oil paintings to designing factory views was matched only by the agility with which shop owners changed partnerships and locations as financial assets fluctuated. Not that the peripatetic quality of the trade impaired the craftsmen's entrepreneurial character; instead, it suggests a dichotomy between practical lithographers and other operating lithographers.

To advertise as a practical lithographer was a common trade practice not only in Boston but in Philadelphia, New York, and other American cities. Historians have assumed that the phrase practical lithographer was simply a common description advertising the diversity of commercial printing performed by lithographers. However, it is now clear that the slogan identified shops that actually did printing on the premises as opposed to firms that contracted printing to other shops. All lithographers sold prints, but not all lithographers were printers. Therefore, the shop name imprinted on a lithograph does not always indicate the firm that executed the print. What the slogan practical lithographer

meant to customers was that a shop was actually engaged in the practice of lithography as opposed to a concern simply taking orders for lithographic work. That distinction was made by an R. G. Dun and Company credit investigator in about 1876 when the New York branch of the Hatch Lithographic Company took on a new manager described as "an experienced accountant and mechanic though not a practical lithographer." And for C. Frank King, the Bostonian whose works historians generally describe as exceptional examples of chromo-lithographic art, practical lithography was not part of his operation. King's firm was a nonpracticing one which never printed chromo show cards.[1]

"For sale here" are the familiar words associated with chromo show cards which were, in essence, nineteenth-century advertising posters. Show cards were used by both retailers and manufacturers; such cards were intended to inform the public of inventory and services by using color pictures in a persuasive and alluring way, often with romantic or humorous imagery. Suitable for window display or countertop ornamentation, show cards were typically seen inside a shop, hung on the walls in a banner style near related merchandise. "Bufford's Banner Show Cards" was the label used by J. H. Bufford's Sons in applying for copyright protection in 1887 for a chromo advertisement titled "A Soapy Argument" (Fig. 4.1). Before show cards were displayed, they were mounted in one of several ways, as indicated by the following 1877 announcement from the C. Frank King firm:

> Lithographic show cards mounted on the Patent Composition Mount, with enamel water-proof finish, last longer, look better, and are more durable than mounted in any other way. Samples mounted *free of charge*. Show-cards mounted on stretchers, with enamel finish. Also, frames and glass.[2]

C. Frank King and Company, located at 32 Winter Street in Room K, first advertised a long-standing association with the printer Charles H. Crosby in the *Boston Directory* for 1878. Three years later, according to the Dun investigator, King was devoting his full attention to the merchandising of patent composition mounts for show cards. Considered to be "shrewd, sharp, and enterprising" by his contemporaries, King had formerly solicited lithographic orders from prominent brewers and manufacturers, subsequently letting the work out on contract. "John Roessle's Premium Lager Beer," King's show card copyrighted in 1877 by John Roessle and now in the Library of Congress, is a superior composition of

4.1. J. H. Buffords Sons, *A Soapy Argument*, 1887. Chromolithograph; 27¾ × 13½ in. Courtesy of the Prints and Photographs Division, Library of Congress.

crayon drawing, vibrant inks, and bronze powders. Charles H. Crosby probably printed the Roessle show card for C. Frank King, although the name of the latter rather than the former is imprinted. Throughout New England and Canada, King sold composition mounts, buying most of his supplies in New York from the Hatch Lithographic Company and the Harris Finishing Company. Benjamin T. Harris of Brooklyn held the 1872 patent for an improvement in mounting show cards, the plastic composition formula creating a permanent mounting with recessed hooks for hanging. In his patent specification, Harris maintained that his mounting eliminated the common problem of chromo show cards twisting and warping because of atmospheric changes. Harris's mounts, Hatch's chromos, and personal persuasiveness combined to provide a good cash flow for King; he was reported in 1882 to be living well although doing "no lithographing or engraving himself."[3]

Most show cards were delivered to retailers by traveling salesmen who solicited orders for wholesale merchants and manufacturers. These cards were part of the canvasser's outfit, together with catalogues and sample cases of goods. Boston salesmen in 1878 could buy their canvasser's outfit from sixteen shops, including Alexander Hollyer at 75 Essex Street, who advertised "chromos, show cards, etc., mounted and varnished on stretchers."[4]

Drummers or traveling salesmen were a new breed of American worker emerging after the Civil War and capitalizing on all the modern communication and transportation technology of the day. It was estimated that fifty thousand Americans had answered the call to traveling salesmanship by 1871.[5] Archibald M. Willard's 1885 painting, the "Drummer's Latest Yarn," depicted the spirited, adventuresome, and devil-may-care character of those who carried show cards coast to coast.

Perfecting techniques for printing show cards was the challenge of practical lithographers. For production, which typically totaled several thousand prints from a single design, steam presses printed the sheets; hand presses were used only in proofing designs. Varnishing or an application of gelatin after printing intensified ink color. An improvement in printing show cards was patented by W. C. Hutchings of Hartford, Connecticut, in 1872, incorporating gilding after the chromo had been varnished. The procedure was calculated to make the gilding "stand out brightly and boldly in relief." With different colors of paper, inks, and bronze powders, the effect could be varied.[6]

Along with improvements in printing and mounting show cards, there were advances in the design of store display cases. Frank Gale Bufford, the oldest

son of lithographer John Henry Bufford, patented in 1883 a showcase design in which the top counter was composed of a series of glass panes superimposed above tiers of drawers. Claiming that his invention saved salesmen's time and preserved the freshness of chromos or other merchandise, Bufford's horseshoe-shaped case and counter also provided instant visibility to customers. Such inventiveness underscored the printer's keen awareness of eye appeal in successful retail merchandising.[7]

Formats for Show Cards

Lithographers from Water Street to State Street and beyond sent hundreds of show cards with artistic or commercial titles to Washington in application for copyright protection. These copyright deposits, now in the Library of Congress, form an extraordinary collection of advertising prints, a chronicle of the individual images that sold American products during the nineteenth century's greatest era of commercial expansion. Lithographers used several themes again and again, often combining themes to create an even stronger selling format:

1. *Factory views,* such as those depicted for Macullar, Parker, and Company's Cloth and Clothing Warehouse and Manufactory, allowed the manufacturer to sell his technological sophistication and mercantile efficiency (Fig. 4.2). This tinted lithograph, made about 1879 and now in the collection of the Boston Athenaeum, was probably made from the same stone used in a print manufactured by the Hatch Lithographic Company in 1874, the former showing twenty separate factory views and the latter nineteen. Beginning with the boiler room and progressing to the custom department workshops and finally to the area where goods were prepared for shipping, these precise depictions provided convincing testimony of a product well made by skilled men and women. The "Salem Lead Company," a show card printed by Charles H. Crosby in 1872, combined two factory perspectives demonstrating accessibility by land and water. And L. H. Bradford's show card for the "Lawrence Machine Shop" gave this Boston manufactory an undeniably idyllic setting. Architectural views, such as the Hatch Lithographic Company's print of the "Passenger Station, Boston and Providence Railroad," were the inspiration for most factory show cards. Whereas the former were probably printed for building subscribers or stockholders on special occasions, the latter were made to promote products made within specific buildings.

MACULLAR, PARKER & COMPANY'S
CLOTH & CLOTHING WAREHOUSE & MANUFACTORY
·· 400 WASHINGTON ST. BOSTON

DIMENSIONS OF BUILDING: LENGTH 225 FT. WIDTH 50 FT. HEIGHT 70 FT.

4.2. Probably Hatch Lithographic Company, *Macullar, Parker & Company's Cloth & Clothing Warehouse & Manufactory*, ca. 1879. Tinted lithograph; 17¾ × 30 in. Courtesy of the Boston Athenaeum.

2. *Exhibition endorsements* as symbolized in commemorative medals and described in type, were an ever popular show card format. In a period in which national and international exhibitions presented opportunities for public and professional judgment of both products and technology, there was no stronger selling image. "Thurston, Hall and Company, Cambridgeport, Mass., Manufacturers of Crackers," was signed D. Drummond and dated 1877 (Fig. 4.3). Although no lithographic firm is indicated on the card, Charles H. Crosby's shop probably made the print, as Dominick I. Drummond was known to work for Crosby. Obverse and reverse of a commemorative medal together with scrolls announcing the 1876 Exhibition anchor a central image of women and children romping in wheat fields. The print is a striking contrast of bold colors laid over a perfectly balanced composition—a persuasive document for commercial bounty and goodness.

3. *Feminine images,* from goddess-like creatures to everyday wenches to children in fairytale posture, were used over and over in show card designs as well as trade cards. "Gypsy Queen, Straight Cut Cigarettes," copyrighted by the Giles Lithographic Company in 1887, featured a puritanical female inadvertently endorsing tobacco for Goodwin and Company in New York. Only slightly more convincing is Giles's show card for the "Smith American Piano and Organ Company." With a pair of female songbirds posing as cultural dilettantes, a would-be piano salesman is transfixed by Donnizetti's "Trio from Lucrezia Borgia."

4. *Animal images* were fair game for any product advertisement. "Fargo's $2.50 Ladies' Boot," copyrighted by the Forbes Lithographic Company in 1889, depicted a mother goat with her kid to sell kid boots with buttons (Fig. 4.4).

5. *Product illustrations,* especially those images demonstrating and describing product use, were a successful theme for all classes of manufacturers. "Wheelock's Patent Steam Cylinder Packing," a show card printed by Charles H. Crosby for a Worcester, Massachusetts, proprietor, incorporated elaborate mechanical detail in a beautifully artistic format allowing extensive copy for product endorsement (Fig. 4.5). The show card features a skillful gradation of color inks together with effective use of bronze powders. A prestigious display of past customers along with an historic founding date of 1795 and a Manufacturers' Charitable Exhibition Award in 1865 put this company's image in a class by itself.

Another Crosby print for Mason and Hamlin organs combined factory views with product illustration. Far more creative in its selling power is Hatch's show card for the same organs (Fig. 4.6). In five separate pictures, the artist

4.3. Probably Charles H. Crosby, *Thurston, Hall and Co., Manufacturers of Crackers*, 1877. Chromolithograph; 19½ × 25¼ in. Courtesy of the Prints and Photographs Division, Library of Congress.

4.4. William H. Forbes and Co., *Fargo's $2.50 Ladies' Boot,* 1889. Chromolithograph; 26¼ × 18¾ in. Courtesy of the Prints and Photographs Division, Library of Congress.

4.5. Charles H. Crosby, *Wheelock's Patent Steam Cylinder Packing*, ca. 1870. Chromolithograph; 21 × 26½ in. Courtesy of the Boston Athenaeum.

4.6. Hatch Lithographic Co., *Mason & Hamlin Organs*, ca. 1878. Chromo-lithograph; 18⅞ × 23⅞ in. Courtesy of the Boston Athenaeum.

has shown how the organ can be used: for children's practice, parlor entertainment, orchestral accompaniment, church music, and composers' instruments. Certainly the circle of romantic composers is the most clever device in the print: at the organ are seated Franz Liszt, to his left Richard Wagner, followed by Johannes Brahms, and Richard Strauss.

Preserves and pickles never looked sweeter than in C. Poole, Jr.'s show card chromolithographed by Armstrong and Company. The artist was Joseph E. Baker, who apprenticed with J. H. Bufford in the 1850s.[8] With fancy-labeled bottles and well-dressed ladies testing the goods, no serious consumer could contemplate the economy of home canning.

6. *Humorous images* which often illustrated a pun on the product title also had show card appeal. "Chew Punch Plug Tobacco," a chromo copyrighted by Giles Lithographic Company in 1886 for a Louisville, Kentucky, concern poked fun at the tobacco label by positioning Punch, the grotesque hump-backed puppet, underneath the show card title (Fig. 4.7).

7. *Testimonial designs* were a standard show card image for medical merchants. In 1850, J. H. Bufford and Sons printed a card for "Dr. Stephen Jewetts Justly and Highly Celebrated . . . Strengthening Plasters" (Fig. 4.8). On the right side of the card, Aesculapius stands as the Roman god of medicine, and on the left side is Hygia, a Pocahontas-like figure whose image and name were contrived to symbolize hygrastics, the science of health and hygiene. Bronze powders were used to print the border around Dr. Jewetts' laboratory and the ennobling phoenix placed above. Proclaiming its product to be "Unequalled for removal & effectual cure of chronic disorders of all diseases of the blood, skin, digestive organs, throat and respiratory organs, etc.," Bufford's card must have sold hundreds of Bostonians down the road to good health—if not with alcohol-enhanced bitters then with pulverizing plasters.

Commercial Profiles of Show Card Lithographers

Of the Boston lithographic firms making show cards from 1850 to 1900, most were periodically investigated by credit agents who determined the financial condition and overall business reputation in the trade. Fires, such as one in 1872, devastated the financial stability of many firms, some of which were never able to recover a positive cash flow and thus were continually mortgaging presses and equipment.

4.7. Giles Lithographic Co., *Chew Punch Plug Tobacco*, 1886. Chromolithograph; 21½ × 13¾ in. Courtesy of the Prints and Photographs Division, Library of Congress.

4.8. J. H. Bufford and Co., *Dr Stephen Jewetts Justly & Highly Celebrated Health Restoring Bitters, Pulmonary Elixir, and Strengthening Plasters,* 1850. Chromolithograph; 19½ × 24 in. Courtesy of the Prints and Photographs Division, Library of Congress.

The inconsistent quality of prints published by J. H. Bufford and Sons after the Civil War was perhaps due to the firm's recurring financial crisis. From 1871 to its closing in 1891, the company progressively faltered by overextending its physical capacity and mismanaging financial operations. Repeated mortgages of lithographic stones, presses, and office furniture; a photograph department leased to a former employee; and irregular payment of wages to others, along with unkept promises of recovery, summarized the investigations made by the R. G. Dun Company, whose reporting began on January 10, 1871, just three months after the eldest Bufford died.[9]

At the opposite end of the financial spectrum was Louis Prang, the model of Boston lithographers. His factory at 286 Roxbury Street was built in 1867 near the Boston and Providence Railroad station where salesmen as well as chromos could be quickly dispatched. In contrast to the J. H. Bufford company appraisal of 1871, Prang was found to be "doing a profitable business" and worth about one hundred thousand dollars, a sum that the Bufford firm did not match until six years later. The photograph of Prang's factory, probably made about 1876, is a new acquisition for the Archives Center at the National Museum of American History (Fig. 4.9). Also new to the collection is the 1881 photograph of Prang employees, perhaps made on the occasion of the twenty-fifth anniversary of the company's founding (Fig. 4.10). Of the total 281 men and women employed by Prang in 1881, 68 were printers and 31 were designing artists, lithographers, and engravers.[10]

In 1881, Prang published a show card to advertise his Christmas cards, the mainstay of his business success. The juvenile image of the card was transformed to fantasy with a spilled basket of cards sailing through the air, and like magic, becoming beautiful white doves. Reappearing again in an 1885 show card for valentines, the doves become a chariot of love for Venus and Cupid in an amorous image titled "On the Warpath."

For show cards advertising beer, Prang's compositions often incorporated realistic detail of labels and selling props, and in other situations, the feminine image, a proven favorite of brewery advertisers, was romanticized or modernized. His 1895 show card for the Franklin Brewing Co. was a pictorial riddle repeating the company's name on the crate-like table, the beer bottle, and the newspaper. Philadelphia artist Léon Moran signed this striking print depicting the Gibson girl–style endorsement for the George Wiedemann Brewing Co., Newport, Kentucky, in 1896. The bronze powders added a freshness to the medals won several years earlier at the Columbian World Exposition. Prang's show

4.9. Unknown photographer, L. Prang and Co. Lithography, ca. 1876. Photograph from glass plate negative. Courtesy of the Collection of Advertising History, Archives Center, National Museum of American History, Smithsonian Institution.

4.10. Unknown photographer, L. Prang and Co. Employees, 1881. Photograph from glass plate negative. Courtesy of the Collection of Advertising History, Archives Center, National Museum of American History, Smithsonian Institution.

card for Boston's American Brewing Co. repeated the formula used two years earlier for the Franklin Brewing Co.: the man, the crate-like table, and the bottle of beer in an image titled "The Philosopher."

Julius Meyer, the German printer with whom Prang had shared a partnership from 1856 to 1860, continued as a practical lithographer on State Street printing all kinds of color work, including show cards, views, tobacco labels, tickets, and drawings of every description.[11] Meyer's show card for "Walter Baker and Co.'s Chocolate and Cocoa Preparations," Dorchester, Massachusetts, could have been the result of a business connection established between 1859 and 1869, when he resided in Dorchester. The chocolate company, established in 1780, boasted an exhibition medal in each corner of the card: the Exhibition of the Industry of All Nations, held in New York, 1833; the Massachusetts Charitable Mechanic Association, 1853; the Paris Universal Exposition, 1868; and the Vienna Exhibition of 1873. With a factory view incorporating a sympathetic landscape and idealized community, Meyer's show card is a fitting tribute to an extant building now restored and adapted to commercial use.

As a businessman, Meyer was described as a shrewd and careful fellow operating a small shop. In 1871, the Dun credit investigator estimated that Meyer was worth from three to five thousand dollars. His show card for French cologne water, printed in 1877, was as conservative in its use of tint stones as was his business reputation in the trade (Fig. 4.11). The fencing duo depicted a humorous play on the product called "Ja'ques' the Rival of Farina's" while conveying an early, French style of lithography. Meyer's son, Julius, Jr., succeeded him in business in 1885 and reportedly "soon squandered the little he inherited," and by 1886 he was sold out under foreclosure of a mortgage.[12]

If Julius Meyer and Co. was one of the smallest lithographic shops in Boston, William H. Forbes and Co. was the largest. Established in 1862 as a practical lithographer, engraver, and letter-press printer, Forbes was first located at 265 Washington Street printing factory labels, maps, tickets, bonds, show cards, and a host of related commercial work. Formerly a journeyman printer, Forbes had developed, by 1869, a reputation for prompt payment in the trade as a manufacturer of fancy cards using a steam printing press. On July 1, 1871, Forbes struck a partnership with George A. Stearns, a clerk for the Waltham Bleaching Co., who had no knowledge of lithography but contributed instead a reported thirty-five thousand dollars to the business. And in 1875, a joint stock company was formed under the name of Forbes Lithograph Manufacturing Co. The pres-

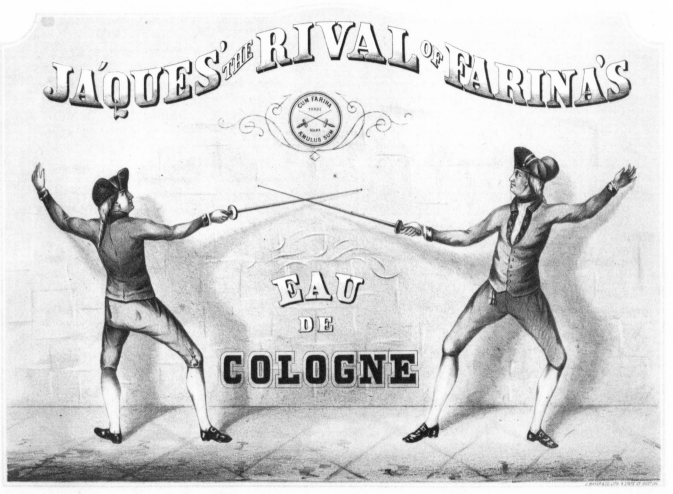

4.11. J. Meyer and Co., *Ja'ques' the Rival of Farina's, Eau De Cologne*, 1877. Tinted lithograph; 13⅞ × 19¼. Courtesy of the Prints and Photographs Division, Library of Congress.

ident, W. P. Hunt, held the patent for the "albert type machine"; he added seventy thousand dollars to the operation along with his patent. Forbes continued as treasurer.[13]

In 1877, Forbes's factory location was moved to a large building at 197 Devonshire Street. By the next year, company employees totaled 475 workers, including 65 designers, engravers, and lithographers running 70 presses.[14] Their show card for Boston's "Electric Lustre Starch Company," printed in 1886, used a domestic setting with European-style architecture to illustrate the product and sell the image of a satisfied customer. The print could have been first designed for a foreign market as the bulk of Forbes's business was for the English and German trade.

Another nineteenth-century Boston firm which continued into the twentieth century manufacturing show cards from time to time was George H. Walker and Company, known primarily as a publisher of maps and atlases. In 1880, George Walker, whose estimated worth was between six and seven thousand dollars, admitted to partnership his brother Oscar W. Walker, worth about one thousand to fifteen hundred dollars. While his brother followed the map business, George individually also did a flourishing business in lithography. The Dun reporter in 1883 noted that George was "making a specialty of prominent Roman Catholic clergymen thro' whose influence the pictures find a very ready sale among their parishoners." The investigator believed Walker to be making money fast through his connections with the clergy and safely evaluated his assets at ten to fifteen thousand dollars.[15]

Walker's show card for "Peckham's Cough and Lung Balsam" was copyrighted in 1886 for George A. Peckham, Providence, Rhode Island. The print is a curious blend of old technology and modern imagery. While a robust young lady is demonstrating the latest sporting craze of the 1880s, roller skating, the tinted lithograph looks old-fashioned compared to the brightly colored chromos then in vogue.

In contrast to Walker's show card for Peckham's, brilliant color work was the hallmark of show cards printed by Charles H. Crosby and Co. In spite of superior craftsmanship, Crosby's financial situation was even more crippling than the Buffords'. First associated with Emery Moore in 1852 as Moore and Crosby, by 1856 Crosby had dissolved the partnership after having mortgaged two of Adams's power presses. He continued as a solo practitioner at 3 Water Street, listing five other Water Street addresses over the next fifteen years of business. Compared to Prang's operation in the early 1860s, Crosby's was gigantic: Prang had seven presses in 1860, while Crosby owned fifty presses. Al-

though there is no date on Crosby's show card for Comstock, Gove and Co., based on the lithography's address in the *Boston Directory* for 1867, the advertisement was probably printed that year at the 13 and 46 Water Street location. A superb example of crayon work, the chromo was signed in stone by E. Ackermann. Another show card design also announcing the "for sale here" message was Crosby's advertisement for "Bed Lounges—McDonough's Patent Manufactured by E. D. Lacount" in Boston. Delineated by D. Drummond, the image was both luxurious and modern, an eye-catching card for those seeking home furnishings with therapeutic benefits.[16]

Like many other Boston lithographers, Crosby was ruined by the great fire of 1872. Having only recently been discharged from bankruptcy before the fire, Crosby formed a silent partnership with Daniel M. McLellan, formerly an artist and partner in the firm of Armstrong, McLellan, and Green. The arrangement was short lived, and eventually McLellan became the manager for the Boston branch of the Hatch Lithographic Co. Crosby, however, claimed two thousand dollars from the wreckage of the fire and, with another four thousand donated by a wealthy relative in England, he opened shop at 159 Dorchester Avenue in 1873. Once again he took in a silent partner, Charles H. Baker, formerly a paper hanger, who contributed fifteen thousand dollars to the business. Although the credit investigator for R. G. Dun and Co. believed that Crosby was making money quickly, he also noted a troublesome pattern of indebtedness. As many as three steam printing presses were mortgaged, along with large numbers of chromos and pattern books.[17]

Crosby's desire to hire first-class artists at any cost threw his accounts further into the red. Gerald A. Klucken, a German who eventually earned a reputation as the best crayon artist at Armstrong and Co., drew for Crosby. Charlie Weis, a lithographer who started as a letter artist with Crosby, also switched to Armstrong. And Samuel S. Frizzell, who was formerly an artist for J. H. Bufford, signed the show card printed for William Mason of Taunton, Massachusetts. According to Leeds Armstrong Wheeler, these salary expenses forced a major reduction in Crosby's operations by 1876.[18]

Expensive talent was one problem, but Crosby's Western land speculation and Pennsylvania coal mine venture finally collapsed his printing business in 1883. By October of that year, he was an employee at George H. Walker, the same firm that bought out Armstrong-Moore in 1901.[19]

Whether as manufacturers of prints or as firms contracting orders for chromos, lithography shops were in operation primarily to make money. Show cards evolved first from chromo pictures designed in the artistic tradition, and

second, from commercial judgment about how to sell a product. Such images emerged from the American trait of inventiveness decades before advertising manuals addressed the issue of images that sell.

Notes

1. R. G. Dun and Co. Collection (New York City) 437:400; (Massachusetts) 88:157, Baker Library, Harvard University Graduate School of Business Administration.

2. *Boston Directory* for 1877, 1351.

3. *Boston Directory* for 1878, p. 231; R. G. Dun Collection (Massachusetts) 88:126, 157; Patent Specification Number 126, 885, May 21, 1872, U.S. Patent Office, Washington, D.C. Located in the Prints and Photographs Division of the Library of Congress is an 1872 chromolithograph delineated by Dominick I. Drummond; the firm names of Charles H. Crosby and C. Frank King, publisher, are imprinted.

4. *Boston Directory* for 1878, 1085.

5. Linus Pierpont Brockett, *The Commercial Traveler's Guide Book* (New York: H. Dayton and Co., 1871), 27.

6. Patent Specification Number 128,148, June 18, 1872, U.S. Patent Office, Washington, D.C.

7. Patent Specification Number 283,374, August 21, 1883, U.S. Patent Office, Washington, D.C.

8. David Tatham, *John Henry Bufford, American Lithographer* (Worcester: Proceedings of the American Antiquarian Society, April 1976; reprint ed., Lunenburg, Vt.: Stinehour Press, 1976), 62.

9. See chapter 2, "Profiles of American and European Companies," in Luna Lambert Levinson, "The Seasonal Trade: Gift Cards and Chromolithography in America, 1874–1910" (doctoral dissertation, George Washington University, 1980).

10. Ibid.; *Prang Souvenir of the Twenty-fifth Anniversary of the Founding of the House of L. Prang and Co. Held at Turn Hall, Boston, 1881* (Boston: Alfred Mudge and Son, 1882), 15–16; *Boston Directory* for 1881, pp. 55–990; Peter C. Marzio, *The Democratic Art: Pictures for a 19th-Century America* (Boston: David R. Godine, 1979), 35. Beginning at the left side of those seated is Charles H. Ames of the Education Department; followed by Phillip Albrecht, a lithographer for Prang since 1863; Charles A. Gross, a lithographer first hired in 1860; Robert Gehrung, a lithographer who joined Prang's shop in 1867; Herman W. Richter, a bookkeeper; and George Helfrich of the Finishing Department. Standing on the back row at the left is Arthur J. Clark, a traveling salesman; followed by Daniel Fausel, a lithographer for Prang since 1871; Fritz Klemm, a bookkeeper; K. F. Hungen; followed by French artist Peter Thurwanger, whose relative Martin Thurwanger taught painting, lithography, and engraving to Max Rosenthal in Philadelphia; Amandus Meyer, a clerk in the Education Department; and finally Herman Harring, an artist employed by Prang since 1865.

11. In 1861, the *Boston Directory* listed J. Meyer and C. Stetfield as lithographers, engravers, and printers at 97 State Street. From 1862 to 1864, J. Meyer and Company was listed at 97 State Street with a new address, 4 State Street, from 1865 to 1884 (typescript chronology for J. Meyer and Company in the Print Room, Boston Athenaeum).

12. R. G. Dun and Co. Collection (Massachusetts) 77:167, 441.

13. Typescript chronology for W. H. Forbes and Co. from the Print Room, Boston Athenaeum; R. G. Dun and Col. Collection (Massachusetts) 77:266, 284.

14. Moses King, *King's Handbook of Boston*, 3rd ed. (Cambridge: Moses King, 1878), 142. When the new factory for W. H. Forbes and Co. was built in 1877, the certified worth of the company was $234,437.88 (R. G. Dun and Co. Collection [Massachusetts] 77:284).

15. R. G. Dun and Co. Collection (Massachusetts) 86:247. In 1880, George H. Walker and Co. (Oscar W. Walker), lithographer, engraver, and publisher, was located at 81 Milk Street (*Boston Directory* for 1880, p. 973).

16. R. G. Dun and Co. Collection (Massachusetts) 70:759. In 1874, Crosby's shop was at 159 Dorchester Avenue, the next year at 410 Washington Street. He returned to Water Street in 1878, practicing at number 15; in 1881–82, he operated at 576 Washington Street (*Boston Directory* for 1874, p. 243; ibid., p. 231; ibid., 1878, p. 231; ibid., 1881, p. 255; ibid., 1882, p. 263). Crosby advertised "upwards of *Fifty Presses* of various descriptions, together with *thirty tons* of Lithographic Stones, and also *several tons* of Book and Fancy Types, Borders, etc." in 1861 (*Boston Directory* for 1861, p. 13).

17. R. G. Dun and Co. Collection (Massachusetts) 70:664, 864, 960. Daniel M. McLellan was advertised in 1876 as the manager of the Boston branch of the Hatch Lithographic Co., located at 8 Summer Street (*Boston Directory* for 1876, p. 1081).

18. Leeds Armstrong Wheeler, *Armstrong and Company, Artistic Lithographers* (Boston: Boston Public Library, 1982), 52–62. On December 10, 1881, a Dun and Co. investigator reported that Crosby "employes about 30 men and is busy all the time" (R. G. Dun and Co. Collection [Massachusetts] 87:252).

19. R. G. Dun and Co. Collection (Massachusetts) 70:664, 864; ibid., 87:252; Wheeler, *Armstrong and Company*, 50.

The Photolithographs of L. H. Bradford

DAVID TATHAM

On the evening of Saturday, December 12, 1885, a man in his mid-sixties engaged a room at the Robertson House, a small hotel a few blocks north of Faneuil Hall in Boston. He registered as "L. Harrington" of Gloucester, Massachusetts. The next morning he appeared at the hotel office, bought a cigar, complained of feeling ill, and asked to be called at 9:00 A.M. the following day. The clerk who went to his room at that hour found him dead. A note on the table read:

> To Martin L. Bradford—This is the best way of fixing the matter—let the city bury me.
>
> Yours, Lod.
>
> P.S. I can't see but I've come home to die.[1]

In reporting this incident on its front page later in the day, the *Boston Globe* made two false assumptions: that the man's name was Lod Harrington, and that he had committed suicide. An autopsy soon established heart disease as the cause of death.[2] It took longer to identify the man as Lodowick Harrington Bradford. The only newspaper obituary to mention an occupation called him "a bank note engraver of much merit."[3] At least a few readers must have recognized this as a woefully inadequate description. Bradford had indeed worked as an engraver at both the beginning and the end of his forty-year career in

the graphic arts in Boston, but he had spent most of his professional life in the realm of lithography. There his achievements had been twofold. First, from 1848 to about 1860, he operated, originally in partnership with Eben Tappan and then on his own, one of Boston's leading lithographic shops. Second, for about ten years beginning in 1857, Bradford pioneered the American practice of photolithography. His first achievement is well known; his second is barely understood and has been the subject of some confusion in histories of American photography. That he should have returned to the locale of his birth to die in obscurity is a measure of how rapidly his very real accomplishments in the graphic arts had been forgotten.

Bradford's innovations in photolithography grew out of his experience as a practical lithographer. His shop, like most others of his day, was divided into drawing and printing operations. During the late 1840s and 1850s, Bradford's draftsmen and presses brought forth not only framing prints, show cards, music title pages, certificates—prints of the kind that routinely kept job shops busy— but also a substantial number of expertly executed scientific illustrations for scholarly books and periodicals, many printed in colors. Bettina Norton discusses a number of these in her history of the shop.[4] Sally Pierce, in her notes to the exhibition of Tappan and Bradford lithographs organized by Charles Mason for the Boston Athenaeum in 1979, discusses some distinctive aspects of the shop's "style."[5] We know nothing of Bradford as a draftsman except that he advertised himself as an artist early in his career. If he drew on stone—and he very likely did—he left his prints unsigned. We know scarcely more about his personal life. He was born in Boston in 1820 of old Yankee stock, perhaps on the site or in the neighborhood of the Robertson House. He married in 1849. In his later years his wife lived in Gloucester, where he also resided weekends and summers. The Martin Bradford to whom he addressed his last note may have been a brother or a son. However obscure the facts of his life may be, Lodowick Bradford's likeness at about age thirty-seven is well documented by a photolithographic self-portrait published in 1858 (Fig. 5.1).[6]

In its size and operations, the shop that Bradford headed in the 1850s typified American lithographic practice as it had existed since the 1820s. His help probably consisted of no more than a couple of pressmen, a few draftsmen on call, some apprentices, perhaps a bookkeeper—a family-sized group of artisans and artists that swelled when work was plentiful and shrank when it wasn't.[7] We may suppose that Bradford oversaw every operation, promoted his product, solicited work, and also drew, printed, and kept books as the need

Photolith. of J.A. Cutting & L.H. Bradford.

L. H. Bradford

LITHOGRAPHER 221, Washington ST. BOSTON

5.1. J. A. Cutting and L. H. Bradford, *L. H. Bradford,* 1858. Photolithograph; 7½ × 4⅝ in. Courtesy of the American Antiquarian Society.

arose. While this small-scale, craft-oriented approach worked well enough in 1848, it had begun to falter by 1860. When Bradford had entered into partnership with Tappan in 1848, no more than four other lithographic printers existed in Boston. By 1860, the number had risen to twenty, making the trade intensely competitive.[8]

Throughout the 1850s, these shops sought competitive advantages over each other, but largely in vain. Anyone with modest capital had access to perfectly adequate equipment and personnel. The advantages of large volume production must have seemed attractive to some, but the conditions necessary to replace many small shops with a few large factories came only in the 1870s. Specialization of product offered some possibility for competitive advantage, and Bradford's work in reproducing scientific drawings probably represented a conscious and successful attempt to dominate this field. It was not a very large field, however. Quality control offered another basis for competition, though a costly one, and here, too, Bradford seems to have striven to distinguish his product from those of other Boston lithographers. He probably spent little time worrying about competitors in other cities, for with the notable exception of Currier & Ives in New York, American lithographers of the era thought and worked in regional terms.

Over this world of job lithographers struggling to survive loomed the younger and exceedingly vigorous pictorial art of photography. Yet as late as the mid-1850s there was no practical way to print photographs on paper with ink. Every astute commercial printmaker in America understood that if the means could be found to ally photography and lithography—to affix a printable image to a lithographic stone by photographic rather than manual means—a vast realm of new opportunities would open. If the means of successfully uniting the two were original enough to secure a patent, then the patent holder might well have an edge on other pictorial printmakers, not only regionally but nationwide. Bradford sought this means of combining photography with lithography, gained it, and developed it over a period of about ten years. The fact that he failed to make a commercial success of it not only deprived him of such glory as comes with dominating an important field of endeavor, but also, and more important, it deprived him of his livelihood as a lithographer.

Before examining what Bradford did, how he did it, and why he failed commercially, it will be useful to consider briefly the camera's earlier impact on lithography. This amounted to no more than the development of a specialty in the freehand copying of photographic images onto stone. Between the late 1840s and the mid-1850s, many lithographic draftsmen excelled at this task of metic-

ulous imitation. One example will suffice. Early in 1857, Bradford's shop produced a lithographic drawing of English High School in Salem, Massachusetts, as a frontispiece for a directory of its graduates (Fig. 5.2).[9] The print's legend identifies the source photograph as one by the Salem photographer Daniel A. Clifford (Fig. 5.3).[10] In comparing the print with the photograph, what emerges as significant is not so much the addition and subtraction of figures on the sidewalk and in the schoolyard, or the foliage supplied to the trees in the background, but rather the copyist's success in duplicating the tonal values of the photograph in certain passages of his drawing. The gradations of reflected light on the windows and blinds, and in the interior space visible through the window at lower right, come from the photograph with exceptional fidelity. (That other passages, such as the side of the building, are less faithful to the photograph testifies only to the exigencies of time in the lithographer's shop.) This was, of course, no more than admirable simulation. Photolithography would soon make the act of copying the surface qualities of a photograph pointless, at least until the appearance of the photorealist painters more than a century later.

Bradford's launch into photolithography was propelled by James Ambrose Cutting. Cutting, born in 1814, ranks among the more colorful entrepreneurs of mid-nineteenth-century Boston. A photolithograph likeness of him published in 1858 (Fig. 5.4) is a pendant to Bradford's, a product of their brief partnership. The pattern of Cutting's life took shape around 1842 in northern New Hampshire when he obtained a patent for an improved bee hive, used the money it brought him to move to Boston, and then embarked on a career of seeking patents for technical processes that, though he claimed to have invented then, were often already in use by others. In 1852 he set up a daguerrean studio in Boston. He hit the jackpot in July 1854, when he secured three patents for the type of photograph on glass that he named the Ambrotype. Cutting had most certainly not invented this kind of photograph, and his patents covered only relatively minor steps in preparing the finished product, but, though hotly contested, they effectively prevented anyone else from legally selling photographs of this sort without his permission. He licensed Ambrotypists throughout the country and as this process swept the daguerreotype aside as the popular form of photography in 1855, he reaped handsome royalties.[11]

In 1856, Cutting seriously turned his attention to photolithography.[12] He may have previously taken the first step in this direction around 1854 with Isaac Rehn, a daguerreotypist in his Boston studio, who was later a prominent photographer and photolithographer in Philadelphia. In 1856 Cutting joined forces with the photographer Austin A. Turner. Between 1856 and 1859, the partner-

THE OLD SCHOOL HOUSE.

5.2. Unknown artist, *The Old School House*, 1857. Lithographic frontispiece to *Catalogue of Members of the Late English High School of Salem, Massachusetts,* Salem, 1857. Courtesy of the American Antiquarian Society.

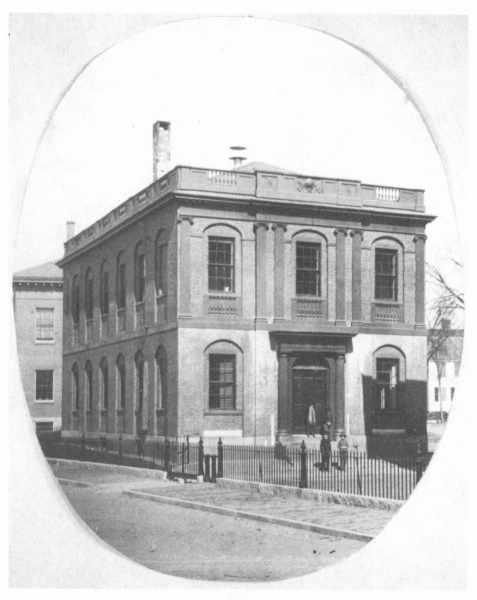

5.3. F. Fogg (from a negative by D. A. Clifford), English High School, 3 Broad Street, Salem, Mass., ca. 1868. Photograph. Courtesy of the Essex Institute, Salem, Mass.

Cutting & Bradford's Photolithography

Jas. A. Cutting

PHOTOGRAPHER.
[CUTTING & TURNER]
Nº 13 Tremont Row, Boston.

5.4. Cutting and Bradford's Photolithography, *Jas. A. Cutting,* 1858. Photo-lithograph; 9⅜ × 5⅞ in. Courtesy of the American Antiquarian Society.

ship of Cutting and Turner advertised itself in Boston directories as makers of "ambrotype, photograph, and photolithographic pictures." The Cutting and Turner imprint invariably refers to photographic work. Because a photographer cannot make photolithographs without access to a lithographic press, Cutting formed a second partnership, Cutting and Bradford, to print photographic images from any source.[13]

By sometime in 1856, the three men had devised a workable process of photolithography. It is hard to know how to apportion the credit precisely among them, but Bradford surely deserves the major share. The essential problems needing to be solved were lithographic rather than photographic, and it was Bradford and not the others who for the first time in America printed photographic images on paper with ink, some in editions of a few hundred impressions. He stayed with the process and improved it after the others had moved on to other things. In reporting on the process in 1859, *Humphrey's Journal* credited it jointly to Cutting and Bradford, making no mention of Turner, but this article, which is little more than elaborate puffery, was probably prepared by Cutting.[14]

In March 1858, Cutting and Bradford patented the process.[15] It differed in two important respects from the experiments in photolithography conducted in Europe in 1852–55 that led to the Collotype, best known in the work of Alphonse Poitevin. Poitevin worked from a negative transparency; Bradford from a positive transparency. This meant that, unless one was willing to accept a mirror image in the final reproduction, Bradford's process involved one less generation (negative/positive/stone) than Poitevin's (negative/positive/negative/stone), and this may have contributed to the fine tonal gradation of Bradford's prints. Often, as we will see, Bradford dispensed with transparencies altogether.

Poitevin printed from a colloid layer for which the lithographic stone served only as a support; he later used glass for the same purpose. Bradford printed from the stone itself. How much Bradford may have known about the work underway in Europe is unclear, but since brief mentions of it appeared in the press from time to time, he is certain to have been aware that others were trying to find a practical means of photolithography. Closer to home, Joseph Dixon of Jersey City had reported a kind of photographic preparation of a stone matrix in *Scientific American* in 1854.[16] None of these attempts had met with commercial success by 1858.

In principle, Bradford's process seemed relatively simple. In darkness, he coated the printing surface of a lithographic stone with a gelatin to which he

had added gum arabic, sugar, and a light-sensitive bichromate. He then placed a positive transparency on the gelatin and exposed it to light. The light hardened the gelatin where it reached it—under the light areas of the transparency—and made it impervious to liquids. The gelatin untouched by light—under the dark areas—remained soft and was washed off with a soap solution. Those areas of the stone's surface now free of gelatin were ready to accept ink. Bradford next inked the entire surface of the stone, including the areas of hardened gelatin. He etched this gelatin and its ink off the stone with acid, leaving the surface beneath them ready to accept water. At this point the stone was ready to be prepared for printing on a lithographic press in the usual way.

The extent to which any single grain of gelatin hardened was controlled by the amount of light that reached it. In line work, with no tone, the grains of gelatin hardened either completely or not at all. In tonal work, however, the gradations of light passing through the transparency acted on the gelatin differently grain by grain. At its best, the process yielded prints of exceptionally fine tonal gradation with, of course, no sign of a screen.

Bradford realized from the outset that he could often get better results by dispensing with a transparency and using the photosensitized stone directly as a photographic plate. To do this, in darkness he loaded a coated stone into a custom-built camera box and exposed it through the lens.[17] This took some muscle. It also required a larger and sturdier camera box than those used by the photographers of his day. The weight and size of the box and the stones, and the need to load them in the dark, must have limited this operation to Bradford's shop. None of his apparatus seems to have survived to the present. It is possible that Turner had something to do with the design of the camera box.

In March 1858, with their patent secure and a number of photolithographs successfully printed, Cutting and Bradford offered to sell rights to their process, hoping to repeat the success of the Ambrotype licenses. The response was tepid at best. By 1859 Cutting had left both of his partnerships to open the last of his ventures in Boston, the Aquarial Gardens, a remote ancestor of the present New England Aquarium. Bradford presumably purchased Cutting's share of the patent. Turner moved to New York City where, in 1860, he produced photolithographs of his own.[18] From mid-1859 to about 1867, Bradford was the only photolithographer in Boston and one of only a few in America.

At least forty-five different photolithographs printed by Bradford survive. (See checklist in chapter 5 appendix.) For what we know about most of them—

indeed, for their very survival—we must thank John Walter Osborne and Sylvester Rosa Koehler. Osborne deserves much fuller treatment than can be given him here; suffice it to say that in 1859 he developed his own highly successful system of photolithography in Australia, took a government pension as his reward, embarked on a long tour of Europe and America interviewing every practitioner of a photolithographic or photomechanical process he could find, and then settled in the United States. He met with Bradford in 1864 and perhaps also in 1867, taking with him from their meetings annotated specimens of Bradford's work.[19] Koehler, who knew Bradford in Boston between 1867 and 1885, was for several years the head of lithographic production for Louis Prang, though he is best known in the twentieth century for his work as editor of the *American Art Review* in the early 1880s and for his publications on American etching. He served as curator of prints at both the Museum of Fine Arts, Boston, and the Smithsonian Institution.[20] In 1888, guided by Koehler, Osborne donated his collection of specimens of the work of Bradford and many others to the Smithsonian where in the Graphic Arts Division of the National Museum of American History it constitutes a major resource for the study of the early history of the photolithographic and photomechanical processes. The American Antiquarian Society owns a smaller, complementary collection of Bradford photolithographs, some of them annotated.[21] In its variety and in the evident seriousness of its applications, Bradford's work stands out from all his contemporaries.

A few of the surviving prints seem certain to have been early trials. Among them is a photolithograph of a statuette of Benjamin Franklin (Fig. 5.5).[22] The lighting suggests a photographer's studio. The lack of definition, arising, perhaps, from the use of the stone as a photographic plate, continued to be a problem for Bradford, though he managed to obtain an adequate degree of sharpness in the work he published in 1858. A view of Boston rooftops (Fig. 5.6) with Park Street Church's steeple in scaffolding, is also quite early; Osborne annotated an impression "1856 (about)." Another, more distant, rooftop view (Fig. 5.7), without scaffolding on the steeple and now including Bulfinch's State House, was taken from a vantage point on Washington Street, perhaps high in the building (No. 221) on the west side in which Bradford kept his studio. A third view from a window or rooftop, annotated "1856 (about)," includes parts of several buildings (checklist 10).

With their early trials behind them, Cutting and Bradford took examples

5.5. L. H. Bradford, Statuette of Benjamin Franklin, ca. 1856–58. Photolithograph; 8⅜ × 4⅝ in. Courtesy of the Division of Graphic Arts, National Museum of American History, Smithsonian Institution.

5.6. L. H. Bradford, *View of Park Street Church Steeple Encased in Scaffolding,*
ca. 1856. Photolithograph; 13⅞ × 10. Courtesy of the American Antiquarian
Society.

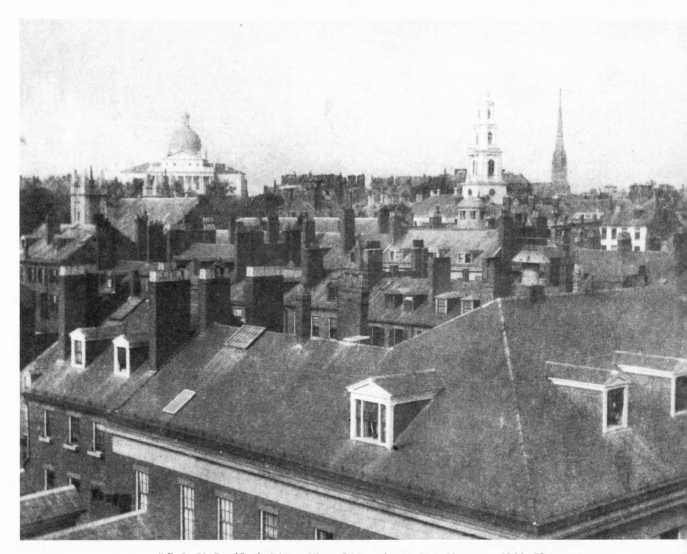

5.7. L. H. Bradford, *Distant View of Massachusetts State House*, ca. 1860. Photolithograph; 7⅞ × 10 in. Courtesy of the Division of Graphic Arts, National Museum of American History, Smithsonian Institution.

of their work to printers, publishers, and other potential users. They arranged to have their process introduced at the February meeting of the American Academy of Arts and Sciences in Boston. The Proceedings of that meeting reported:

> Messrs. J. H. [sic] Cutting, photographer, and L. H. Bradford, Lithographer, have succeeded in so preparing the stone that the figure thrown upon it from the camera is fixed permanently there, and can be printed from as an ordinary drawing. The discovery promises to be of very great value in the arts.[23]

Once their patent was secure in March 1858, they sought a wider audience through the publication in New York of specimen prints in the *Photographic and Fine Art Journal*. The eight that appeared from March through December of that year included their own portraits, two views of private residences, a photomicrograph, an engraving, and a display of ornamental work.

Then, as if none of this had happened, Bradford reannounced the process ("A New Discovery!") in the February 1859 number of *Humphrey's Journal*.[24] Each copy contained two specimen photolithographs. One of these was a display advertisement, *Photolithography by L. H. Bradford & Co.* (Fig. 5.8), a sharply defined linear design meant to show how much like a line engraving a photolithograph could look. At top, Apollo crossing the sky in his chariot symbolizes the sun, the motive power of photography. The idealized male nudes flanking the cartouche may perhaps be seen to represent the manual energy required to print "sun pictures" on a lithographic press.

Below this elaborate title appears a map of an imagined "Photo-lithographic Bay," a convoluted inlet ringed with roads and hills. In the fanciful village of Suffolk, at the head of the bay, Bradford, or whoever drew the map, located several buildings, identifying them with the following names: Baily [sic], Vogel, Trouvelot, Van Derlip [sic], Jekins [sic], Smith, Bartholomew, Moody, Simons [sic], Spindler, and Stetfield. Allowing for misspellings, at least ten of these eleven can be identified as persons having some connection with lithography in Boston around 1859. They range in age from George Girdler Smith, who was then in his sixties, to George W. Simonds and Willard C. Vanderlip who, at ages nineteen and twenty, were probably still apprentices. These names very likely constitute a roster of persons affiliated with Bradford's shop in 1858 or 1859,

5.8. Unknown artist, *Photolithography by L. H. Bradford and Co., Boston*, 1858. Photolithograph published in *Humphrey's Journal*, February 1, 1859; 6¾ × 3¾ in. Courtesy of the Division of Graphic Arts, National Museum of American History, Smithsonian Institution.

draftsmen, pressmen, and apprentices identified for posterity on their own handiwork, presumably the first artist-designed photolithograph published in the Western hemisphere.[25]

The clarity of the line work may come from a technique that Koehler described in relation to another print (checklist 26). In that case Bradford placed a thin film of transparent gelatin on top of an original pen-and-ink drawing, traced the design with a point, filled the resulting incised lines with black pigment, and then used the gelatin as a positive transparency.

Each copy of *Humphrey's Journal* contained a second photolithograph, either *Indian Hut, Vermont,* or an untitled photomicrograph of *Haematopinus eurysternus,* the short-nosed cattle louse. The former demonstrated that Bradford could print subjects that had been photographed at far remove, and that he could work from anyone's negative as well as from his own camera-loaded lithographic stones. In this case the imprint identifies Turner as the photographer. The other print, deriving from a photograph taken through a microscope, a technique that had been in successful use for about a decade, reinforced Bradford's reputation as a specialist in scientific illustration.

The examples published in the two journals embraced most of the new medium's commercial possibilities. The use of photolithography for the printing of portrait photographs must have seemed an obvious and appealing application at a time when the duplication of photographic images by photographic means was difficult and costly. Bradford's process was capable of duplicating such images in quantity, far more easily and cheaply than any other method. Yet it failed to gain any significant currency. Of the few known examples, only Cutting's and Bradford's portraits carry titles; each identifies himself by a printed signature. The others give no information about either the sitter or the photographer. The sitters include a man in an ornate vest, another man who tucks his right hand beneath his jacket lapel, and a seated woman in fancy dress (Fig. 5.9).[26] An unusually fine group portrait of a father and his four children remains unidentified (Fig. 5.10); the family may have posed for Turner, or Bradford, or any other photographer in Boston or elsewhere.

Of two portraits of private residences, one is identified in a printed legend: *Residence of Judge Parker, Cambridge* (Fig. 5.11). Four children stand in front of the house next to a leaf-patterned tree-guard at the edge of a roadway lined with carriage tracks. The other residence is unidentified but carries a Cutting and Turner imprint. In photographing these buildings Turner was in a sense preparing himself for the major work of his career as a photolithographer in New York, his book *Villas on the Hudson* (1860).[27]

5.9. L. H. Bradford, *Seated Woman in a Fancy Dress*, ca. 1856–60. Photolithograph; 7¾ × 6¼ in. Courtesy of the Division of Graphic Arts, National Museum of American History, Smithsonian Institution.

5.10. L. H. Bradford, *Family Portrait: A Man and his Four Children*, ca. 1856–64. Photolithograph; 8⅝ × 11½ in. Courtesy of the Division of Graphic Arts, National Museum of American History, Smithsonian Institution.

5.11. L. H. Bradford, *Residence of Judge Parker, Cambridge*, ca. 1856–58. Photo-lithograph published in *Photographic and Fine Art Journal*, October, 1858; 5⅝ × 8½ in. Courtesy of the Division of Graphic Arts, National Museum of American History, Smithsonian Institution.

The reproduction of commercial artwork must have held promise for Bradford. His process allowed a sheet of original drawings in tone, such as a display of eight cane-backed chairs apparently meant for a furniture catalogue (Fig. 5.12), to be photographed and printed without the intercession of a wood engraver or lithographic draftsman, saving time and money. But of the surviving forty-five examples of Bradford's work, only two document his production of ephemera of this kind.

A much larger portion of the examples reproduce works of fine art. Bradford photolithographed six reproductive engravings.[28] On one of these, after Raphael's *La Belle Jardiniere,* Osborne inscribed "Direct in Camera." The lack of clarity stemming from his process is a condition particularly disconcerting in works dependent on line. Koehler described the problem in an annotation on an impression of Bradford's "Direct in Camera" reproduction of an engraving depicting Miriam leading the Israelite women in a song of thanksgiving after the crossing of the Red Sea. He wrote, "characteristic in showing the peculiarly undefined line obtained by Bradford's process."

There is slightly greater clarity in Bradford's reproduction of an engraving after Bernardino Luini's *Virgin of the Columbine,* a painting wrongly ascribed to Leonardo da Vinci throughout most of the nineteenth century. Osborne wrote on this impression, "about September 1865—printed by Prang." Koehler added, "probably printed by Prang from an old stone." While these brief jottings raise more questions than they answer, they suggest that by 1865 Bradford no longer possessed the capability of printing his own work and depended on others, Louis Prang in this instance, to print the stones he prepared. Bradford also photolithographed Pietro Marchetti's engraving after a Madonna and Child by the Nazarine painter Johann Friedrich Overbeck; Alphonse François's engraved portrait of Michelangelo; and the engraved image of a romanticized country boy.

Two other prints may have been reproduced by Bradford for use as book illustrations, though no American book containing either one has yet come to my eye. One of these prints reproduces Gustave Doré's illustration for the story of the Sleeping Beauty in Thomas Hood's book, *The Fairy Realm,* published in London in 1866. The other (Fig. 5.13) reproduces, at about two-thirds scale, the "Wine Hills" variant of John Foster's woodcut *Map of New-England* of 1677, commissioned apparently by Thomas W. Field as part of his study of the two versions of the map.[29] This photographic reduction in scale—or magnification in the case of the cattle louse—demonstrated another of photolithography's capabilities.

5.12. L. H. Bradford, *Eight Cane-Seated Chairs,* ca. 1856–64. Photolithograph; 7⅜ × 13 in. Courtesy of the Division of Graphic Arts, National Museum of American History, Smithsonian Institution.

5.13. L. H. Bradford, *A Map of New-England* (John Foster's "Wine Hills" map of 1677), ca. 1856–64. Photolithograph; 7⅞ × 10⅜ in. Courtesy of the Division of Graphic Arts, National Museum of American History, Smithsonian Institution.

Including the cattle louse, eighteen of Bradford's known photolithographs are scientific subjects. Among them are a rattlesnake, a sea dollar, human tissue samples stretched on glass rods, a bisected thigh bone showing the structure of a tumor, and fossil trilobites. The fossils, printed with the legend *Paradoxides from Braintree,* were described by the geologist William Barton Rogers in a paper read before the American Academy of Arts and Sciences in 1856 and later published without illustrations in the Academy's *Proceedings.*[30] On an impression of the print in the collections of the American Antiquarian Society, Bradford inscribed the date "Feb 12th 1858." (Fig. 5.14). The tissue samples, which probably date from 1866, were trial plates for the U.S. Surgeon General's Office publication, *The Medical and Surgical History of the Rebellion, 1861–65.* The published illustrations are Woodburytypes.

The scientific subjects include thirteen photomicrographs, more impressive as technical achievements than as things of beauty: one reproduces part of a spider's back greatly magnified (Fig. 5.15). For John Dean's paper *The Gray Substance of the Medulla Oblongata and Trapezuim,* published in 1864 by the Smithsonian Institution, Bradford printed nine plates reproducing thirty-six photomicrographs, each a magnification of seven diameters.[31] These illustrate sections of the sheep, human, and cat brain. In a prefatory note, Dean describes his method of photography and thanks Bradford for his labor and patience.[32] The value of photolithography for this kind of scientific illustration was obvious. The lithographic press enabled the camera's "truthful lens" for the first time to broadcast its findings about things inaccessible to the unaided eye. It automatically incorporated the gradations of tone seen through a microscope, and it also avoided the possibility of error in transcription inherent in copying by hand. Of course it must have been clear that an expert scientific draftsman could accomplish certain things that a camera could not—a clearer articulation of detail than Dean's photographs offer, for instance. But these photolithographic photomicrographs offered the appeal of newness and novelty in the early 1860s. No one in America was better prepared than Bradford to exploit that appeal. He had the technical means as well as great experience in pictorial scientific documentation. Yet, in this, as in every other application of photolithography, he failed.

Why did he fail? First, because his process, like those of his contemporaries in France, England, and America, was not good enough. Like other early photolithographic processes, it did not work in damp or humid atmospheres, and this was a major drawback for a system that claimed speed as one of its virtues. Further, Bradford never seems to have obtained more than a few hundred

5.14. J. A. Cutting and L. H. Bradford, *Paradoxides from Braintree*. W. B. Rogers, 1858. Photolithograph with annotations in graphite by Bradford; 7¾ × 6 in. Courtesy of the American Antiquarian Society.

5.15. L. H. Bradford, *Spider's Back,* ca. 1856–64. Photolithograph; 7⅛ × 5⅛ in. Courtesy of the Division of Graphic Arts, National Museum of American History, Smithsonian Institution.

impressions from a stone, an inadequate number for a process meant to accommodate large-volume orders. In time Bradford might have solved these and other technical problems, but every significant change he made lessened the protective force of his patent.

The patent itself probably contributed to his failure. If, as seems probable, he paid a pretty penny for Cutting's share, he may have been left short of capital and perhaps seriously in debt. The failure to sell licenses must have discouraged potential investors. He never seems to have had the funds or the temperament to promote and enforce the patent nationally and, in any event, its value proved to be nil. No one made photolithographs under the patent other than Bradford himself. Further, photolithography in these years did not lend itself to color reproduction; it shared none of the lucrative trade in show cards or chromo framing prints.

As soon became clear, a truly reliable and efficient means of printing photographic images with ink required far greater technological and personnel resources than Bradford or any other shop lithographer could provide. The first of the new generation of processes arrived in Boston around 1874 when the publisher James R. Osgood brought Ernest Edwards from England. His admirable heliography process easily surpassed Bradford's best work. The scale of the operation and the cost of capitalization, including a large new building, must have seemed staggering to the practical lithographers, but by the mid-1870s no one could seriously question that the future of commercial pictorial printing of any kind lay in large-volume factory production. This was as true for conventional lithographic printing as it was for the new photo-allied processes. Louis Prang successfully transformed his small shop operation of the 1850s into an industrial enterprise by the 1880s. The Armstrong, Bufford Brothers, Crosby, and Forbes firms followed essentially the same course and like Prang assembled specialized departmentalized staffs, built factories, and took on a national outlook. Overwhelmed, the small shop operators gradually went out of business.

Bradford, who had few options left in the 1870s, ceased to practice lithography altogether. Retreating to his earliest trade, he hired himself out as a bank note engraver. Within the flourishing field of pictorial printing he became a nonperson. As he passed through the busy pre-Christmas streets of Boston on his last journey to the Robertson House hotel, many examples of photolithographic or photomechanical pictorial printing must have been within the reach of his eye, but other than himself, few people outside of a handful in his profession would have comprehended that these pictures were descended directly and indirectly from his work.

The forty-five photolithographs that remain from Bradford's attempts are, of course, incunabula of the process that, less than a century after his death, inundated the Western world with photo-offset images. But they represent an end as well as a beginning, an end to an era of individualism in lithographic printing when a name—Bradford, Pendleton, Bouvé, Imbert, Childs, Endicott—meant a print more clearly hand-made than machine-made, and one that, for better or worse, carried a kind of shop "character." With the exception of the work of a few draftsmen of distinctive personality, all this disappeared with the industrialization of pictorial printing. That Bradford in his last days should have abandoned even his own name seems somehow symbolic of the depersonalization that overcame lithographic printing in his lifetime. Only with the birth of a fine art planographic tradition in the early decades of the twentieth century in America, and the appearance of lithographs by John Sloan, George Bellows, Bolton Brown, and others, did individual character again become—in a very different way—a hallmark of American lithography.

Notes

In 1968, in her last graduate seminar in the history of photography, the late Gerda Peterich encouraged me to examine the partnerships James A. Cutting had formed in the late 1850s with L. H. Bradford and A. A. Turner, even though, she observed, it promised to be a "dry and unyielding subject." When it proved otherwise, she urged me to look further into Bradford's work. The present paper, prepared seventeen years later and incorporating much recently unearthed information, testifies less to the durability of my sense of obligation to complete unfinished business than to the persistence in my memory of Professor Peterich's enthusiasm for Bradford's work when she first saw it, and her belief that the study of failed attempts can illuminate the history of photography in ways that the study of successes cannot. I also owe thanks to Elizabeth Harris and Helena Wright of the Graphic Arts Division of the Smithsonian Institution's National Museum of American History, and to Georgia B. Barnhill of the American Antiquarian Society, for ever-resourceful assistance during my research in their collections. Professor David A. Hanson of Fairleigh Dickinson University has generously shared with me some of the fruits of his own important research into early American photolithography. The Syracuse University Office of Research provided funds for the photographic work and travel needed to prepare the final version of this paper.

1. *Boston Globe*, December 14, 1885. Martin Bradford remains unidentified.
2. *Boston Globe*, December 16, 1885.

3. *Cape Ann Breeze* (Gloucester, Mass.), December 17, 1885.

4. Bettina Norton, "Tappan and Bradford: Boston Lithographers with Essex County Associations," *Essex Institute Historical Collections* 114 (July 1978):149–60.

5. Sally Pierce, "Tappan & Bradford and L. H. Bradford & Co. 1849–1859." Flyer distributed at the exhibition "A Sampling of Four Boston Lithographers" held at the Boston Athenaeum in 1979.

6. Norton, "Tappan and Bradford," 151–52. Bradford's portrait appeared in the *Photographic and Fine Art Journal* (April 1858).

7. For the names of several artists associated with Bradford's shop, see Norton, "Tappan and Bradford," 152–55.

8. Boston city and business directories for 1859 and 1860 list more than twenty lithographers, but at least a few of them seem to have been draftsman only.

9. *Catalogue of Members of the Late English High School of Salem, Massachusetts* (Salem: George Creamer; H. P. Ives & A. A. Smith; Henry Whipple & Son, 1857).

10. Clifford practiced photography in Salem in the late 1850s. The photographic print reproduced here was apparently made from his negative by Frederic Fogg, a photographer active in Salem from 1861 to 1874. Since Fogg appears in the Salem directory in the same year (1861) that Clifford is first absent from it, it is possible that the former acquired part or all of the latter's stock. Bradford's copyist omitted three of the four figures in the photograph. He moved the figure of the child at right to a more central position in relation to the door of the school house.

11. Cutting's portrait appeared in the *Photographic and Fine Art Journal* (March 1858). A biographical sketch, reprinted from the *Boston Traveller,* makes up most of his obituary in the *Worcester Daily Spy,* August 12, 1867. Though M. A. Root in his *The Camera and the Pencil* (Philadelphia, 1864), p. 373, claimed that the term "Ambrotype" came from the Greek *ambrotos,* meaning imperishable or immortal, it seems just as likely that the term came from Cutting's middle name, Ambrose.

12. While Cutting has always been seen as the driving force, it is possible that either Bradford or Turner originated the idea and persuaded Cutting to fund and promote it. For the possible involvement of Isaac Rehn, see note 13.

13. The essential studies of Turner are by David Hanson. "Early Photolithographic Stereographs in America: William and Frederick Langenheim and A. A. Turner," *History of Photography* 9 (April–June 1985):131–40; and "A. A. Turner, American Lithographer," *History of Photography* 10 (July–September 1986):193–211. Isaac Rehn, who had a long career in Philadelphia as a photographer and who made photolithographs there in the late 1850s and 1860s, was apparently associated with Cutting in Boston as a daguerreotypist in 1853 or 1854. He seems to have claimed to Root, whom he knew in Philadelphia, to have "perfected" the Ambrotype (Root, *The Camera and the Pencil,* 373) and he may indeed have contributed significantly to Cutting's success. He may also have begun work with Cutting on a photolithographic process; if so, Cutting's affiliation with Turner would represent a second stage of the development. Impressions of Rehn's photolithographs are in the collections of the Graphic Arts Division, National Museum of History, Smithsonian Institution, and the Library Company of Philadelphia.

14. S. D. Humphrey, "Photo-Lithography," *Humphrey's Journal* 10 (no. 19, February 1, 1859):289–90.

15. U.S. Patent 19.626 titled "Improvement in Photolithography," issued March 16, 1858.

16. Joseph Dixon, "Photographs on Printing Stone," *Scientific American*, April 15, 1854, 242.

17. Annotations on impressions of several of Bradford's photolithographs specify this technique. He was unusual if not unique in its use in the 1850s and 1860s.

18. Hanson, "Early Photolithographic Stereographs," 131. Hanson correctly notes that Turner, beginning in 1860, became the first full-time photolithographer in the United States. Bradford presumably was then still dividing his time between conventional lithography and photolithography.

19. For Osborne, see *Australian Dictionary of Biography* 5:375–76. Osborne describes his collection, gives his reasons for making the gift and the conditions attached to it, and describes his own career in photolithography in his letter of June 6, 1888, to G. Brown Goode, Assistant Secretary of the Smithsonian Institution, Registrar's Record File 23,155; copy in Division of Graphic Arts, National Museum of American History.

20. For Koehler, see Clifford S. Ackley, "Sylvester Rosa Koehler and the American Etching Revival," in *Art & Commerce* (Charlottesville, Va., 1978), pp. 143–50; and Cynthia Clark, "Five American Print Curators," *Print Collectors Newsletter* 11 (July/August 1980):85–86. For Koehler's description and appreciation of Bradford's process, see his "The Photo-Mechanical Processes," *Technology Quarterly* 5 (October 1892), 191–192.

21. The provenance of these impressions is unknown.

22. The statuette is one of many derived from the terra cotta modeled by François Marie Suzanne in 1793. The Suzanne image of Franklin appeared in statuary of all sizes throughout the nineteenth century, from Staffordshire pottery to life-size castings of adaptations of the original, but I have not located the piece shown in Bradford's print.

23. *Proceedings of the American Academy of Arts and Sciences* 4 (1857–60):20.

24. The specimen prints in *Photographic and Fine Art Journal* are checklist nos. 1, 2, 12, 13, 17, 23, 33, and 34. *Humphrey's Journal*, p. 289. The specimen prints in *Humphrey's Journal* are nos. 11, 24, and 33.

25. These are Tillinghast Baily, L. Trouvelot, Willard C. Vanderlip, Francis A. Jenkins, George Girdler Smith, William Newton Bartholomew, David William Moody (probably), George W. Simonds, Barnard Spindler, and Charles Stetfield. Vogel remains unidentified. I am grateful to Georgia Barnhill, Curator of Graphic Arts at the American Antiquarian Society, who directly upon seeing these names, confirmed several of them as lithographic draftsman active in Boston around 1859.

26. The woman has been conjecturally identified as Mary Todd Lincoln in some collections, but comparison of her face with documented likenesses of Mrs. Lincoln shows little real resemblance.

27. A. A. Turner, *Villas on the Hudson* (New York: Appleton, 1860).

28. The source of the impressions Bradford reproduced is unknown. In addition to numerous private collections in Boston, both Harvard University and the Boston Public Library owned many reproductive engravings.

29. Field, in his *An Essay Towards an Indian Bibliography* (New York: Scribner, Armstrong and Co., 1873), 178, says "I have seen two copies of the map varying so much as to prove almost beyond doubt that there were two editions of it, as well as of the text. To establish this, so far as to defy skepticism, I caused a photolithographic copy of one to be made to place beside the other." The

"Wine Hills" and the "White Walls" versions are reproduced in Wendy Shadwell, *American Printmaking: The First 150 Years* (New York: Museum of Graphic Art, 1969), as plates 2 and 3.

30. *Proceedings of the American Academy of Arts and Sciences* 3 (1852–57):315–18. On March 17, 1858, Professor James D. Dana wrote to Rogers from New Haven, "I thank you most warmly for the photograph of your trilobite. It is exceedingly fine. Your photolithographic illustrations of the subject will make a beautiful suite." Emma Rogers, ed., *Life and Letters of William Barton Rogers*, 2 vols. (Boston: Houghton Mifflin, 1896), I:386.

31. John Dean, M.D., *Smithsonian Contributions to Knowledge 173. The Gray Substance of the Medulla Oblongata and Trapezium* (Washington: Smithsonian Institution, 1864). At least two printings were issued, including one with mounted photographs.

32. In his preface, Dean says, "For the labor and patience bestowed on the photolithographs by Mr. L. H. Bradford ... I owe and gladly render my most grateful thanks."

Appendix

Checklist of Known Photolithographs Printed by L. H. Bradford

Because most of Bradford's photolithographs cannot be dated with anything approaching precision, the following list is arranged by subject rather than chronologically. Dimensions are given for each image in inches, height before width. Impressions in the collections of the American Antiquarian Society and the Graphic Arts Division of the Smithsonian Institution's National Museum of American History are identified by call numbers. Most of the annotations on the impressions are by Osborne and Koehler. Osborne's date from no earlier than 1864. Koehler's are probably from the 1890s. The year "1856" in Osborne's annotations sometimes refers to the year of origin of Bradford's process rather than to the print itself.

The following abbreviations apply:

AAS	American Antiquarian Society
B	Bradford
HJ	*Humphrey's Journal*
K	Sylvester Rosa Koehler
O	John Walter Osborne
PFAJ	*Photographic and Fine Art Journal*
SI	Smithsonian Institution, Division of Graphic Arts of the National Museum of American History

Portraits

1. *L. H. Bradford./Lithographer 221, Washington St. Boston.* Imprint: *Photolith. of J. A. Cutting & L. H. Bradford.* 7½ × 4⅝. Published PFAJ April 1858. AAS (Lithf Cutt Brad) O: "Photolith by L. H. Bradford."

2. *Jas. A. Cutting./Photographer. (Cutting & Turner)/No. 10 Tremont Row, Boston.* Imprint: *Cutting & Bradford's Photolithography.* 9⅗ × 5⅞. Published PFAJ March 1858. AAS (Lithf Cutt B Cutt).

3. [*Man Wearing a Fancy Vest.*] 6½ × 4¾. SI (GA 3720). O: "Bradford"; K: "Recd from B. by O. in 1864."

4. [*Man With Hand in Coat.*] 7¼ × 5⅛. SI (GA 3721). O: "Bradford"; K: "From B. to O. in 1864."

5. [*Seated Woman in a Fancy Dress.*] 7¾ × 6¼. AAS (Lithf Brad Woma). O: "Photolithography by Bradford's Process 1856." SI (GA 3723.1). K: "Bradford's Process 1858–1860." SI (GA 3723.2). O: "Bradford"; K: "Recd from B. by O. in 1864." SI (GA 3722). An impression from a different stone.

6. [*Portrait of a Man and his Four Children.*] Oval, 8⅝ × 11½. SI (GA 3311). O: "Bradford"; K: "From B. to O. in 1864."

7. [*Statue of Benjamin Franklin.*] 8⅜ × 4⅝. SI (GA 3725). O: "Copied Directly by Camera before July 1858 by L. H. Bradford"; K: "From B. to O. in 1864."

Views

8. [*View of Park Street Church Steeple Encased in Scaffolding.*] 13⅞ × 10. AAS (Lithf Brad Buil). O: "L. H. Bradford Photolith 1856 (about)."

9. [*Distant View of Massachusetts State House.*] 7⅞ × 10. AAS (Lithf Tapp B Bost). Unknown hand: "photolithograph taken directly in camera on stone Boston." SI (GA 3310.1). O: "The stone exposed in the camera—from L. H. Bradford 19/8/64—made about four years ago"; K: "Ordinarily B. exposed the prepared stone under a transparent positive. In this case he exposed it directly in the camera. Stone prepared with gum arabic, bichromate, and a little sugar." SI (GA 3310.2). K: "Recd from B. by O. in 1864."

10. [*View of Boston Buildings.*] 11⅞ × 9¼. AAS (Lithf Brad Builv). O: "Photolithographist L. H. Bradford 1856 (about)."

11. *Indian Hut Vermont.* Imprint: *Photolithographed by Cutting & Turner/Patent of J. A. Cutting & L. H. Bradford.* 7¾ × 10 including title. Published HJ February 1859. SI (GA 3314). K: "Published with No. 19 of Humphrey's Journal. Received from Mr. Cooper (by O.) 1861."

12. *Residence of Judge Parker, Cambridge.* 14. 5⅝ × 8½. Published PFAJ October 1858. SI (GA 3724). O: "Bradford"; K: "From B. to O. in 1864."

13. [*Unidentified Residence.*] Imprint: *Photo-Lithographed by Cutting & Turner.* 10 × 6⅞. Published PFAJ December 1858.

Photolithographic reproductions of engravings and other prints

14. [*The Virgin Mary, the Infant Jesus, and Saint John. (La Belle Jardiniere)*], engraving after the painting by Raphael. 9⅛ × 5⅞, printed with a tint. SI (GA 3730). O: "Direct in Camera—Bradford"; K: "From B. to O. in 1864."

15. [*The Virgin of the Columbine.*], engraving after the painting by Bernardino Luini. 5⅛ × 7. SI (GA 3729). O: "Bradford—about September 1865—Printed by Prang"; K: "*Probably* printed by Prang from an old stone."

16. [*Madonna and Child.*], engraving by Pietro Marchetti after the painting by Johann Friedrich Overbeck. Circular, 9½″ diameter. SI (GA 3732). O: "Bradford"; K: "Recd from B. by O. in 1864."

17. *Photo-Lithograph of Michael Angelo*, engraving by Alphonse François after a sixteenth-century portrait of Michaelangelo. Oval, 6⅞ × 4½. Published PFAJ August 1858.

18. [*Miriam's Celebration of Thanksgiving After the Crossing of the Red Sea.*], engraving. Circular, 9¼″ in diameter. SI (GA 3731). O: "Direct in the Camera—Bradford"; K: "Characteristic in showing the peculiarly undefined line obtained by Bradford's process."

19. [*Country Boy.*], engraving. 7⅛ × 8⅞, printed with a tint. SI (GA 3309). O: "Bradford"; K: "Recd from B. to O. in 1864."

20. *A Map of/New-England*, John Foster's wood cut "Wine Hills" map of 1677. 7⅞ × 10⅜. SI (GA 3727). O: "Bradford"; K: "Recd from B. by O. in 1864."

21. [*Scene from the Story of the Sleeping Beauty*], wood engraving designed by Gustave Doré. 9⅞ × 7⅞. The illustration was first published in Thomas Hood, *The Fairy Realm* (London, 1866). SI (GA 3728). O: "About 1868"; unknown hand: "Negative by Black. Photolithograph by Bradford. J. E. Tilton & Co. Publishers, Boston." AAS (Lithf Brad Old W). O: "Photolithography Bradford Boston 1856 [*sic*]." This inscription refers to the year of origin of Bradford's process rather than to the year of the print.

Merchandise

22. [*Eight Chairs*], apparently from a chair catalogue, photolithographed from drawings. 7⅜ × 13. SI (GA 3726). O: "Bradford"; K: "Recd from B. by O. in 1864."

23. [*A Display of Ornamental Brackets, Mouldings, and Other Objects*], from a photograph. Imprint: *Photo-Lithographed by Cutting & Turner*. 7¾ × 11⅞. Published PFAJ December 1858.

Specimen Photolithographs

24. *Photo-Lithography/by/L. H. Bradford & Co./Boston.* Imprint: *Process Patented by J. A. Cutting and L. H. Bradford, March, 1858.* 6¾ × 3¾. Published HJ 10 (No. 19, February 1, 1859). AAS (Lithf Brad Spec V). SI (GA 3308).

25. [*Bank Notes, Temperance Emblem, and Map.*] 7¾ × 11¾. Unpublished. The bank notes are greatly reduced in size. AAS (Lithf Brad Spec).

26. [*Flowers and Maps.*] 10¼ × 11 (approximately; the only known impression lacks right edge of image). Unpublished. SI (GA 3744). O: "Bradford—scratched Positive drawing on some transparent medium"; K: "Recd by O. from Bradford. Traced on tracing gelatine with the point, lines filled in with a black pigment, and this used as a transparent positive in the usual way of Bradford's process."

Scientific subjects (not including photomicrographs)

27. [*Rattlesnake.*] 9¼ × 7⅛. SI (GA 3734).

28. *No. 64* [tissue sample]. 8½ × 6. AAS (Lithf Brad No 64). O: "Bradford 1856."

29. *No. 206.* [tissue sample]. 8½ × 6, printed with a tint. SI (GA 3313.1). Unknown hand: "Specimen of L. H. Bradford's Photolithography. Not to be copied or used in any way than as a specimen. Presented to J. W. Osborne, Esqr. July 30, 1866." SI (GA 3313.2). Duplicate impression with the same inscription.

30. [*Sea Dollar.*] Circular, 2″ in diameter. SI (GA 3738). O: "Bradford"; K: "From B. to O. in 1864."

31. [*Bisected Thigh Bone Showing the Structure of a Tumor.*] 7¾ × 4. SI (GA 3733.1). O: "Bradford." SI (GA 3733.2). O: "Thigh bone showing structure of tumor"; K: "from B. to O. in 1864."

32. *Paradoxides from Braintree. W. B. Rogers.* 7¾ × 6. AAS (Lithf Cutt B. Para). Lacks printed title. Unknown hand: "Photolithograph by J. A. Cutting & L. H. Bradford. Feb 12th 1858. To Mr. John Wingate Thornton. Paradoxides from Braintree. W. B. Rogers." SI (GA 3735). O: "Bradford"; K: "From B. to O. in 1864."

Photomicrographs

33. [*Short-nosed Cattle Louse (Haematopinus eurysternus).*] Imprint: *Photo-Lithograph by Cutting & Turner.* 3 × 4¼. Published PFAJ November 1858 and HJ 10 (No. 19, February 1, 1859). SI (GA 3745). O: "Bradford"; K: "From B. to O. in 1864."

34. [*Head Louse (Pediculus Humanus capitis).*] Imprint: *Micro-Photo-Lithography/of Messrs Cutting & Turner No 10 Tremont Row, Boston, Mass.* 6⅞ × 3½. Published PFAJ September 1858.

35. [*Section of Wood.*] 4 × 3⅞, printed with a tint. SI (GA 3736). O: "Section of Wood—Bradford"; K: "From B. to O. in 1864."

36. [*Spider's Back.*] 7⅛ × 5⅛, printed with a tint. SI (GA 3737). O: "Spider's Back. Micro." K: "From B. to O. in 1864." The same photograph, differently cropped, appears under the title "Section of the skin of a spider," in *Microscopic Photo-Lithography, Entomological Series*, consisting of mounted photolithographs "executed & published by I. Rehn & Co., No 920 Chesnut [*sic*] St. [Philadelphia], n.d.

37–45. Nine plates illustrating John Dean, *The Gray Substance of the Medulla Oblongata and Trapezium* (Washington: Smithsonian Institution, 1864), each plate consisting of four photomicrographs 3¼″ in diameter. The photolithographs were exhibited at the

April 12, 1864, meeting of the American Academy of Arts and Sciences in Boston (*Proceedings* 4 [1857–60], 262). The subjects of the plates are as follows: I–IV (Figs. 1–16), sections of the medulla of the sheep; V–VII (Figs. 17–28), sections of the human medulla; VIII (Figs. 29–32), sections of the human medulla and olivary body; IX (Figs. 33–36), sections of the medulla of the cat. SI (GA 3312), Plate IV. K: "Recd by O. from B. in 1864." SI (GA 3740), Plate VIII. SI (GA 3742), Plate IX.

6

American Master Prints, 1900–1950

SINCLAIR HITCHINGS

Today, the boom market in American prints of the 1920s and 1930s can serve as a vantage point. This rising market began by 1970; by 1980, numbers of prints established by sellers and buyers as highly desirable fetched prices upwards of a thousand to three thousand dollars. The increase in the numbers of prints selling for more than a thousand dollars continues. Despite occasionally startling prices (you can buy the Bellows lithograph, *Stag at Sharkey's,* for love *and* money, a lot of money: twenty-five thousand dollars might not be enough), the boom has not been a fad or a craze, but rather a deep expression of interest and enthusiasm, marked by many new definitive catalogues, fully illustrated, of the work of American printmakers. Important in the literature are many dealer's catalogues; a frequently used title is "American Master Prints." The burgeoning literature, by itself, would indicate that something big happened in the graphic arts in the United States after 1900.

Beginning in 1980, Marius Péladeau and I set out to discover, if we could, what is an American master print. Is there any such thing? We started from strength, since the Farnsworth Museum, Rockland, Maine, which Marius directs, and the Boston Public Library, where I am Keeper of Prints, each have sprawling collections of twentieth-century American prints. We viewed our investigation in part as a collecting project, since we planned, from the beginning, to use our studies as guidance in strengthening the collections under our care. We aimed, ultimately, to draw upon the enhanced collections for a traveling exhibition and a publication, which has yet to occur.

Not surprisingly—in retrospect—our undertaking turned out to be bigger than we anticipated, as so often happens. So much bigger, in fact, that I look now with amazement at the energies and talents so many American artists directed to printmaking in the first fifty years of this century.

Curators are incurable list-makers. We began by making lists. The market presents, with relentless repetition, its own list, based on what is available to buy and sell. We also desired to know about prints which receive no attention from the market because of the obscurity or neglect of the artist or the lack of a supply of prints to feed the process of buying and selling. And we knew in advance that sometimes we would disagree with the market on what was significant or insignificant.

Being Americans, we chose a democratic view of that much-used and abused word, "master." In asking if there are American master prints, we looked for mastery of technique coupled with a highly personal style and a strong and successful impulse to communicate. We looked for prints that could hold their own in any company and that represented a personal exploration of expression through one or several printmaking media. We asked for prints possessing the authority to claim a place in our thinking. We realized, increasingly, that these prints might look different from the familiar landmarks of the past; they might not remind us of Whistler or Meryon or Goya or Lautrec or other masters. Since the market thrives on familiarity and repetition, and since art historians love to find influences and trace precedents, certain artistic expressions from this particular time and place might take some getting used to, if they were to be generally accepted and understood. Part of our job was and is to encourage this process.

The partnership of two people and two collections in an inquiry into "American Master Prints" has been elastic and has left plenty of scope for individuality. From the start I declared that I desired to collect American printmaking wholesale—to buy, on occasion, sight unseen, in order to bring to the Boston Public Library a print by an unfamiliar printmaker; to build a sense of what and how much a printmaker had produced. For a printmaker of interest, I desire to see in the collection not one or two examples, but, if possible, ten or fifteen or twenty or more, to help me find some sense of the printmaker's work. I desire to know all the details of the artist's printmaking, and have collected books, pamphlets, articles, exhibition catalogues, and ephemera until I am now surrounded by this material at the Boston Public Library. I desire to

know how the artists lived, what they thought, what they wrote, whom they knew.

Let me give three examples of this effort to gain a sense of the quality, quantity, and character of a printmaker's work. Obviously, it is much easier to assess a printmaker's accomplishment if you have in your hands a catalogue raisonné which shows every print in an excellent reproduction and which enhances this visual access with text describing the artist's life and printmaking. My three examples, J. J. Lankes, Adolf Dehn, and Walt Kuhn, to date have not received this desirable but expensive red-carpet treatment. Nor have many of their contemporaries, despite the continuing publication of new books.

J. J. Lankes (1884–1960) during forty years of wood engraving made 1,224 prints; the Boston Public Library owns 23 of them. A minor collection, without doubt, but still large enough to make it possible, with the additional help of Lankes's *A Woodcut Manual* and several articles about him, to reach certain conclusions. He was a craftsman with a love of wood; his friend, Ray Nash, commented that "besides being an inveterate schoolboy 'drawer,' he was a born whittler, with an ingrained love for kinds and qualities of woods and for the cutting tools to work them with."[1] He was also a poet. He could memorably portray the exterior world, as in his wood engravings of southern farmhouses and one-street southern towns, but many of his subjects are drawn from the country of his mind. He thought about sky, and stars, and the moon, and churches in snow, and trees, and twilight, and dawn, and these and other themes recur in his prints. A fully illustrated catalogue raisonné of his prints would be an enormous task; lacking such a survey, the market accords him only a nod, and Lankes enthusiasts find that his prints surface at modest prices. From a selfish point of view, I hope this limited interest continues.

Adolf Dehn (1895–1968) made lithography his life's work; he left us well over six hundred lithographs. By persistence I have now seen a good many of his prints; their technical virtuosity is impressive, but mostly I find in them no spark of idea or impulse, no irrepressible vitality, which would draw me back to them. I have come to agree with Richard Cox that Dehn's early work in lithography is his best: "Many of his most imaginative works, the satirical drawings and lithographs, were produced while he roamed about Europe between 1921 and 1930. ... Dehn quietly impeached the stylish emissaries of the flapper age wherever he located them—in Vienna, Berlin, Paris, New York, even Minneapolis," in Cox's view.[2] I continue to see works by Dehn from this period, and I continue to find some of them, when offered for sale, irresistible. A book pre-

senting a selection of Dehn's jazz-age pictures would be, to me, the most fitting tribute to his talents.

Walt Kuhn (1877–1949) made numerous prints but did little to popularize or promote them. Some of them reached the market at the time he made them; others, scenes from his *Imaginary History of the West,* conveying his ribald private musings, reached friends inscribed with Christmas greetings. The Cincinnati Art Museum's excellent publication on Kuhn, issued in 1960, contains substantial quantities of information; the only mention of prints, however, is in the chronology:[3]

1915–27: Devoted considerable time to etching and lithography

In 1967, New York's Kennedy Galleries held an exhibition, Walt Kuhn as Print-maker, and issued a six-page folder containing a title page, a two-paragraph introduction, three reproductions of prints, and a listing of fifty etchings and thirty-two lithographs. The introduction explains: "With the exception of a few examples shown during his lifetime, the greater portion of his prints has remained locked up and forgotten in a warehouse these many years." The listing of prints is prefaced by the statement: "Walt Kuhn's prints are of the greatest rarity. Of certain subjects only one to six impressions exist. ... Others vary in number of impressions, but none exceed fifty of any subject."

By the time the Boston Public Library Print Department purchased seven prints by Kuhn from Kennedy in 1983, many of the prints listed in 1967 were no longer available. Following this purchase I still puzzled over the question, How does one assess Kuhn's printmaking? My tentative answer is that his prints of circus performers, his portraits of women, and his joking scenes of the frontier are all desirable, though they vary greatly in authority and strength of design. Some of his strongest prints bring to mind the work of Derain and other European artists, and they underline Kuhn's artistic split personality. He wished to incorporate European modernism into his American art, and to some extent he did, although the union was never really completed. His was a troubled spirit. His favorite subject, the circus, caused him to forget the tug of different artistic views and styles. For his circus subjects, above all, we remember him. In print-making, as in painting, his life's work is very uneven; much of it is not compelling, and much of it is forgettable.

Perhaps you've noticed that in discussing the prints of Lankes, Dehn, and

Kuhn, I have avoided the phrase "American Master Prints." A master works at a high level, and his or her work evokes marvel because it consistently comes forth at that level. A persistent characteristic of many of the Americans is their unevenness. I find consistent quality in Lankes, but like Ruzicka, Allen Lewis, Thomas Nason, and certain other American wood engravers, a sizable portion of his work belongs in the realm not of high art but of craftsmanship—commercial emblems, marks, and other commissions, sometimes including bookplates, which he designed and executed with a special talent.

Dehn and Kuhn are notably uneven, and so were many of their contemporaries. Demand has been modest for Bellows's "Men Like Gods" series, illustrating H. G. Wells; the prints are curiosities, though they might provide images for someone compiling a book on heaven visualized in Art Deco terms. Bellows's visions of the Germans in World War I are not only secondhand, they are second-rate, lapsing into sentimentality. Compare them with Kollwitz's "Peasant Revolt" etchings; they cannot stand the comparison. To say that Bellows confronts Goya in his war prints is ludicrous. There is only one Bellows print which suggests Goya, his *Hungry Dogs* of 1916, a triumph of gritty alleyway chiaroscuro.

Yet Bellows threw himself into his art with tremendous energy and commitment. He created many memorable prints, prints which hold attention and stamp themselves in memory. As Bolton Brown remarked, his portraits of family and friends have intimacy and freshness.[4] He was a great portraitist, possessing strong human feeling and intensely identifying himself with his subjects. His boxing subjects, his landscapes, his series of nudes, and his Irish subjects, undoubtedly enriched by his friendship with John Butler Yeats, are among the notable American prints of the first half of our century.

Seeing the prints themselves is essential, but equally important is mastering the large literature that exists.[5] A publication I highly prize—it was purchased from John Warren, the Philadelphia specialist in art books, for a modest price, and has repaid me many times over—is the papercover *Illustrated Catalogue of Etchings by American Artists* issued by Albert Roullier in 1913 at his Chicago art gallery, the A. Roullier Art Galleries. The catalogue presents sixteen American printmakers, featuring for each one a picture, a biographical sketch by H. H. Tolerton, and a price list of prints.[6] The names in highest esteem today are John Marin (prints listed are in his early style, a personal variation of Whistler's style of etching), Bror J. Olsson-Nordfeldt, and Joseph Pennell. The Nordfeldt list illustrates the challenge of assessing not only a printmaker's total output but his

best work. One hundred and five of his prints are listed. He was turning out city views drawn and etched in the energetic spirit of Pennell—a San Francisco series, a Portland, Oregon, series, and two Chicago series. A reproduction of *The Illinois Steel Company, Chicago*, number 58 in the price listing, shows high stacks and a smoke-shrouded world. Much ink has been left on the surface of the plate by Nordfeldt in his skillful wiping, à la Pennell.

Also listed are an Italian series of etchings, a Spanish series, several portraits, and a depiction of Washington Market in New York City. Finally, at the very end, are ten "Woodcuts in Colour." The market today shows little enthusiasm for Nordfeldt's etchings in the manner of Pennell but avidly pursues the color woodcuts. Seldom seen on the market are Nordfeldt's best works, in my view, his etchings of New Mexico scenes and people from the early 1920s.[7] My descriptions do not do justice to Nordfeldt's immense productivity and wide range of styles; they may illustrate, again, however, that persistence is necessary in seeking out the literature, including reproductions, and seeking out, at the same time, the original prints which tell so much the reproductions do not.

Are there such things as American master prints? Most certainly there are—by Pennell, Sloan, Marin, Bellows, Hopper, Lozowick, Martin Lewis, Rockwell Kent, Reginald Marsh, Stuart Davis, Milton Avery, Raphael Soyer, Yasuo Kuniyoshi, Stow Wengenroth, and Ivan Albright, among others. The outpouring of prints in the United States after 1900 constituted a major artistic happening, one that will be duly chronicled in histories of printmaking in times to come. There was intense activity among American-born artists and the constant stimulus from abroad of artist-visitors or artist-immigrants who added their visions and their skills.

Many hundreds of artists found printmaking a highly attractive form of expression as the American revivals of wood engraving, of etching, and of lithography gained momentum, following revivals in Europe. Such intense activity pushed New York, for the first time, onto the level of Paris and London as one of the great printmaking cities of the world. The American movement in printmaking, with New York as its acknowledged capital, was a national one having a number of regional centers. Praising the federal art projects of the 1930s, Carl Zigrosser wrote in 1942: "Another contribution by the projects has been the development of special graphic techniques: silk screen in New York, color lithography in Chicago, carbograph in Philadelphia, stylotint and crayon aquatint in Cleveland."[8] California was a continent away from Manhattan and could nour-

ish native visions a continent apart. It also, of course, welcomed artists who brought their visions with them—Charlot, Bellows, and Haskell, for example. Bellows could respond to the dramatic light, clarity of light, far reaches of sight, and rugged landscape of the West. His few western subjects, including *The Sand Team* and *Well at Quevado,* are memorable.

The Californians who stayed home included Paul Landacre, whose wood engravings in black and white are strikingly different from the wood engravings of the East Coast artists. Like many American artists of the time, Landacre was a perfectionist with an ideal of technique and the ability to realize it. He is at his best when interpreting on a woodblock the ramparts of mountains rising from a valley, a rain squall sweeping the land, the brightness of a tree blossoming in spring, seen in a big reach of sight embracing the land. Franz Geritz, as uneven in his work as many of his compatriots, studied woodcut and linoleum cut and came in time to a highly personal knowledge of color printing from linoleum blocks. His *Craters, Mono Lake,* a woodcut of 1927, is strong, but *Sunrays in the Redwoods,* a linoleum cut in colors of 1936, achieves much more—the impact of shafts of light across deep shadow in a print carried out with flat colors. The colors possess subtlety, and the design subtly suggests Art Deco style. Like many prints of the period, this one is roughly the size of a person's hand, yet it suggests big spaces.

Students of early American prints, through the era of Currier and Ives, often ask for instruction in connoisseurship. It is possible to teach them to see that a print is well or poorly printed; that the applied watercolor or gouache, in many handcolored prints, is expertly effective or amateurishly garish or weak; that coloring is of its period or is recent; that a restrike is able to be distinguished from first printings. It is possible to talk about the printmakers' tools and presses and skills. The subject is very limited, because it was not until the beginning of our own century that many American painters began to own etching presses and lithographic presses; not until this century did we see the emergence of printers who worked only with artists. Only then, about 1900, did the United States begin to offer the artist working conditions which included the versatility and refinement of printmaking skills sought by Whistler more than four decades earlier. After 1900 we can insist on knowing who printed the print, whether the artist or a specialist printer, and usually the question can be answered. The people are there who are accountable for the print. When I hear a curator say that the impression of *Stag at Sharkey's* owned by his or her institution is superior to the impression owned by another institution, I chuckle.

The assertion might be true, but I half expect to see the ghost of Bolton Brown materialize to explain that while the two impressions are different, each possesses qualities esteemed by himself and Bellows. This imagined discourse on the characteristics of two impressions from the lithographic stone constitutes connoisseurship of a higher order than Currier and Ives prints, with their combination of craftmanship and mass production, will permit.

Notes

1. Ray Nash, "J. J. Lankes," *Printing and Graphic Arts* (Lunenburg, Vt.: The Stinehour Press) 8, No. 4 (December 1960):100.

2. Richard Cox, "Adolph Dehn: Satirist of the Jazz Age," *Archives of American Art Journal* (Washington, D.C.: Smithsonian Institution) 18, No. 2 (1978):11.

3. *Walt Kuhn 1877–1949* (Cincinnati Art Museum, 1960).

4. Speaking at "A Tamarind Symposium: Two Hundred Years in the Art of Lithography, Past, Present, and Future: 1810–2010" (University of New Mexico, February 1985) on the relationships between artists and printers, Leonard Lehrer of Arizona State University quoted Bolton Brown's "Prints and Their Makers," *Prints* 1 (1930):13–24, on Bellows's lithographs: "His best pieces are by no means those huge affairs, such as prize fights, where he was largely the mere illustrator, but certain simple and utterly charming rambles on stone, more often than not with his wife and daughter ... as subject. It was in some of these that he touched his high-water mark ... and very high the highest was, too."

5. There are many useful and pertinent publications, from which could be culled a short list of key surveys of what was happening in American printmaking. Among these, in my view, would be: *Catalogue of the Department of Fine Arts, Panama-Pacific International Exposition, San Francisco*, 1915, 44–61; The American Institute of Graphic Arts, New York, *An Exhibition of Etchings by Contemporary American Artists, February 28th–March 23rd, 1917* (held at the National Arts Club); *Illustrated Catalogue of Lithographs, Engravings, and Etchings Published by The Weyhe Gallery*, New York, September 1918; Victoria and Albert Museum, London, *Exhibition of Contemporary American Prints*, May 14–June 22, 1929; Whitney Museum of American Art, New York, *Between Two Wars: Prints by American Artists, 1914–1941*, March 3–31, 1942; Carl Zigrosser, *The Artist in America: Twenty-four Close-ups of Contemporary Printmakers* (New York: Albert A. Knopf, 1942); and The Brooklyn Museum, *The American Institute of Graphic Arts Presents American Printmaking 1913–1947*, November 18 to December 16, 1947.

6. Albert Roullier Art Galleries, Inc., *Illustrated Catalogue of Etchings by American Artists*, with biographical sketches by H. H. Tolerton. (Chicago: The Lakeside Press, 1913). The printmakers are George Charles Aid, George Walter Chandler, Charles W. Dahlgren, C. K. Gleeson, Lester G. Hornby, Katharine Kimball, Bertha Lum, John Marin, Donald Shaw McLaughlin, Bror J. Olsson-Nordfeldt, Joseph Pennell, Otto J. Schneider, J. André Smith, Everett L. Warner, Cadwallader Washburn, Herman A. Webster, and Charles Henry White.

7. "In 1920 he exhibited more etchings, considered the first series having Santa Fe themes, which he had printed on the museum's etching press. The twenty etchings were described by a local

critic as 'more rugged and done with greater freedom than Mr. Nordfeldt's earlier work, reflecting his progress as a modernist.' Coke has called this series Nordfeldt's finest work in the medium, and it does indeed demonstrate Nordfeldt's grasp of black and white design possibilities," writes Sharyn Rohlfsen Udall in *Modernist Painting in New Mexico 1913–1935* (Albuquerque: University of New Mexico Press, 1984). Nordfeldt's *Man from Arroyo Hondo,* an etching, is reproduced as No. 15 in *American Institute of Graphic Arts Fifty Prints Exhibited by the Institute 1927* (New York: William Edwin Rudge, 1928). Nordfeldt's etchings *Boy, Pup,* and *Placita Attalaya* are reproduced in *Artists of the Canyons and Caminos: Santa Fe, the Early Years* by Edna Robertson and Sarah Nestor (Salt Lake City: Gibbs M. Smith, Inc., 1982), 4–5.

8. Quoted from Zigrosser's Introduction to the 1942 Whitney Museum catalogue, *Between Two Wars.*

Illustrations

Rudolph Ruzicka, Allen Lewis, and J. J. Lankes were pioneers of modern American wood engraving. Ruzicka began a series of views of New York in 1908; one of his New York prints is shown here (Fig. 6.1). Allen Lewis's black and white prints illustrating *Journeys to Bagdad* (Yale University Press, 1915) remain, with their imagination, humor, and technical virtuosity, a landmark. Later, Lewis became a master of the color wood engraving (Figs. 6.2–6.3). The subtlety of Ruzicka's color and the richness of Lewis's can be suggested even in these black-and-white halftones. J. J. Lankes began engraving on wood in 1917. *A Woodcut Manual* (he preferred the word woodcut even though his prints were wood engravings), published by Henry Holt & Co. in 1932, retains to this day its energy, outspokenness, and strong expression of feeling for the art and craft of prints from wood (Fig. 6.4).

A sensitive portraitist, William Auerbach-Levy conveyed his subjects unforgettably. An early series of prints shows people of the New York streets. Auerbach-Levy, truly a master, is little discussed today, because of the search for modernism by dealers, curators, and collectors when they approach his generation. A traditionalist master, however, is as much a master in his technical command and intense perceptions as a modernist master. (Figs. 6.5–6.6). Eugene Higgins looked to Daumier and other nineteenth-century French printmakers as he sought in his art to convey the spirit of the homeless, the hungry, the poor, the dispossessed. He sought to free himself from patness and smoothness of technique. A master of etching, he is as memorable as Auerbach-Levy in his individuality and humanity (Figs. 6.7–6.8).

6.1. Rudolph Ruzicka, *St. Paul's Chapel in New York*, 1910. Color wood engraving, 7½ × 4¹⁵⁄₁₆ in. Courtesy of the Boston Public Library.

6.2. Allen Lewis, *Mother and Child*, 1923. Woodcut in colors for Marchbanks Press poster, New York, 10^{11}/$_{16}$ × 8^{5}/$_{8}$ in. Courtesy of the Boston Public Library.

6.3. Allen Lewis, *The Archer*, ca. 1926. Color woodcut, 10⅜ × 8⁷⁄₁₆ in. Courtesy of the Boston Public Library.

6.4. J. J. Lankes, *Dawn*, ca. 1927. Wood engraving, 5⅝ × 4¼ in. Courtesy of the Boston Public Library.

6.5. William Auerbach-Levy, *The Journey's End*, 1916. Etching, 11⅞ × 6 in. Courtesy of the Boston Public Library.

6.6. William Auerbach-Levy, *Portrait of Timothy Cole*. Drypoint; 9 × 10¹⁵⁄₁₆ in.
Courtesy of the Boston Public Library.

6.7. Eugene Higgins, *Indian Laborer,* 1919. Etching; 8⅞ × 6¹¹⁄₁₆ in. Courtesy of the Boston Public Library.

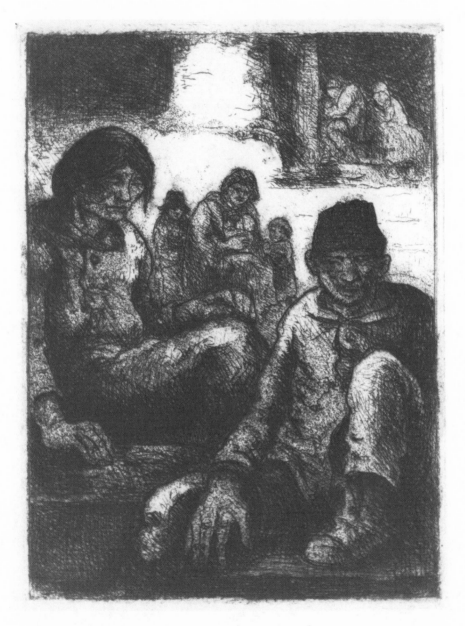

6.8. Eugene Higgins, *Loungers on the Steps, Taos*, 1932. Etching; 7¹⁵⁄₁₆ × 6 in. Courtesy of the Boston Public Library.

7

The Imperious Mr. Pennell
and the Implacable Mr. Brown

CLINTON ADAMS

Joseph Pennell and Bolton Brown (Figs. 7.1, 7.2), two of the principal figures in the establishment of artists' lithography in America during the first decades of the twentieth century, were bitter antagonists.[1] The dispute between them, exacerbated by their assertive and conflicting personalities, had its source in sharply divergent views of the nature of lithography and, in particular, of the merits of transfer lithography. According to Pennell, Aloys Senefelder, the inventor of lithography, had claimed the transfer method to be *"probably the most important part of his discovery"* (Pennell's italics). "It has been said by critics and experts," Pennell wrote in 1912, "that a drawing on paper is not so full and rich as a drawing on stone. Artists know this is false. And no expert is able to tell the difference—to tell whether the drawing was made on paper or stone."[2] Pennell had no doubts on the subject; his position had been upheld in a British court of law.

In 1896 the artist Walter Sickert published a letter in which he said that through Pennell's use of the transfer method "the art of lithography is degraded."[3] Pennell demanded an apology, Sickert refused, and Pennell took the matter to court. There, in April 1897, with Whistler appearing as a witness for Pennell, it was decided that transfer lithography was indeed lithography, and the jury awarded Pennell fifty pounds in damages.

Brown refused to accept this. The verdict of the British court meant nothing. In Brown's judgment, Pennell, despite his books and immense prestige, knew little about lithography; he misrepresented the meaning of Senefelder's statement; his lithographs were not *real* lithographs; his writings were fraud-

7.1. (*Left*) Unknown photographer, *Joseph Pennell,* ca. 1905. Photograph. Courtesy of the Library of Congress.

7.2. (*Right*) Unknown photographer, *Bolton Brown,* ca. 1933. Photograph. Courtesy Millicent Coleman.

ulent and uninformed; he was a liar who must be exposed.[4] Though of similar age—Pennell was born in 1857,[5] Brown in 1864[6]—Brown outlived Pennell by a full ten years and during that decade, far from content to let sleeping lithographers lie, Brown pursued Pennell and, more important, Pennell's reputation in the field of lithography, implacably beyond the grave.

Before examining more closely their conflicting views, it is necessary to introduce more fully the two protagonists (Figs. 7.3–7.4).

Both Pennell and Brown were born into families whose American ancestry predated the Revolutionary War, Brown in upstate New York, Pennell in Philadelphia. Brown was the son of a clergyman; Pennell was reared in a Quaker school. Both became infatuated with drawing at an early age; both espoused the need to draw directly from nature; both became fine draftsmen. After study at the Pennsylvania Academy of the Fine Arts, Pennell embarked upon a successful career as an illustrator, first in the United States and then in England, where he became a close friend and associate of Whistler. Brown received baccalaureate and graduate degrees in painting from Syracuse University before entering on a complex career as a professor at Cornell and Stanford universities and as a founder of the Woodstock art colony.[7]

During their lifetimes their paths crossed only occasionally. It is evident that they sometimes met at the opening of exhibitions and other public events. Otherwise, there was little direct contact between them; they did not move in the same social circles. Once in February 1923 on the occasion of a "lithographic evening" at the Anderson Gallery in New York, Brown printed a lithograph for Pennell; this lithograph, *Brooklyn Docks in Snow* (see Fig. 7.7), is signed by both artist and printer, and is identified by Louis Wuerth as Pennell's final work in the medium.[8]

Three years later, on 23 April 1926, Pennell died at the age of sixty-eight at his home in Brooklyn, thus bringing to an end an illustrious career as an etcher, lithographer, illustrator, and writer. Few are the American artists who have received such honors at their death. The morning after Pennell's death the *New York Times* carried a lengthy front-page story, together with a photograph of the artist and a series of memorial tributes from leading figures in the art world.[9] On its editorial page the *Times* lamented the loss of "a significant art, a devoted teacher, a spirited advocate of beauty in public places and private homes, [and] a fervent enthusiasm for the pictorial possibilities of modern industry. But the loss that will be most keenly felt is that of a singularly vital and stimulating personality. Mr. Pennell possessed above everything the precious

7.3. Unknown photographer, *Bolton Brown at his press,* ca. 1933. Photograph. Courtesy of Millicent Coleman.

7.4. Childe Hassam, *Portrait of Joseph Pennell*, 1917. Transfer lithograph; 16 × 12 in. [Griffith 3]; printer unknown. Courtesy of the University of New Mexico Art Museum; Robert Reck photograph.

quality of individuality and kept the spirit of youth to his last hour."[10] On the evening of 18 May 1926 a large and distinguished group of men and women gathered at the Pennsylvania Academy of the Fine Arts in Philadelphia to honor Pennell's memory. "From all sections of the country telegrams and letters of appreciation poured in during the meeting, bearing the tribute of many individuals and organizations."[11]

In the months following Pennell's death a stream of such tributes was published. Two feature articles on Pennell's work appeared in the *New York Times*.[12] Four memorial exhibitions were held, at Memorial Hall in Philadelphia, the Metropolitan Museum of Art and the American Academy of Arts and Letters in New York, and the Library of Congress in Washington. The exhibition at the Library of Congress included a reverential display of the artist's press and etching tools, a lithographic plate, and his pencils and crayons, all just as he had left them.

He was variously called "a genius,"[13] "a cyclonic influence,"[14] and "one of the really great American artists ... a staunch champion [and] an indefatigable fighter."[15] "What Sargent was to the art of painting Pennell was to the illustrative arts—our foremost American representative," proclaimed one authority.[16] "[Pennell] did more for the future of the graphic arts in this country than any one other man," added another.[17]

Pennell's position has continued secure into the 1980s. Una Johnson speaks of his "distinguished place in American graphic expression,"[18] and James Watrous reminds us that Pennell was once "described as the dean of American printmakers, an accolade for a creative artist about which there was no dispute."[19]

But whatever may be the standing of Pennell the artist, there was also a second Pennell: Pennell the writer, lecturer, and professional gadfly who, as Royal Cortissoz once said, "was all the time getting between the reader and Joseph Pennell."[20] Carl Zigrosser, who knew Pennell well, spoke of him as "a picturesque looking figure ... easy to caricature, with his stoop, his scraggly whiskers and his squeaky voice. He was called 'Scolding Joe,' but his bark was worse than his bite. His intemperate speech was a mannerism that he had adopted from his master, Whistler."[21] J. Bertram Lippincott, who was Pennell's publisher, observed that "Mr. Pennell had his own ideas about everything. ... One of the difficulties which publishers had was to get him to eliminate some of the frank statements in regard to individuals, living or dead. ... When dining in his company, it was interesting to observe the effect of his frank criticisms on people who did not know him well."[22]

Even Pennell's wife and literary collaborator Elizabeth Robins Pennell allowed that he was "plain-spoken" and that his writings often gave at least the appearance of bigotry and prejudice.[23] Taking note of his "mine of invective," she loyally attempts an apology for his frequent allusions to dagos, niggers, and Jews, an apology which is difficult to accept in the face of his language. "The man of strong character," she writes, "seldom wins the approval of the multitude, and during his lifetime his picturesque shorthand made him many enemies. . . . Not every one has so fine a sense of humor as the victim who enjoyed his dismissal of her work as a magnificent monument of mediocrity, or the rare reader who read aright his description of the Sistine Madonna in Dresden as a shoddy piece of commercialism."[24]

Brown's intemperate language was of a different sort from Pennell's, characterized less by invective—except when speaking of Pennell—than by the extreme self-assurance which runs as a thread throughout his letters, journals, and published writings—a self-assurance which others often read as an unconscionable arrogance. At one point, Brown described himself as "the best teacher of art in the United States";[25] at another, he claimed that the work he printed for George Bellows constituted "an entirely new chapter in the history of lithography."[26]

It was, of course, precisely Brown's self-assurance which led to many of his most significant achievements. Study of his writings on art and art education suggests that he may indeed have developed a program of distinction at Stanford University during the 1890s, a program well ahead of its time.[27] His achievements as a mountaineer while at Stanford were later honored by the naming of a mountain, elevation 13,538, as Mt. Bolton Coit Brown; his solo ascent of Mt. Clarence King in 1896—a feat possible only for a man of total self-confidence—has been called "the finest Sierra climb of the nineteenth century."[28] And an objective examination of Brown's lithographic printing—his own lithographs as well as those he printed for Bellows and other artists—gives firm support to his claim that they constituted "a new chapter in the history of lithography."

The isolation and extreme poverty in which Brown spent his later years, in sharp contrast to Pennell's fame and fortune, stemmed in part from qualities of temperament and character. John Taylor Arms described him thus:

A strong man, with strong convictions, he fought always against weakness, ineptitude, and insincerity. . . . With unlimited inclination and capacity for work, he expected the same from all serious minded people. He was not

known to his fellows as he should have been, for he gave his friendship not easily but only to those he believed would value it and give him of their best in return, but those he did admit to his world found in him a forceful and courageous spirit, strong for honesty and truth, kindly in his judgments, generous in his nature, unfailing in his loyalty, profound in his knowledge.[29]

In 1928 the director of the Art Institute of Chicago, Robert B. Harshe, who was an etcher and author of a book on printmaking, visited Brown in Woodstock and invited him to become the institute's Scammon Lecturer in 1929. It was this invitation which led to publication of Brown's book *Lithography for Artists* by the University of Chicago Press in 1930. Of his conversation with Harshe, Brown wrote:

> I was reluctant [to accept] because, as I pointed out, I had not enough to say, to a general audience, to occupy the six hours of the Scammon Lectures. He steadily overrode me on that point, and in the end a tentative agreement was reached that I was to give the lectures. Something was said about printing my book instead of, as usual, printing the lectures. ... Of course, the claim made on the cover and the title page and elsewhere, that the book is the Scammon Lectures, is a "complete full-blown fiction." I protested against it and crossed it out in the proofs. The book grew through a long period and had been complete years before I knew the Scammon lectures existed. I had stenographic reports made of my lectures and not a word of them is in the book.[30]

What was in the Scammon Lectures, it is now evident, were many words on Joseph Pennell.[31] "Pennellism," Brown said, "has become, in America, a disease, and I wish to help combat its inroads. ... By his extraordinary gift at propaganda, his ignorance, and his unscrupulousness, he has literally put it all over the people of this great, if not artistic republic."[32]

Brown apparently reconciled himself to the institute's publication of *Lithography for Artists* rather than the actual text of his Scammon Lectures only because he had been unable otherwise to find a publisher for that work.[33] He was infuriated when Harshe told him that the institute's trustees would not approve of Brown's "attack" on Joseph Pennell, who was himself a former Scammon lecturer.[34] "[Mr. Harshe] was for having me rewrite [my book] in accordance with the supposed desires of the institute's trustees. Naturally I could not do that. ... [I said] that what I had written was not an 'attack,' but merely a

correct statement of an important fact. ... Pennell had been playing the devil with lithography for years and I was the man that knew it, and it was not right that I should be choked off from saying so."[35] Ultimately, after much argument, Brown's manuscript was published with only minor revisions. At one point where Brown had called a Pennell comment "not true," the word "mistaken" was substituted.

Even so, the suppression of what he had actually said as Scammon Lecturer continued to rankle Brown. More determined than ever to combat all that Pennell stood for, Brown developed the transcripts of his lectures into a manuscript, "Lithography Since Whistler," apparently completed in 1933.[36] In two of its chapters, "My Ten Years in Lithography" and "Pennellism and the Pennells," he sought to administer an antidote to the disease he had diagnosed, first by demonstrating the faults in Joseph Pennell's technical writings on lithography and, second, by continuing to argue against use of the transfer method.

On the first of these points Brown's arguments are convincing. The many errors in Pennell's books demonstrate that despite his imperious manner and air of utter infallibility, his knowledge of the technical processes of lithography was fragmentary at best. Pennell's frequently expressed contempt for technicians and printers served only to compound the errors that he made.[37] On the second point Brown is less convincing, for in his zeal to demonstrate the superiority of drawings on stone—Brown used the single word *crayonstone*—he, like his opponent Pennell, takes a more extreme position than can be justified by a balanced view of the evidence.

A review of the arguments Brown sets forth in "Pennellism and the Pennells" serves to identify five central themes:

1. That Pennell misrepresented what Senefelder meant when he described the transfer process as the "principal and most important part" of his discovery;
2. That Pennell was wrong when he claimed that "no expert is able to tell the difference" between lithographs made on paper and on stone;
3. That Pennell was wrong when he claimed that "you can do anything on paper that you can do on stone."
4. That Pennell's victory in his lawsuit against Sickert, hinging on the legitimacy of transfer lithography, was based on misguided premises; and
5. That although Pennell might be able to justify the use of transfer lithography on grounds of necessity or convenience, he should not claim it to be the qualitative equal of *crayonstone*.

Let us examine each of these in turn.

(1) A reading of Senefelder's statement in context reveals that he attached importance to the transfer process because of its potential value for use in government offices. "For circulars, and in general all such orders of government as must be rapidly distributed, an invention like this is of utmost consequence; and I am convinced, that before ten years shall elapse, all the European governments will be possessed of a lithographic establishment for transferring writing to the stone."[38] Senefelder goes on to speak of the value of the process for military orders in time of war, for multiplication of literary manuscripts, for publication of music, and for the printing of books in oriental languages. Only at the end of this discussion of the merits of the transfer process does Senefelder refer to the drawings of artists, expressing the hope that "clever artists may devote themselves to its improvement." Brown is thus correct in stating that Pennell distorted Senefelder's meaning through use of partial quotation. He fails, however, to recognize the very great improvements which were made in transfer papers during the 1870s and 1880s, particularly the development in France of *papier végétal*. Nicholas Smale's recently published comparison of Whistler's earlier and later transfer lithographs serves greatly to illuminate this issue and to qualify Brown's arguments.[39]

(2) Brown is correct in rejecting Pennell's claim that "no expert is able to tell the difference" between a transfer lithograph and a print from stone. In most cases the difference is readily apparent, even to an amateur; in almost all cases it is evident to a trained observer.

(3) Brown is correct in rejecting Pennell's claim that "You can do anything on paper that you can do on stone."[40] This, Brown replies, "is a statement more than merely false; it is preposterously and laughably so. I should not be telling a larger whopper if I said you could do anything with a lead pencil that you can do with charcoal."[41]

(4) Brown argues that the verdict in the Sickert/Pennell trial was misguided because it was based on a false perception of the nature of lithography:

> The Sickert contention is important because the kernel of it is that the main matter of public interest in a work of art is how it was DRAWN, not how it was printed, and the drawing on transfer paper is so far removed from stone lithography that it is best thought of as a separate process. ... [I] say again what I have said before, that Pennell made some very excellent drawings. I do not have to force myself grudgingly to "admit" it; I say it freely and gladly. And I will go out of my way to allow Mr. Pennell almost any merit you please, except one. I will not allow that he is a lithographer or that his prints are lithography. Walter Sickert was right.[42]

There remains room for argument on both sides of this question. One can endorse Brown's (and Sickert's) request that transfer lithographs be clearly identified as such at point of sale and in museum exhibitions—this in the spirit of full disclosure—without making, as Brown so often does, a qualitative distinction.

(5) This matter of qualitative distinction between prints from paper and stone is the final point at issue, and it is here that Brown's arguments are weakest. The art of lithography would be far poorer were it not for the transfer lithographs of Whistler, Redon, Fantin-Latour, Pennell, and many more recent artists, among them Matisse, Picasso, de Kooning, and Motherwell.

Nor is the matter of convenience a point to be rejected out of hand. "Drawing on transfer paper ideally suited Whistler's artistic aims and style, for he delighted in recording scenes and events out of doors in an abbreviated and evocative style that retained the appearance of spontaneous sketches ... [and] there is ample evidence to show that the method was a necessary part of his manner of working."[43] Such considerations were of even greater importance to Pennell, whose subjects took him great distances from printers and to places— Spain, Greece, Panama, and the American West—where stones could not have been transported.

In adjudicating the dispute between Pennell and Brown we then come to these conclusions. First, that Pennell often made mistakes in his technical discussion of lithographic processes; that he was frequently wrong in his overstated claims for transfer lithography; and that his imperious air of infallibility cannot be justified by the evidence. Second, that Brown was right in technical matters; that there was merit in his recommendation that a clear distinction be made between prints drawn on stone and on paper; but that he carried beyond the bounds of reason his implacable rejection of all that Pennell stood for.

In the end one must agree with Brown that the greatest lithographs are those which are distinctly lithographic: those that in full degree make visible the essential nature of the process (Figs. 7.5–7.8). It is through his or her encounter with the stone that the artist emerges with a trophy—a work of art that could have been achieved in no other way. Witness Picasso's many magnificent lithographs which came into being through his battles with the stone, round after round, state after state, until the essence of his experience had been distilled and recorded. In each of their many states such lithographs speak eloquently of the stoneness of the stone—Motherwell's wonderful phrase—and of the creative process that led to, and indeed, participated indispensably in their final realization.

7.5. Joseph Pennell, *Temple of Jupiter, Evening,* 1913. Transfer lithograph; 21¼ × 16⅝ in. [Wuerth 335], printed in the workshop of Thomas Way. Courtesy of the Boston Public Library; Stein-Mason Studio photograph.

7.6. Bolton Brown, *Sifting Shadows*, 1916. Lithograph from stone; 15½ × 11¾ in. [Brown 54], printed by the artist. Courtesy of the University Art Collections, Syracuse University.

7.7. Joseph Pennell, *Brooklyn Docks in Snow,* 1923. Transfer lithograph; 8⅛ × 10⅞ in. [Wuerth 620], printed by Bolton Brown. Courtesy of Tamarind Institute, University of New Mexico.

7.8. Bolton Brown, *Rustic Bridge*, 1920. Lithograph; 13 × 16¾ in., inscribed (in the stone): "Drawn on stone from nature" [Brown 260], printed by the artist. Courtesy of the University of New Mexico Art Museum.

Notes

1. The record of the relationship between Pennell and Brown during the years in which they both worked in New York is incomplete and unbalanced. Though Pennell seldom mentioned Brown in his published writings (most of which predated Brown's first work in lithography), Brown wrote frequently of Pennell, often in vitriolic terms. See Bolton Brown, "My Ten Years in Lithography," *Tamarind Papers* 5 (1981–82):8–25, 36–54; and "Pennellism and the Pennells," *Tamarind Papers* 7 (1984):49–71.

2. Joseph Pennell, *Lithography* (New York: Frederick Keppel & Co., 1912), 5–6.

3. Sickert's letter was published in the *Saturday Review* on 26 December 1896. For an account of the Sickert trial from the perspective of Pennell and Whistler, see Elizabeth Robins Pennell, *The Life of James McNeill Whistler* (London: William Heinemann, 1908), 2:186–92; from the perspective of Brown, see "Pennellism," 50–51.

4. See Brown, "Pennellism," 52.

5. Joseph Pennell was born in Philadelphia on 4 July 1857. His date of birth is often given incorrectly as 1859 or 1860; see Elizabeth Robins Pennell, *Life and Letters of Joseph Pennell* (Boston: Little, Brown & Co., 1929), 1:7–8.

6. Bolton Brown was born in Dresden, New York, on 27 November 1864.

7. For further information on Brown's life and career see Clinton Adams, *American Lithographers, 1900–1960: The Artists and Their Printers* (Albuquerque: University of New Mexico Press, 1983); and "Bolton Brown, Artist-Lithographer," in *Prints and Printmakers of New York State, 1825–1940;* ed. David Tatham (Syracuse: Syracuse University Press, 1986).

8. Louis A. Wuerth, *Catalogue of the Lithographs of Joseph Pennell* (Boston: Little, Brown & Co., 1931), 620. The date of this lithograph is established by the account of the "lithographic evening" published in the *New York Times*, April 24, 1926, pp. 1, 6.

9. *New York Times*, 24 April 1926, pp. 1, 6.

10. Ibid., p. 16.

11. Dorothy Grafly, "A Pennell Memorial Meeting, Philadelphia, May 18," *American Magazine of Art* 17 (1926):370.

12. *New York Times*, 2 May 1926, p. IX/8, and 9 May 1926, p. IV/14.

13. Leila Mechlin, "Joseph Pennell Memorial Exhibition in the Library of Congress," *American Magazine of Art* 18 (1927):519.

14. Lorado Taft, quoted in the *New York Times*, 25 April 1926, p. 14.

15. C. Powell Minnigerode, director of the Corcoran Gallery of Art, quoted by Dorothy Grafly, "Pennell Memorial Meeting," 371.

16. Robert Underwood Johnson, secretary of the American Academy of Arts and Letters, quoted in the *New York Times*, 24 April 1926, p. 6.

17. William M. Ivins, Jr., "Joseph Pennell," *Bulletin of the Metropolitan Museum of Art* 21.11 (November 1926):252.

18. Una Johnson, *American Prints and Printmakers* (Garden City, N.Y.: Doubleday & Co., 1980), 2.

19. James Watrous, *A Century of American Printmaking, 1880–1980* (Madison: University of Wisconsin Press, 1983), 43.

20. Royal Cortissoz, quoted in "Joseph Pennell," *Art Digest* 4 (mid-December 1929):24.

21. Carl Zigrosser, *A World of Art and Museums* (Philadelphia: Art Alliance Press, 1975), 18–19.

22. J. Bertram Lippincott, quoted by Dorothy Grafly, "Pennell Memorial Meeting," 371–72.

23. Elizabeth Robins Pennell, *Life and Letters,* 2:279.

24. Ibid., 1:viii–ix.

25. Bolton Brown to David Starr Jordan, president of Stanford University, January 1900. Stanford University Archives, David Starr Jordan Papers, SC58, 14–15.

26. Bolton Brown, "My Ten Years in Lithography," *Tamarind Papers* 5 (1981–82):39.

27. Brown most fully set forth his views on art education in an article, "What Should An Art School Be," *Overland,* 2d ser., 19 (March 1892):301–17.

28. Steve Roper, *The Climber's Guide to the High Sierra* (San Francisco: Sierra Club Books, 1976).

29. John Taylor Arms, "Bolton Brown: The Artist and the Man," in *Catalogue of Lithographs by Bolton Brown* (New York: Kleeman Galleries, 1938), unpaged.

30. Brown, "My Ten Years," 46, 52.

31. Brown writes: "In 1929, at the Art Institute of Chicago, I gave the Scammon Lectures. . . . The talks I gave were . . . stenographically taken down, so that I know what I really did say, and, as already remarked, I said what I am saying now about the question of transfers and the deceptiveness of calling them lithographs, and the part the Pennell book played in getting the public to use this name." (Bolton Brown, "Pennellism and the Pennells," *Tamarind Papers* 7 [1984]:68.)

32. Ibid., 58, 57.

33. For an account of Brown's difficulties in securing a publisher, see "My Ten Years," 45–46.

34. Pennell's Scammon Lectures were published under the title *The Graphic Arts, Modern Men and Modern Methods* (Chicago: University of Chicago Press, 1921).

35. Brown, "My Ten Years," 51.

36. The manuscript of "Lithography Since Whistler," which remained unpublished at Brown's death, is now in the John Taylor Arms Collection, Bryn Mawr College Library. Two chapters were later published in *Tamarind Papers* (see note 1). See Adams, *American Lithographers,* 46, n. 170.

37. Although in print Pennell projected an air of total authority, he is reported by Burr Miller to have confessed to his father, the printer George C. Miller, "You know damn well I don't know a thing about lithography!" (See Adams, *American Lithographers,* 49.) Brown alleges that the English lithographer Francis Ernest Jackson once said, "Joe Pennell knows nothing whatever about [lithography], all he knows he learned standing by my press." (Brown, "My Ten Years," 9.)

38. Alois Senefelder, *A Complete Course of Lithography* (London: 1819; reprinted in facsimile, New York: Da Capo Press, 1977), 256–57.

39. Nicholas Smale, "Whistler and Transfer Lithography," *Tamarind Papers* 7 (Fall 1984):72–83. Smale comments further on the points at issue between Brown and Pennell, particularly as they

relate to Whistler's transfer lithographs, in "Brown, Pennell, and Whistler: Eradicating Errors and Presenting a Non-Partisan View," *Tamarind Papers* 8 (1985):68–70.

40. Joseph Pennell, "The Truth about Lithography," *Studio* 16 (1889):38.

41. Brown, "Pennellism," 52.

42. Ibid., pp. 51, 69.

43. Smale, "Whistler and Transfer Lithography," 72.

8

The Etchings of Ernest Roth and André Smith

ELTON W. HALL

During the last quarter of the nineteenth century a powerful movement to introduce etching as an artistic medium took place in this country. Many capable artists, working primarily in New York City, produced a substantial body of meritorious work which is now recognized as significant in the history of art in America.[1] Unfortunately, the public demand for etchings became so intense that in order to satisfy it a vast quantity of pictorial junk was produced by hacks. These potboilers diluted and obscured the honest efforts of serious artists, who soon abandoned etching. The medium was largely neglected for another two decades.

The lamp was not completely extinguished, however. Joseph Pennell had made a beginning before the end of the first period, although he spent most of the dark ages in Europe. Charles F. W. Mielatz produced some notable New York City scenes in the 1890s. James D. Smillie, one of the leaders of the first generation, taught younger students who carried on in the next. In the early years of this century the interest in etching began to pick up some momentum again. Ernest D. Roth and Troy Kinney published their first prints in 1905, the year that John Sloan began his series "New York City Life." In 1913 the Association of American Etchers was founded.[2] The Panama Pacific Exposition, which took place in San Francisco in 1915, included a large group of American prints. André Smith took the Gold Medal for etching, and Ernest Roth won the Silver Medal for etching (as well as a bronze medal for painting). That year John Taylor Arms, Childe Hassam, Arthur Heintzelman, Edward Hopper, and Martin Lewis all began to produce and publish etchings. In 1916 the Brooklyn So-

177

ciety of Etchers held its first exhibition, and both André Smith and Ernest Roth participated. Early the next year the Painter-Gravers of America was founded. The twenty-nine charter members included Ernest Roth, with André Smith and nine others joining within the first year.

Among these etchers were several who had been trained as architects or made architecture and city life their special subjects. These included Arms, Mielatz, Roth, and Smith. Later Samuel Chamberlain, Frederick G. Hall, Donald Shaw McLaughlan, Louis Orr, and Louis Rosenberg would join the ranks. Of this group Ernest David Roth and André Smith will be the subject of this chapter, because their work was remarkably similar at least in their early stages, they were particularly good friends, and they were both known to me.

Ernest Roth (Fig. 8.1) was the older of the two. Born in Stuttgart, Germany, in 1879, he came to New York at age five. His artistic training took place at the National Academy of Design and the Pennsylvania Academy of the Fine Arts. In 1905 Roth went to Italy where he produced in Venice what were to be his first published plates. Little is known of his early life. He did not write many letters and was said to have been very shy. His signed and dated plates are as good a record of his movements as may be found.

Frank Jewett Mather, Jr., described meeting Roth in Florence about 1907. Mather was obviously quite impressed with the young artist, for he wrote of the "rigorous fidelity of his portraiture of places we loved and the patient enthusiasm with which he had enmeshed the very spirit of the two cities" (Venice and Florence) (Fig. 8.2).[3] Roth was a meticulous craftsman devoted to exact renderings of the architectural subjects he chose. Mather recalls suggesting to Roth that he make use of "the usual syncopations and readjustments practiced by sketchers." Roth replied that he would leave things out after he was sure he could put them in.[4] Roth was, in fact, able to leave out a good deal; a good example is his *From the Punta, Venice* of 1907, which is much more in the style of Whistler or Haden than *Ponte Vecchio*.[5] Fortunately, Roth's devotion to detail did not give his prints the labored look that they might have had in less sensitive hands, but with the passage of time it has enhanced the documentary value of the prints, for they preserve a good deal of the physical appearance of the subjects as well as Roth's vision of them.

While Ernest Roth was working in Italy, another young artist was coming along in Connecticut. André Smith was trying his hand at etching, with landscape his principal subject. Within a few years his path would cross that of Ernest Roth, and they would become lifelong friends.

8.1. Keith Shaw Williams, *Ernest Roth*, 1941. Etching; 8 × 9¾ in. Author's collection.

8.2. Ernest D. Roth, *Ponte Vecchio, Evening, Florence,* 1906. Etching; 9⅜ × 9 in. Author's collection.

André Smith's father was in the export business and had gone out to Hong Kong on business, where André was born on December 31, 1880. In 1887 the family moved to Germany, where André's father soon died. His mother brought her children to the United States, living in Boston from 1890 to 1893 and then in New York. André attended Columbia Grammar School before going to Cornell University, where he earned a bachelor of architecture degree in 1902 and a master of science degree in architecture in 1904.[6]

As an etcher, André Smith was self-taught. He is said to have begun in high school and continued at Cornell.[7] His earliest known dated plate is entitled *Apple Trees, Pine Orchard,* done in 1908.[8] It is a modest effort showing the corner of a barn, two trees, some open space, and a distant wood. There appear to be three bites and a considerable plate tone. Had this been as far as Smith went, he would have remained in the ranks of the large number of amateur etchers who have produced vast quantities of pleasant but undistinguished prints ever since the revival of the 1880s. But André Smith always had his eye on the horizon. In *The Thimble Islands* of 1910 (Fig. 8.3) his drawing and technique have markedly improved. His lines are clear and crisp, his drawing is more restrained, he is not afraid of a large, open area, and the plate is wiped much cleaner, thereby avoiding the muddy look of his earlier efforts. This may have been achieved through his study of the old and modern masters who inspired him "to strive for proficiency in an art which I consider above all the most direct and expressive."[9] Through search and experimentation he gradually developed the ability to make the peculiar qualities of etching serve his purpose. By 1914 he had produced over fifty plates.[10]

From these two very different entrances to the world of etchings, André Smith and Ernest Roth developed very similar styles. According to their mutual friend, Frank Besedick, they met in the architectural office shared by Rob Dunbar and Sid Ross where Smith went to work following his graduation from Cornell. In 1913 they both produced plates in San Gimignano, Italy.[11] Possibly they were together on that occasion. The following year each made an etching of the Cathedral of St. Pierre in Beauvais, France (Figs. 8.4 and 8.5). The two prints are remarkably similar in technique and treatment of the subject. The essential architectural elements are delicately rendered with no attempt to be tricky or smite the viewer with a dramatic effect. The restraint exercised by each artist is evident in the large areas of open space and the minimal use of line. One noticeable difference is that the streets in Smith's plate are teeming with people going about their business, while Roth's print shows only a few vague figures in the distance. Among the generalizations that might be made about the

8.3. J. André Smith, *The Thimble Islands*, 1910. Etching; 5½ × 7½ in. Author's collection.

oeuvres of these two artists is that Smith's prints tend to be more populous than Roth's. While this may reflect Roth's shyness and Smith's gregariousness, it also may be the result of their methods of working, which is discussed below.

Apparently Ernest Roth concentrated on painting in 1915, for the catalogue of his plates lists none for that year, one in 1916, one in 1918, and nothing more until 1921, when he returned to printmaking. Meanwhile, André Smith was constantly probing. A letter from Smith to Roth of July 31, 1915, comments: "It is true that I myself have had some idea of applying European speed principles to American scenery, but my efforts have so far been quite in vain. I have but few sketches and a number of experimental plates, chiefly in drypoint, to my credit or discredit, I'm not sure which."[12]

Another letter, undated but probably from about the same time states: "I am etching—trying to do things that no sane etcher would attempt. At any rate they interest me, are distinctly American and if the time and copper are wasted it's not the first time it's happened. I'm getting into a regular habit of spending time and copper, and I only hope that some day I'll get paid back with at least one good plate."[13]

These letters indicate Smith's attitude towards his work, which is confirmed by his productivity during the succeeding twenty years. He worked for the stimulation and satisfaction that his accomplishments brought him rather than to please others, particularly the customers. Nor was he content to continue indefinitely in the same style; he was always searching.

Other letters from Smith to Roth's wife, Elizabeth, indicate that he had a good sense of humor. Apparently Roth was not much of a correspondent, so Smith would forward news of their progress when they were traveling together. In an undated letter Smith describes Roth's painting: "Ernest surprised me by pronouncing several of his canvases finished which I feared might need at least one or two more coats of paint." He further describes Roth's bearing while painting:

For a man who is enjoying himself while painting, he certainly does have the most all-awful time of it, groaning and sighing under the strain of it and yet enjoying every stroke of it! And between sweatings of happy blood over his paintings he also is having a splendidly awful time making a few pencil drawings. He is making three drawings of the same subject with the hope that one of them will be the one he really wants. This one he will etch. The rest of them, I suppose, will go into that vast storage space of unfinished masterpieces that all of us artists have.

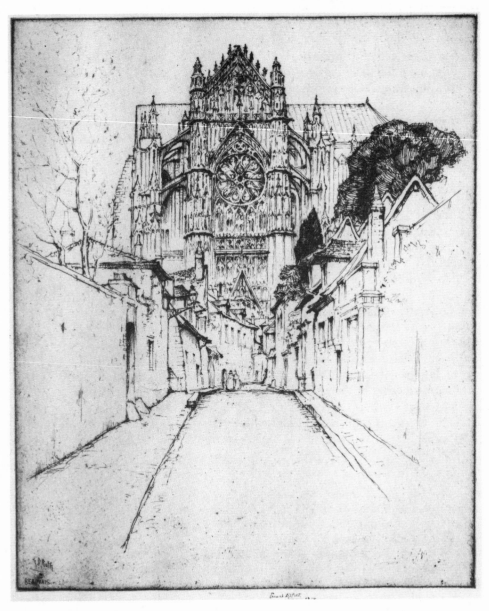

8.4. Ernest D. Roth, *St. Pierre, Beauvais*, 1914. Etching; 10⅜ × 8⅝ in. Author's collection.

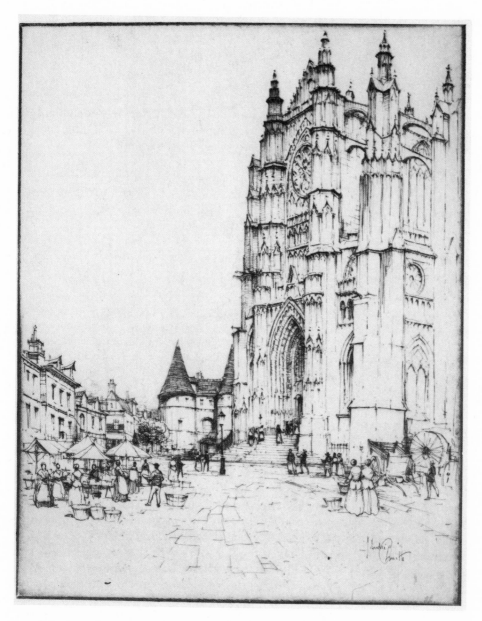

8.5. J. André Smith, *The Cathedral at Beauvais*, 1914. 9½ × 7½ in. Author's collection.

In another communication to Elizabeth Roth, Smith made a cartoon of Mrs. Roth decorating hatboxes as a headpiece to a rude poem. In a message written on the same sheet, he says that he deplores the disappearance of the good old insulting valentines of our childhood days. These letters, all of which are illustrated, show Smith's ability to make mischief.[14]

When World War I broke out, the etching trips to Europe were curtailed. Smith joined an officer training program in the Army and in September 1917 was commissioned a first lieutenant in Company B of the 40th Engineers, a camouflage unit. Early the next year he was chosen as one of a group of eight artists to proceed to the front with the American Expeditionary Forces for the purpose of sketching the action. The familiar names of Belleau Wood and Chateau Thierry appear among his drawings. He was involved in the battles of Champagne-Marne, Marne-Aisne, Saint-Mihiel, and Meuse-Argonne. His last duty was a commission to design the Distinguished Service Cross.

One hundred of his drawings with accompanying descriptions were published in a book entitled *In France with the American Expeditionary Forces*. In his Foreword Smith described the various ways that war can be seen:

> War posed for me in the attitude of a very deliberate worker who goes about his task of fighting in a methodical and thorough manner. If the picture of war which the sum total of my drawings shows has any virtue of truth or novelty, it is in this respect: it shows war the business man, instead of war, the warrior. It is an unsensational record of things actually seen, and in almost every instance drawn, as the saying is, "on the spot."[15]

A number of the drawings provided subjects for etchings.

While André Smith was in France, Roth stayed at home. He produced two prints during the war years, both American subjects. *The Wheelwright Shop, New Rochelle* (Fig. 8.6) is one of them. This print is more in the Whistler-Haden tradition than Roth's earlier Italian architectural subjects. With the wagon in the foreground lightly sketched in and a series of compositional devices, including planks and tree branches, leading the eye to the heavily bitten house, a strong focus is the result. Unfortunately, a few odd scratches in the foreground mar the plate by distracting the eye to an area where there is nothing to see. With the disappearance of the wheelwright, this print takes on the additional dimension of an historical record as well as that of a pleasing picture.

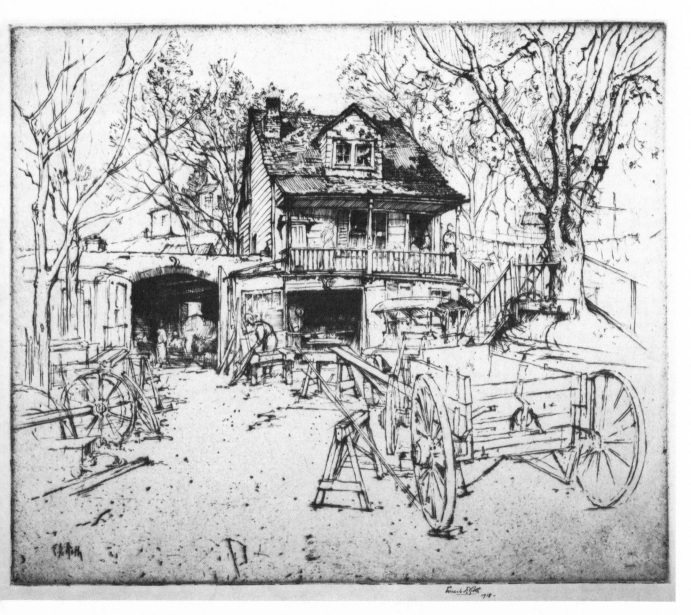

8.6. Ernest D. Roth, *The Wheelwright Shop, New Rochelle*, 1918. Etching; 10 ×
12 in. Author's collection.

When the war was over, Roth and Smith again went abroad, this time to Spain. Sixteen plates of Spanish subjects constitute Roth's published plates for 1921. Among Smith's prints may be found scenes in Segovia, Toledo, and Cuenca, where they traveled that year.

André Smith had not come through the war unscathed. While learning to be a soldier at Plattsburgh, N.Y., back in 1917, he had injured his leg. It never completely healed, and in 1925 it finally had to be amputated. His recovery was long and complicated, involving additional operations in an attempt to relieve excruciating pain. For the rest of his life he was to be troubled by phantom pains in the leg he no longer hand. During his convalescence in Pine Orchard, Connecticut, he made friends with a young man named Attilio J. Banca, who came to work for him and became his lifelong friend and assistant. Banca joined Smith and Roth on their travels abroad, and was given the nickname "Duke" by Smith, who had also dubbed Ernest Roth "Pronto."

One of Roth's two etchings of 1926 was *Independence Hall, Philadelphia*.[16] It is a large plate (14 × 11 in.) and exemplifies Roth's mature style at its best, being characterized by a strong composition and an economical, expressive use of line. That same year André Smith made a compelling etching called *The Bridge House* (Fig. 8.7). During his year in France with the American Expeditionary Forces, Smith had sketched innumerable buildings of every type. No doubt inspired by his architectural training, he developed a feeling for them and a way of seeing them clearly visible in *The Bridge House*. There are signs that Smith is about to follow a different path than Roth. The plate is much more heavily bitten than most of Smith's earlier work. There is a dark and mysterious feeling about it not previously seen.

A sharper turn from the older style is evident in *The Dark Portal* (Fig. 8.8) of 1928. While maintaining a strong architectural theme, the specific architectural detail has been suppressed. The silhouette of the gondola and bridge in the right background identify the setting as a Venetian canal, but whether or not it is based on a particular building is clearly irrelevant to the intent of the artist. He is getting away from a literal rendering of the subject to his subjective perception of it.

Attilio Banca owned a piece of land on the marsh in Stony Creek, Connecticut. In 1929 he and André Smith decided to build a studio there, and the following year they moved in, naming the studio Marsh House. In 1938, when Banca married, an addition was put on, and during succeeding years the home was expanded to a group of apartments, studios, and gardens. Smith designed

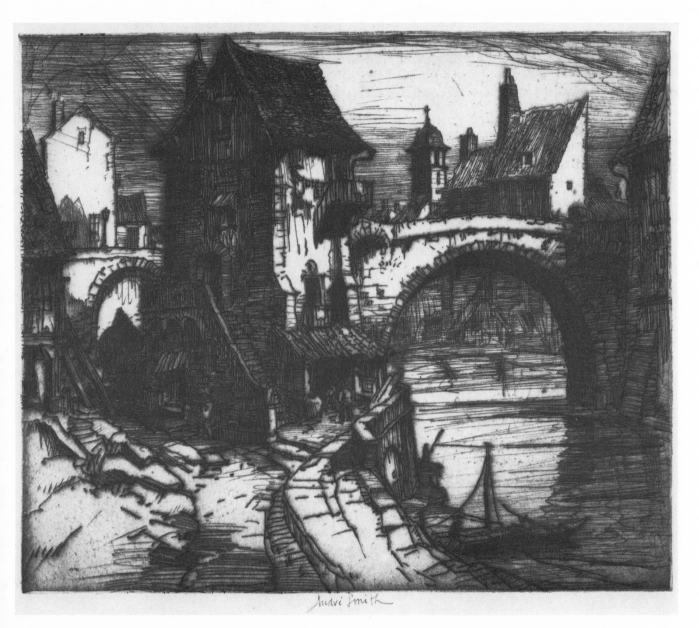

8.7. J. André Smith, *The Bridge House,* 1926. Etching; 7⅝ × 9 in. Author's collection.

8.8. J. André Smith, *The Dark Portal*, 1928. Etching; 9½ × 5½ in. Author's collection.

the house himself in a fantastic and eclectic style, the likes of which have probably never been seen elsewhere in New England. He decorated the inside with murals and the outside with relief sculpture carved in wet cement.

By the 1930s Christian images became increasingly prominent in his work. His earlier depiction of ecclesiastical buildings was probably prompted more by architectural than theological concerns. Although he never attended church regularly, he read the Bible daily and was, in fact, a very religious man.[17] His etching *Man of Sorrows* (Fig. 8.9) is suggestive of this. The strong, deeply bitten lines, diagonals, flat surfaces of the visage, and jagged lines of the crown of thorns produce a powerful image. Smith employed a similar style for landscapes and buildings, but these, perhaps because they lack the literary and theological associations, do not seem to have the impact of this print. At about the same time he produced some more abstract, cubist etchings on which he applied a coarse aquatint, one of which is entitled *Star Dust*,[18] but that is a style with which he experimented more in oil or watercolor than etching.

Among Smith's last etchings is *Consider the Lilies* (Fig. 8.10) of 1934. It is a fantastic image. A group of people are gathered in a junk-strewn lot surrounded by run-down houses and smoke-belching chimneys. None of them appears to be communicating with any other, each seeming intent on his or her own thoughts. One man is conversing with a dog; another is seated backwards on a donkey while contemplating a cross; a third, who is equipped with angel's wings, is lying on the ground reading a newspaper with headlines announcing murder. A woman holding a child is so placed that the head of an oil drum suggests a halo. The scene is loaded with other iconographic and symbolic items, some of which are quite obscure. Above all is a figure of Christ with outstretched arms between two utility poles, a device which Smith frequently used as an obvious symbol for the cross. The title, which was probably an afterthought, is taken from Christ's sermon on the mount: "Consider the lilies of the field, how they grow; they toil not, neither do they spin: and yet I say unto you, that even Solomon in all his glory was not arrayed like one of these" (Matt. 6. 27–38).

Smith further developed this kind of depiction of fantastic images in a series of watercolors produced in the spring of 1936 and published in his book, *Art and the Subconscious*.[19] The method of the drawings was to empty the mind of all conscious thought and then draw whatever suggested itself.

André Smith's last etching was made in 1935. Failing eyesight caused him to abandon the delicate medium for others which required less intense scrutiny.

8.9. J. André Smith, *Man of Sorrows*, 1930. Etching; 7 × 5½ in. Author's collection.

8.10. J. André Smith, *Consider the Lilies*, 1934. Etching; 8⅞ × 11⅝ in. Author's collection.

The last quarter century of his life was devoted to painting in oil and watercolor and to sculpture in cement.

Meanwhile, from about 1910 onward Ernest Roth had become an increasingly prominent and important member of the etching world. He continued in much the same style as he always had, concentrating on Spanish, French, and Italian subjects. He was active in many artists' and etchers' societies and frequently served on juries. He regularly took prizes at competitions, and his work was acquired for the permanent collections of many major art museums in the U.S. and in Europe. It was reported in the November 1927 issue of *The American Magazine of Art* that two etchings by Americans had been purchased for the Uffizi Gallery from *La Seconda Espositione Internationale Dell'Incisione Moderna* held in Florence that summer. They were *Ponte Vecchio* by Roth and *La Maison Des Ambassadeurs* by Frederick G. Hall. In 1928 Roth was elected a National Academician.

The role of the dealer was most important in the development of American etching. Frederick Keppel, long an articulate proponent of these artists, was Roth's dealer in New York. There were regular exhibitions of Roth's work at Keppel's gallery. Goodspeed's in Boston and galleries in other major American cities also handled his prints. Because Roth was more dependent on sales than was André Smith, he was probably more conservative about making major aesthetic changes. His dealers had undoubtedly cultivated a good clientele who liked what Roth produced. For example, Charles Childs recalled in a conversation that when he was working in Goodspeed's print department in 1921, Roth's etching *The Cliff Dwellers, Cuenca* arrived. Fifteen impressions were sold in a week. Although such customers would probably not welcome a radical change, it was Roth's method of working that was probably most responsible for his constancy of style. While André Smith had great imagination and a strong visual memory, and the ability to draw from either as well as from direct observation, Roth could only do the last. An incident on one of his trips to Europe illustrates this. Roth needed a tray for biting his plates. He mentioned his need to Smith, who suggested a particular store where he could buy what he needed. Roth replied that he did not know how to ask for the tray because he did not know the word for it in French. Smith told him to draw a picture of it, and the shopkeeper would know what was wanted. Roth then asked how he could draw it if he didn't

have one in front of him to draw.[20] It is amazing to think that an artist who could render a Gothic façade as skillfully as Roth couldn't draw the simplest thing if he wasn't looking at it. This idiosyncrasy would also explain the lack of people in his prints, since they might not stay put long enough to be drawn.

Roth made careful preliminary sketches of his subject. When working up a design for a plate, he would do a careful drawing of the foreground and a separate drawing of the background.[21] He then combined the two drawings in a final composite from which the plate was drawn. A photograph in the collection of the Mattatuck Museum in Waterbury, Connecticut, which holds a major collection of Roth prints and papers, shows the artist at his drawing table with screened light coming over his left side working on a grounded plate. Propped in front of him and facing in the opposite direction is his final drawing, which he sees and copies from a mirror image.

Roth's advancement in his art took the form of a search for perfection rather than a change in vision. He was a master printer, and, in addition to his own work, he printed for others, most notably John Sloan. A New York dealer obtained four of Whistler's plates and commissioned Roth to produce some posthumous impressions.[22]

An important element in printing an etching is use of a suitable paper. Artists and printers used to pursue, collect, and hoard paper with a zeal unsurpassed by the collectors of the finished products. Joseph Pennell was quite dogmatic about it. He bluntly stated that "the only paper on which etchings can be really properly printed must be one hundred years old." The paper he sought was to be easily and uniformly dampened; it should not be brittle nor tear nor crack; it should take the ink and retain it on the surface without spreading or sinking in. Most important was good color.[23]

The careful printer chose a paper that would enhance the result he was trying to achieve. The importance of it can be readily seen by comparing impressions of the same plate on different papers. Few etchers were more meticulous in this matter than Ernest Roth. During his trips abroad he searched for handmade paper, both new and old. One of his sources was old account books with blank pages at the end. Another source was the small paper mills that used to operate in northern Italy.[24]

In this country the discerning were willing to put themselves to considerable inconvenience in the pursuit of paper. In correspondence between the etchers Richard Bishop and James McBey, McBey describes efforts to obtain pa-

per from Dard Hunter's mill at Lime Rock, Pennsylvania, in 1941. There were many setbacks and after much effort they were only able to obtain a portion of what they sought. Ernest Roth was a part of the expedition.[25]

By 1929, when Roth became the subject of the first volume of the American Etchers Series, the catalogue of his plates comprised 108 titles, of which only 3 were American. In 1935 he did a series of plates showing the waterfront at the lower end of Manhattan. *Downtown New York, Financial Towers* (Fig. 8.11) is representative of this series. It shows the wharves, tugs, and barges in the foreground. At the head of the wharf is a row of old five-story brick buildings representative of nineteenth-century New York. Beyond are the skyscrapers—then considered enormous—which were dramatically changing the appearance of the city. The area is about at Coenties Slip at the south end of Pearl Street, only a block from Fraunces Tavern. Much of this scene would be unrecognizable today. Coenties Slip is now a block from the waterfront, with Franklin D. Roosevelt Drive forming a substantial barrier. New bank buildings which dwarf those in Roth's etching have altered the scene almost beyond recognition. It is gratifying that Roth applied his skill to a few scenes of the island that had been his principal residence for much of his career. His prints contain a blend of history, power, and progress of a great city which Roth has clearly understood and presented in this series.

The most impressive of all of the New York prints is *Queensboro Bridge* (Fig. 8.12). The massive form of the bridge rips into the middle of the picture like a harpoon. In contrast to a single tree on an empty riverbank in the foreground and the deceptively tranquil appearance of the East River are the tugs, barges, cranes, and oil tanks which suggest industrial power. More subdued are the skyscrapers in the background which suggest financial power. This is an eloquent statement about the significance of New York.

The last series of etchings Roth made comprised sixteen or more views of medical schools in this country and abroad, executed between 1945 and 1947. There must have been a commission of some sort that caused him to embark on the project, for it seems incongruous with his earlier projects. Possibly the Columbia University series and the University of Pennsylvania set done in 1938 were the inspiration for the medical schools. A representative example of the series is *New York Hospital and the Cornell Medical Center* (Figs. 8.13–8.15). The preliminary pencil study and the first and fifth states are shown here to indicate Roth's meticulous workmanship. Perhaps in the final state it is overworked. The

8.11. Ernest D. Roth, *Downtown New York, Financial Towers*, 1935. Etching; 12 × 15⅛ in. Courtesy of the Mattatuck Museum.

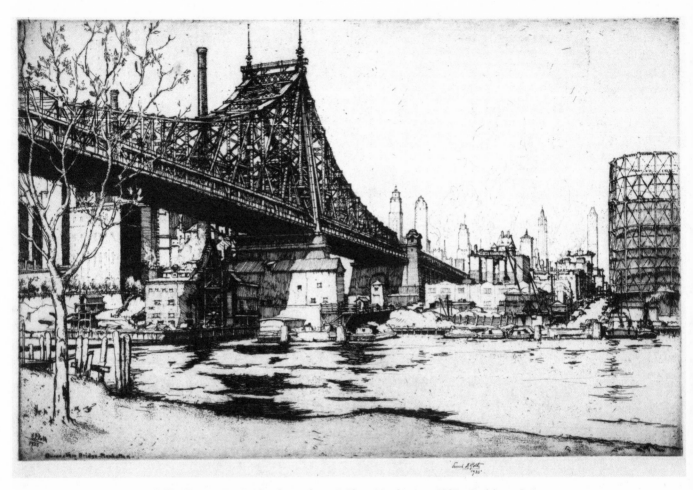

8.12. Ernest D. Roth, *Queensboro Bridge, Manhattan*, 1935. Etching; 9⅝ × 14⅞ in. Courtesy of the Mattatuck Museum.

picture is more of an illustration than a pictorial statement. It certainly lacks the impact of *Queensboro Bridge*, and the same may be said for most of the medical school prints.

Throughout his career Roth devoted himself to the pursuit of excellence in that branch of the art which he had made his own. In articles and essays that appeared about him during his lifetime the words *integrity, honesty,* and *humility* often appear. His service to his fellow etchers and to the organizations that supported them is also mentioned. The unfortunate side of such singleness of purpose is that when public taste changes, one is dropped rather abruptly. The interest in large European color prints that came along after World War II diverted almost all interest in Roth's work. It is heartbreaking for one who held the respect and admiration of a generation of print collectors to see his life's work neglected at the end.

When I met Ernest Roth in 1963, he was a widower living alone on Umpawaug Road in Redding, Connecticut. He was about eighty-four years old and obviously delighted to have a young person come along who was seriously interested in his work. His house, which he and his wife had long used as an escape from New York City, was loaded with pictures. He commented that he would sometimes prop a few canvasses on his front lawn so that passersby would know that an artist lived there. He also told me that Leonard Bernstein lived nearby and that often people would stop and ask him for directions to the Bernstein home. It pleased him to learn that one day someone had stopped at the Bernsteins' to ask the way to the home of the artist, Ernest Roth.

Roth never really understood what André Smith was up to. Considering his own style and approach to his work, it is not at all surprising. I once remarked about the variety of styles in which Smith had worked, to which Roth simply replied, "André went crazy."

Happily, Ernest Roth's life ended on a positive note. The Mattatuck Museum held a major retrospective exhibition of his paintings, prints, and drawings in July 1964. There was considerable public interest in the work, and many pictures were sold. Roth died on August 30, 1964.

Although this does not pretend to be more than an introduction to the prints of Smith and Roth, both of whom were painters as well, one more aspect of André Smith's career ought to be mentioned, because it reveals a good deal about him and helps to explain why his work, which had been so close to Roth's, diverged so far. Since 1928 Smith had been spending winters in Winter Park, Florida, with his friend, Duke Banca. They bought some land in nearby Maitland, where they soon built a house and studio. They met the actress Annie Russell, for whom Smith designed some stage sets, and through Miss Russell

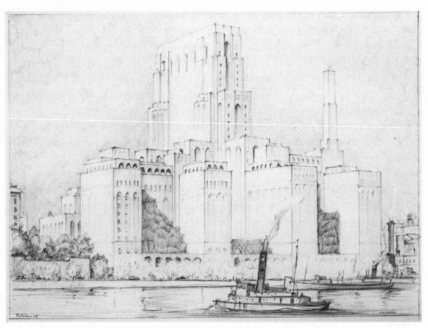

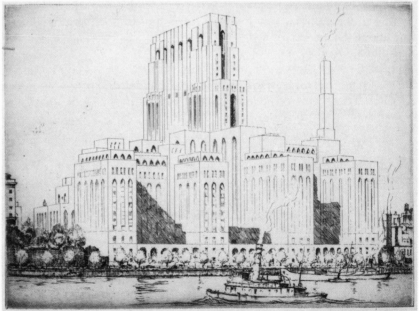

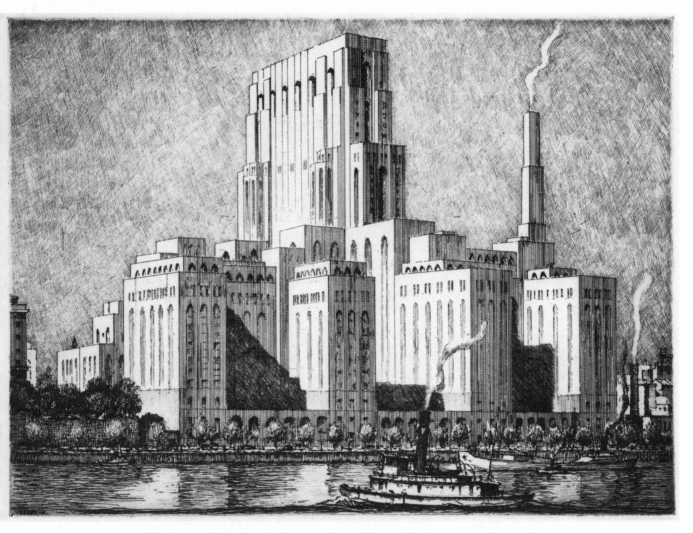

8.15. Ernest D. Roth, *New York Hospital and Cornell Medical Center*, 1945. Etching; fifth (final) state, 8 × 11⅛ in. Courtesy of the Mattatuck Museum.

8.13. (*Opposite, top*) Ernest D. Roth, *New York Hospital and Cornell Medical Center*, 1945. Pencil on paper; 8 × 11⅛ in. Courtesy of the Mattatuck Museum.

8.14. (*Opposite, bottom*) Ernest D. Roth, *New York Hospital and Cornell Medical Center*, 1945. Etching; first state, 8 × 11⅛ in. Courtesy of the Mattatuck Museum.

they were introduced to Mary Curtis Bok (later Mrs. Ephrem Zimbalist). Mrs. Bok took an interest in André Smith and offered to build him a studio and provide a subvention for his work. The result was the Research Studio, which opened in Maitland in 1937 under Smith's direction. A flyer described its purpose: "The Research Studio is a workplace for painters and sculptors. It has for its purpose the encouragement of American artists toward an adventurous and experimental approach to the art problems of today." Each winter a number of artists were invited to come for four months to work in an "atmosphere creative of work and contemplation" at no cost to themselves other than transportation and materials. A number of capable artists spent winters at the Research Studio, the best known of whom were Charles Prendergast and Milton Avery. The gift was from Mary Curtis Bok, but the idea and its implementation were Smith's. His motto, inscribed in the fabric of the studio was, "An artist's job is to explore, to announce new visions, and open new doors." That explains his constant searching and probing within and without himself. He would try anything. His oeuvre is diverse in medium, style, and subject. He didn't much care for public opinion, he did not become involved with organizations the way Ernest Roth did, and he was not particularly interested in whether anyone bought his work. He continued working and experimenting almost to his death, which occurred on March 3, 1959.

André Smith and Ernest Roth were only two members of a large group of printmakers who enjoyed the attention of a considerable public during the first three decades of this century. As public taste and enthusiasm inevitably shift from one thing to another, many such artists go into long periods of neglect. But if they ever produced anything of real excellence, sooner or later they will be known again. Fortunately much of their work has been preserved in museum collections where it is available for those who wish to seek it out. The discovery of one neglected genius inevitably generates interest in a search for more. Thanks to a number of collectors, curators, and printsellers, there has been a steady growth of interest in this group, and their work is again coming out of storage to provide the pleasure, information, and inspiration for which their creators would have wished.

Notes

1. For an account of these etchers see Elton W. Hall, "R. Swain Gifford and the New York Etching Club," in *Prints and Printmakers of New York State, 1825–1940* (Syracuse: Syracuse University Press, 1986).

2. Richard S. Field, in the exhibition catalogue *American Prints 1900–1950* (New Haven: Yale University Art Gallery, 1983), provides an account of the development of etching at the beginning of the century. The essay with its extensive notes contains a good deal of bibliographical information.

3. Frank Jewett Mather, Jr., "The Etchings of Ernest D. Roth," in *The Print Collectors Quarterly* 1 (October 1911):443.

4. Ibid., 444.

5. The Crafton Collection, Inc., *Ernest Roth*, intro. by Elizabeth Whitmore. Volume 1, *American Etchers*. (New York: T. S. Hutson, 1929).

6. Thomas W. Leavitt, *André Smith*, catalogue of a retrospective exhibition held at the Andrew Dickson White Museum of Art, Cornell University, 1968. The introductory essay contains some biographical information supplied by Attilio J. Banca, Smith's assistant and friend.

7. Leavitt, *André Smith*, 5.

8. An impression is in the collection of the author. Pine Orchard is a village in Bradford, Ct., where Smith lived before moving to Stony Creek.

9. Quoted in a pamphlet by Lena M. McCauley, "J. André Smith, Painter-Etcher" (Chicago: Rouiller's Art Rooms, 1910). (Available on microfilm, Archives of American Art.)

10. J. Nielsen Laurick, "J. André Smith," in *The Print Collectors Quarterly* (April 1914):167.

11. The Roth print is listed in *American Etchers* vol. 1. An impression of the Smith print is in the collection of the Mattatuck Museum, Waterbury, Connecticut.

12. The letter is in the Ernest Roth files, Mattatuck Museum.

13. Mattatuck Museum.

14. In the Roth Collection at the Mattatuck Museum there is, in addition to the illustrated letters, a series of Christmas cards, both etchings and watercolors, which follow the progression of Smith's style.

15. J. André Smith, *In France with the American Expeditionary Forces* (New York: Arthur H. Hahlo, 1919).

16. Illustrated in *American Etchers* vol. 1. An impression is in the Mattatuck Museum.

17. From a conversation with Mrs. Attilio J. Banca.

18. Illustrated in Leavitt, *Smith*, Catalogue No. 37.

19. André Smith, *Art and the Subconscious*, (Maitland, Florida: The Research Studio, 1937).

20. The story was told to the author by Mrs. Attilio J. Banca.

21. Examples of both are in the author's collection. Roth himself described his method.

22. There are printers proofs by Roth from plates by both Sloan and Whistler in the author's collection.

23. Joseph Pennell, *Etchers and Etching*, 4th ed. (New York: The Macmillan Co., 1935), 218.

24. From a conversation between the author and Ernest Roth.

25. The correspondence is in the McBey Correspondence File, Print Department, Boston Public Library.

9

Yankee Printmakers in Mexico, 1900–1950

RICHARD COX

Before 1920 Mexico held little fascination for American artists. Winslow Homer wintered in the Caribbean during the 1890s, and a generation earlier Frederic Church and Martin Heade made trips to South America that resulted in a few notable pictures. But no such memorable painted records of Mexico come to mind. Indeed, most American artists eager for foreign adventure went to Europe, where the curiosities of the various countrysides and their peasant peoples were in close proximity to the academies, museums, and art colonies of the major cities. But during the Great Depression and through the 1940s, many important American artists, not to mention the large numbers whose names will never appear in any art history texts, visited and drew Mexico. Historians have often mentioned the influence of Mexican culture upon American art of the 1925–50 period but have seldom closely analyzed the phenomenon. It is not possible in this short space to examine thoroughly the complex ties between Mexican and American art during this period, but it is possible to discuss in detail the Mexican-scene art of three U.S. printmakers, George Overbury ("Pop") Hart, Howard Cook, and Caroline Durieux, all of whom arrived in Mexico before or at the very beginning of the *yanqui* enthusiasm for that Spanish-speaking culture.

Actually, Americans in general began to take a closer look at Mexico early in this century. From 1908 until World War II the prolonged modern Mexican revolution stirred up a range of American feelings and actions. The 1914 occupation of Veracruz by American Marines and the subsequent intervention of General Pershing's troops into Chihuahua in pursuit of the bandit-revolutionary

Pancho Villa brought passionate protest from John Reed and other Greenwich Village radicals who were enamored with the socialist prospects of the Mexican revolution. Egged on by Mexico-based American business interests, the Republican administrations of the 1920s engaged in a concerted campaign of red-baiting against the new Mexican governments that only ended when Franklin Roosevelt attempted to calm chronic Mexican fears of the Yankee Big Brother with his Good Neighbor Policy. All these political twists and turns served to draw the American public's attention to the land south of the border.[1]

If the politicians vacillated between strong-arming "backward" Mexico and promoting its wish for genuine sovereignty, an increasing number of sympathetic Americans began to paint in their minds a picture of this small, poor country as a preindustrial arcadia, a Tahiti in the Western hemisphere, a gentle society whose spirit had not yet taken leave of the agrarian age. Writers and artists were especially given to such romanticizing. To those bored intellectuals who had endured the hell of Babbitt-infested America, Mexico seemed like a refuge from the insensitive oppressions of the despised business culture; to those suffering the hardships of the terrible Depression, it seemed like a possible haven. Tomorrow and yesterday would intermingle in this untainted, *simpático* land where the tequila flowed freely and it cost next to nothing to live. "South of the border, down Mexico way, I met a señorita ... " the song swelled over the airways. In one of the most memorable scenes of the film *The Treasure of Sierra Madre* (1948), Howard (Walter Huston) retreats from the crazed prospecting of gold to some jungle paradise in an unnamed Mexican village. It was an image and a dream that perhaps summed up an entire generation of American sentimentalizing about Mexico. No matter that the complex and tragic nature of Mexican society was not fully appreciated, or that the bulk of American stories and pictures were mostly clichés wrapped up inside a bundle of myths. Mexico, with its political ferment, colorful history, ongoing exotica, and its hot-blooded, inspired artists, became a beacon for those restive members of the American intelligentsia.[2]

While the majority of American artists who came to Mexico between the two world wars were what we might term tourist-artists, amateurs who probably took a three-week class at San Miguel Allende they had seen advertised in *Mexican Life* or *Saturday Review*,[3] there were a modest number of serious printmakers who left a more thoughtful and penetrating account of the country, especially of Mexico before the full invasion of Yankee artists after 1935. Among them were Hart, Cook, and Durieux.

George Overbury ("Pop") Hart began traveling to Oaxaca and the southernmost sections of Mexico before Diego Rivera and José Clemente Orozco were heated topics of discussion in Greenwich Village saloons, and before the *gringo* visitors had made much headway into the more distant parts of the country. Between 1908 and his death in 1934, Hart frequently traveled about Mexico, as well as in Cuba, Santo Domingo, Haiti, Trinidad, and parts of South America, always searching for interesting subjects and trying to quench some thirst for self-knowledge. He would leave Miami or New Orleans on oil tankers, cattle ships, or banana boats, and he would move within the small countries on trains when possible and mules when necessary.[4]

Hart is one of the most enigmatic of modern American artists. We can consider his Paris and Tahiti self-portrait etchings as revealing composites of his personality: as he imbibes champagne in *Happy Days*, and strums a ukulele in *Spirit of Tahiti* (Fig. 9.1), we see a restless, irreverent *bohème*, who landed in ports on nearly every continent early in this century, drawing and drinking himself to an early grave. But not before he lived life to the fullest. Hart has become one of those legendary American happy wanderers, an American Gauguin, and he himself did nothing to discourage this image in several newspaper interviews he gave late in his career. Stories abound about his lusty behavior in remote corners of the globe.[5] Somehow, he still found time to produce about a hundred prints in diverse media and of glaringly uneven quality, as well as many hundreds of watercolors. Only partly in jest, a writer for the *New York World* claimed in 1927 that "laid end to end, Pop Hart's watercolors, drawings, and etchings would probably measure about three times around the Earth."[6] Historians and collectors are only now beginning to appreciate fully the technical inventiveness of his best prints. For decades Pop Hart fell into comparative oblivion, probably a victim of his own vagabond habits as well as the elusive character of his prints and watercolors. As late as the 1960s he was often thought of as a folk artist, and he was even confused with the pop artists of that decade.[7] What were the historians to make of him? Carl Zigrosser occasionally showed his prints at the Weyhe Gallery in the 1920s, and Hart was president of the Brooklyn Society of Etchers for a time, but otherwise the facts are skimpy. He might show up at a party in the Croton-on-Hudson colony or at another artist's studio in lower Manhattan, but soon he would be off on one of his trips.

It is certain that the fundamental core of Hart's art formed early, possibly as soon as 1905, when he began painting shortly after his three-year visit to

9.1. George Overbury "Pop" Hart, *Spirit of Tahiti*, n.d. Drypoint, etching, roulette, and sandpaper ground; 7³⁄₁₆ × 10⁷⁄₈. Courtesy of the University of Iowa Museum of Art.

Tahiti and the Samoa Islands. Over the years he made a modest number of lithographs that were printed in New York by J. E. Rosenthal,[8] but he preferred the intaglio methods—soft ground etchings, mezzotint, roulette, drypoint, aquatint, and monotype—all mixed together in unusual combinations. He would carry plates on his trips, although the actual etching would be done when he returned to the New Jersey shack he had built on the Palisades. He apparently did his own printing. For years he worked primarily in watercolor before he took up printmaking sometime during World War I. Most of the Caribbean prints were made in 1921 and 1922, and many, says Frederick James Gregg, may have been copies of earlier watercolors.[9] The Mexico-scene prints were based on various journeys he made between 1925 and 1934. The small city of Oaxaca and its surrounding tropical hills and beaches were his favorite haunts.

New Orleans was Hart's favorite stopping-off point to Veracruz and other ports of Latin America. Jules Pascin was his companion several times. Together they explored the Mississippi River north of the old city, listened to jazz, and painted in a garret in the Vieux Carré, the old French section of New Orleans. As George Biddle remembers this pair of bohemian souls: "Pop had immortalized their hangout in the lithograph entitled *Springtime in New Orleans*. On the original proof in bold architectural lettering he traced the words, 'Veau Carre.' Pascin had questioned his orthography. Then, it became 'The Early Morning Razor.' But had razor one or two z's? 'O hell,' said Pop, 'call it "Spring Time in New Orleans."'"[10] By the late 1920s a number of American artists were much taken by Pascin's personality and his gently eroticized art. Alexander Brook, Adolf Dehn, Emil Ganso, and Yasuo Kuniyoski were devoted followers,[11] but Hart's repertoire of steamy subjects and his loose style was fully formed before he and Pascin became traveling and drinking companions.

The satirical, impertinent air of *Springtime in New Orleans* sets the tone for a small number of his Latin American prints. Generally speaking, Hart was too skeptical of human nature to idealize or ennoble the native peasants. Prints such as *The Medicine Man, Salutions, Señor,* and *Awaiting Boats Return* (Fig. 9.2) were out-and-out caricatures. Swollen, misshapen hands, bloated eyes, jagged teeth, and rootlike feet pay little respect to any delicate sensibilities the viewer might possess.[12] They carry Hart's realism uncomfortably close to racial and ethnic stereotyping. Although the lives of the poor in Mexico and the Caribbean were unquestionably hard and cruel in the 1920s,[13] Hart was not trying to set social wrongs right in his satires. His were surface travel impressions like those of the renowned New Orleans adventurer and writer, Lafcadio Hearn; in both there

9.2. George Overbury "Pop" Hart, *Awaiting Boats Return*, n.d. Etching; 4⅞ × 6¹⁵⁄₁₆ in. Courtesy of the University of Iowa Museum of Art.

was little serious interest in the lives of the indigenous Latin American people.[14] Hart was probably never in any one place long enough to understand the people and their customs, and his prints did not make moral appeals and protests in the way that the work of significant satirists such as Honoré Daumier and George Grosz did.

Instead, a quiet, romantic vein runs prominently through the majority of Hart's Latin American prints. His Mexican pictures showing women bringing goats to market, unloading the fishing boats, grinding the corn, and the men playing in small bands or preparing birds for a cockfight are actually as much landscapes as they are narratives. Seldom are they specific anecdotes, individual portraits, or anthropological documents. Hart went to Oaxaca in 1925 and again in later years looking for unspoiled, exotic adventure, the kind of primitive simplicity he remembered from his 1901–4 journey to the South Sea islands, before they became popular. Southern Mexico was to be his new Tahiti, as he explained to his New Orleans friend, Lyle Saxon, in 1926:

> "I thought I'd try old Mexico again. I had been there before and enjoyed it. And I thought that if I looked long enough I'd be able to find a place that was untouched—a place where people still enjoyed themselves and had fun— a place with color and the joy of living. ... And there at the end of the rail way line, I found Oaxaca. And boy! It's a dream of a place; untouched, you know, with old churches and convents, and with dirty streets full of the most fascinating looking people you ever saw. Just as it was a hundred years ago ... those old crumbling houses and mouldering walls, and the ever-moving crowds in the streets with guitars twanging and bells ringing and the people lazy and laughing and making love and fighting ... and all those tropical sounds and smells."[15]

The prints that emerged from these impressions and adventures feature mist-shrouded days and nocturnes where the fusion of the story and the heavy air, accentuated by expressive notes of light, gives off strong poetic, even somnambulent feelings. The Indian peasants of *Días de Fiesta No. 2*, *Market Plaza in Mexico*, *Pig Market, Mexico*, and *Matching, Weighing the Birds*, among others, are shrouded, hooded masses, seen in profile or with their backs turned to us; everyone moves in a slow-motion rhythm. Gone are the raucous behavior, swollen faces, and gargantuan feet of the satirical prints to be replaced by a languid, humid village ambiance. Sometimes, warm thundershowers break through. In

Días de Fiesta, No. 2 (Fig. 9.3), Hart typically blocks off a view of the distance through elliptical drawing and suffused light. A broad, unfinished line and a succession of planes and arcs interrupted by abstract dark masses direct the eye to follow the separate parts and to move rhythmically about the front plane of the picture rather than to grasp it as a whole. The staccato drawing negates any exact or academic description, and diminishes the importance of the narrative. *Baptism,* a print of Haitian origin, is a dance of life as much as an accurate record of a Christian ritual. Human beings and their actions are merely suggested and enveloped in an aura of quiet reverie. Principal characters as well as secondary figures bend and sway in echo of the land, cloud, and water forms. Critics said that while these prints bore "the look of a rough draft"[16] and were put together with more than "a dash of helter skelter,"[17] the style was deceptively crude. For an artist of limited formal training, Hart grew quite sophisticated in his picture making. He learned to "organize his entire composition with an almost classic sense of weights, balances, and space, though Hart probably arrived at these relationships intuitively."[18]

Technically, Hart used the full gamut of tonal values. One admirer, Harry Wickey, said that in some instances "these tones resolve themselves into large textural and tonal masses whose boundaries are strictly defined."[19] He sought out every nuance of black and white, realizing the lovely accidents of nature—the shapes, shadows, forms, and textures that escape the human eye and can only be detected by the sensitive artist. The soft tone of the gray areas, achieved by the soft ground and aquatint technique, has the effect of color and adds warmth to the prints. Occasionally Hart used colored inks, or he would hand-color his prints with hues such as a soft, permeating orange (*Cockfight,* 1925). In such prints, Hart tuned the color to a parallel monochrome in a manner similar to what Michelangelo Antonioni captured in his film *The Red Desert.* Joanne Moser is right when she says that Hart was one of a handful of Americans emphasizing the painterly aspects of the various printmaking methods in the 1920s.[20] As Hart put it: "I got a kick out of them [the pre-1921 etchings] but they didn't satisfy me. I wanted to get a more painter-like quality, to get tones like those of watercolors and paintings. Then I tried making a sandpaper ground on a zinc plate. This gave me some interesting tones. *Chicken Vendor,* and *Boats and Natives,* look as if they had an etched ground, but they were done with sandpaper and drypoint. Many of my friends thought I had done them with aquatint."[21]

9.3. George Overbury "Pop" Hart, *Días de Fiesta, No. 2*, n.d. Soft-ground etching, aquatint, and burnishing; 7⅜ × 9⅜ in. Courtesy of the University of Iowa Museum of Art.

The heavily textured prints evoked a brooding sense of quiet, an elegant beauty, and a nonthreatening environment of humble yet mysterious activities (Figs. 9.4, 9.5). We are moved to speculate on historical influences. In New York museum print collections and through the Brooklyn Society of Etchers, Hart might well have examined Goya's moody prints, Whistler's and Pennell's nocturnes, and the many Symbolist prints of the end of the nineteenth century. The Symbolists' rejection of the industrial, material world in favor of what Robert Rosenblum called "an immaterial realm of reverie, dream, an exploration of unnamable sensations and longings"[22] roughly approximates Hart's attitude as he roamed from one exotic adventure to another in preindustrial corners of the world. Even Hart's early prints of the American East Coast have a dreamlike, ethereal atmosphere that is closer to the printmaking poetry of Arthur B. Davies than to that of New York realist artists John Sloan and George Bellows, with whom he is sometimes compared. A better comparison to an Ash Can School artist is to the brooding, romantic prints of Eugene Higgins. Hart's story line in all his prints hovers between contrivance and documentary realism: he drew real, humble people in plausible surroundings in which he seems to evince a desire to return to the security of a vaguely remembered innocence and purity. To a committed adventurer like Pop Hart, if it came down to a choice between civilization and primitive society, it was no choice at all. He told reporters in late 1926 that he wanted to escape the New York art world, to free himself from "white collars and cups of tea": "If you are going to etch a plate that's worth etching you've got to go off in a corner by yourself and suffer. ... Civilization with steam heated houses, subways and taxicabs is all right as a place for pictures to go to after they're painted, but it will strangle a real live, unbranded artist."[23] His prints offered a curious and resolute retreat from modern urban society. This romantic sentiment in time became the dominant motivating force behind the legions of Yankee artists who crossed the border after 1935.

Mexico and all of Latin America had become a much stronger magnet when Howard Cook and Caroline Durieux arrived South of the Border in the early years of the Great Depression. By then, Americans generally had started to take an interest in Mexico's curiosities, and artists were feeling the tug of the dramatic mural painting developments of that nation. The Mexican art renaissance, coming out of the over-all revolution of the 1915–25 decade, had a major impact on many artists in the U.S. Thomas Hart Benton, John Steuart Curry,

9.4. George Overbury "Pop" Hart, *Grinding Corn*, n.d. Lithograph; 12¾ × 17⅜ in. Courtesy of the University of Iowa Museum of Art.

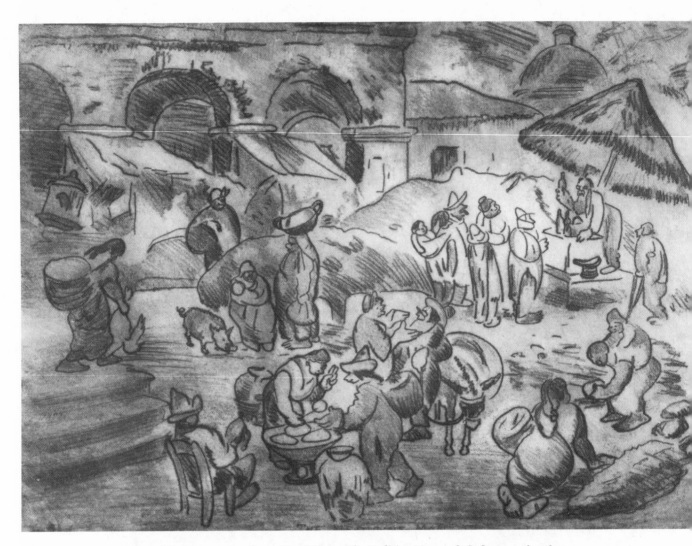

9.5. George Overbury "Pop" Hart, *The Medicine Man*, n.d. Soft-ground etching and aquatint; 9¹⁵⁄₁₆ × 12⅝ in. Author's collection. Courtesy of the University of Iowa Museum of Art.

Ben Shahn, Philip Guston, Jackson Pollock, Cook, Durieux, and many others were much affected. Mexican art had passion and formal intention. It dealt with crucial human and social issues but did not seem parochial. As Robert Hobbs says: "Mexican art offered a way out of the dilemma of how to be modern, original, and American as well as how to use European vanguardist innovations without being stifled by them."[24]

Cook, who grew up in New England and was educated at the Art Student's League, liked to travel and visited most of the United States and some of Central America when he was a young man before the Depression.[25] A Guggenheim fellowship financed Cook's first trip to Mexico in 1932. Foundations set up by the Guggenheim, Carnegie, and Rosenwald corporations would make it easier for artists to reach far-off points in the 1930s and 1940s. Cook's journey to Mexico could not rival the adventures of Pop Hart's southward trips: Hart never seemed to know exactly where his journeys would lead him or for how long; and he always went on his own resources, which he had scraped together from painting movie sets and working in local carnivals. But the foundation stipends did have their own advantages. The artists knew exactly how much money would be theirs and for what period of time it would be coming in, which made it simpler to make plans and easier to bring along needed art supplies. Further, the foundation's evaluation requirements pushed the artists into producing a body of work.

Cook and his wife, Barbara Lathram, arrived in Taxco in 1932, where they rented a small house on a hill overlooking the cathedral. Local residents must have taken a good look when they saw Cook lugging a 300-pound etching press up the steep paths of this mountain village.[26] Very few North Americans had yet discovered the charms of Taxco, although they were about to, since a new gravel road connecting Mexico City and Taxco had just been finished.[27] Even before arriving in Mexico, Cook had studied the work of Orozco, Siquieros, and especially Rivera, which partly explains why his own drawings and prints took on a more monumental note in Mexico. He had previously been essentially a printmaker of New York skyscrapers and New England landscapes, but the human figure now became central to his art. In Mexico, he made close-to-the-earth studies of working peasants. (A second Guggenheim fellowship in 1935 would take him through the rugged, insulated Scots-Irish settlements of Appalachia, where he would render the raw-boned people of Kentucky and North Carolina.)

Cook's fascination with the Mexican people and landscape dated at least as far back as 1926, when he spent over a year in New Mexico. His style, fea-

turing the geometric patterns of the desert terrain and the indigent architecture, as well as a solemn reverence for the Indian people and their rituals, took shape when he was living in Taos. *Coconut Grove,* 1932 (Fig. 9.6), and *Mexican Landscape,* 1933, with their stacked planes, pleated hillsides, and alternating warm and cool coloration, relate to Cook's earlier New Mexico prints, and to Cézanne. The layered and modulating values almost make us believe that Cézanne was peering over Cook's shoulder as he composed his landscapes. The simple gathering of Mexican villagers is the subject of *Fiesta,* 1933 (Fig. 9.7), and *Taxco Market,* 1933. Although less thrilling than the Christmas Eve torchlight processions, or the Great Buffalo Dance and other rituals of the New Mexico Indians that he rendered, the Taxco marketplace scenes are not routine. A classical serenity settles on them. Village life is viewed as ordered and unproblematic. The faces of the individual peasants blend into a carefully choreographed pattern of legs, backs, dresses, serapes, fruits, and vegetables. It is a ballet of closely ordered and chiaroscuroed shapes that push Cook's previous form exaggerations into a much bolder and stylized decorative language.

The 1932–33 prints also brought something entirely new to Cook's art— densely packed compositions derived from the Mexican murals, which would help give more breadth and substance to his work. One of Cook's purposes, he told the Guggenheim officials, was to study the technique of *buon fresco* so that one day he could paint public murals in the United States.[28] Cook closely examined Rivera's work at the 1931 exhibit on Mexican painting at the Museum of Modern Art, and before he settled into his Taxco house he examined Rivera's murals in Mexico City and Cuernavaca.[29] Rivera's skill at combining large groupings of figures and organic plant forms into a balanced, decorative schema most impressed the American printmaker. Cook applied these lessons in *Acapulco Girl,* 1932 (Fig. 9.8), where the finely wrought face was blended into a delectable southern Mexico tropical landscape. Cook had also begun to experiment with the generation-old theory of dynamic symmetry, which was a pseudo-scientific way of segmenting the major rectangular divisions of the compositions by diagonal accents. As Janet Flint writes: "Against just such a framework of intersecting diagonals, Cook has simplified and grouped his figures in rhythmic arrangements of interlocking planes and angles. As in his [later] murals, realistic space has been virtually eliminated in favor of maximal use of planar space."[30]

Pure landscape and figure-within-landscape prints, however, were not Cook's major achievements in Mexico. Portraiture showed the most original and penetrating side of his art. The peasant faces he rendered could be delicately

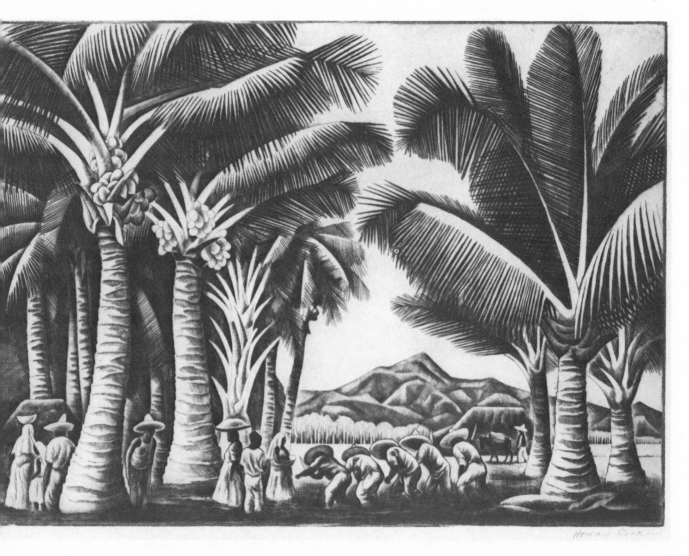

9.6. Howard Cook, *Cocoanut Grove (Acapulco Girl)*, 1932. Etching; 7¹⁵⁄₁₆ × 10⅞ in. Courtesy of the National Museum of American Art, Smithsonian Institution. Gift of Barbara Latham.

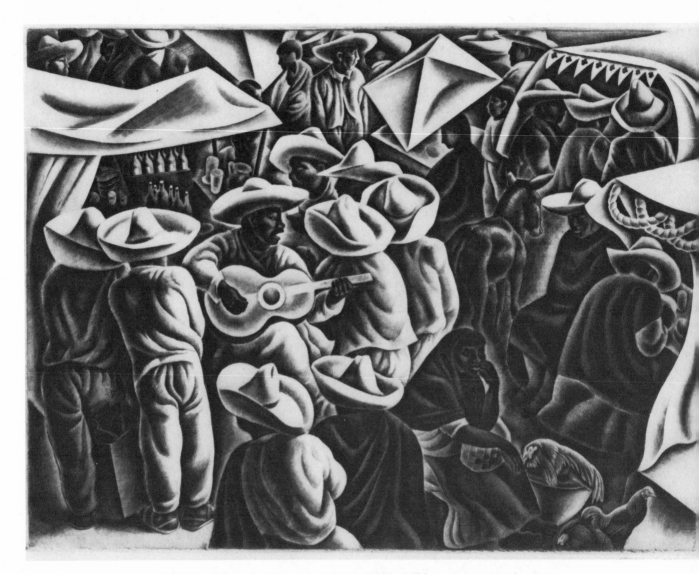

9.7. Howard Cook, *Fiesta (Fiesta Taxco)*, 1933. Etching; 10⅞ × 14½ in. Courtesy of the National Museum of American Art, Smithsonian Institution. Gift of Barbara Latham.

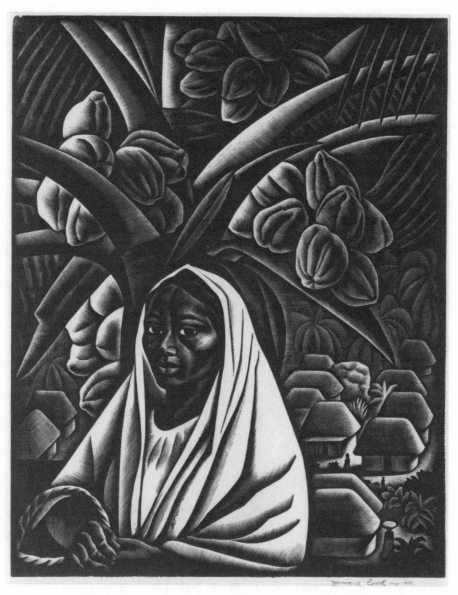

9.8. Howard Cook, *Cocoanut Palm (Acapulco Girl)*, 1932. Wood engraving; 10 1/16 × 8 in. Courtesy of the National Museum of American Art, Smithsonian Institution. Gift of Barbara Latham.

exquisite, as in *Mexican Interior,* 1933 (Fig. 9.9), where the orb-shaped face of the young woman on the left echoed the delicate globes of the ceramic pots in the adobe hut. Cook composed his pictures methodically, carefully working out regularized, stable volumes and patterns. In *Head of Guerrero Woman,* 1933, and *Old Woman of Taxco,* 1933, the strong, isolated faces of María and Tía María, displace the environment and become landscapes themselves; the bone structure and middle-age lines (the women were not as old as they appear)[31] are like topographical maps of the Sierra Madre del Sur where these women live. In these prints and in the subsequent portraits of Appalachian Mountain people, Cook proved that he was primarily gifted as an imagist, unhampered by any storytelling compulsion. These portraits are more exacting than flattering, and various rural Mexican symbols collect around them: the weather-beaten contour of the cheeks and brows seem as enduring as the scarred desert hills; there is the monumental presence of peons whose ancestors survived the cruel times of Indian wars, Spanish conquistadors, and the unremitting colonial oppression, as well as the daily hardships of the Mexican desert. In constructing these archetypes, Cook seems to be scratching this epic land in search of the elemental unity of woman and the earth. And perhaps he was searching for a deeper, personal solitude.[32]

The textures of Cook's etchings are as rich in their own way as Hart's prints and much more defined. The white and velvety gray areas of the aquatint exude a warm light that keeps the remote village women from becoming forbidding symbols. "The dark tones, composed of many fine, sensitively etched and inked lines, are not opaque, but richly luminous."[33] For Cook, the challenge was to be an alert, fascinated witness of this alien culture without becoming a mere documenter or sloppy sentimentalist. In his prints there is an evident reaching beyond social description to a feeling of solemn poetry. Traces of Rivera's iconographic approach to the Mexican people are evident in Cook's etchings, and one also notices a kinship to the American regionalist art of the mid-1930s, where the artists ennobled the yeoman workers and their families' struggles with the natural elements and economic hardship. But, above all else, Cook's social vision and his formal development was a matter of personal discovery, of painstaking trial-and-error experiments, as well as a deep-seated need to experience out-of-the-way folk cultures. He was a loner, stubborn and taciturn. Despite his keen appreciation of Mexican revolutionary painting, he made no attempt to participate in the Taxco art colony which had formed in William Spratling's nearby hacienda, where Rivera, Siqueiros, Miguel Covarrubias, and

9.9. Howard Cook, *Mexican Interior*, 1933. Etching; 16⅛ × 10¹¹⁄₁₆ in. Courtesy of the National Museum of American Art, Smithsonian Institution. Gift of Barbara Latham.

other noted artists and literary figures gathered in the early 1930s. To those like Barbara Lathram and Carl Zigrosser who knew him best, Cook was an inveterate Yankee individualist who insisted on finding his own way.[34]

From the prints of Hart and Cook one would never guess that the machine age had already begun to lay its hand upon Mexican society. But in Caroline Durieux's prints, the aspiring bourgeoisie of urban, industrialized Mexico come to life. Since 1932 Durieux has devoted her full energies to social satires of the middle-class and the nouveau-riche she has examined in Mexico, Cuba, Brazil, Chile, France, and Louisiana. Her sardonic point of view developed from her youth in the New Orleans French Quarter, until she became a full-blown satirist intent on "probing the ills of society with the cold precision of a surgeon working on an interesting case."[35]

In 1926 Durieux and her husband, Pierre Durieux, a General Motors businessman, moved to Mexico City after a four-year stay in Havana. Whereas Cook and Hart went looking for adventure and inspiration, Durieux was favored by the circumstances of her husband's career; and yet, ironically, hers was a more penetrating interpretation of Mexico than that of the other two artists. Between 1928 and 1936, when she was living in Mexico City, Durieux met all the major Mexican artists. She regularly visited Spratling's Taxco salon, where Siqueiros and Rivera often held court.[36] The latter was a devoted friend and admirer. Rivera liked her spirit and her fluency in Spanish, and he was relieved that she did not fawn over him or imitate his work. Durieux gave fair and trenchant criticism of the Mexican artist's works, and if she thought Rivera or Siqueiros was on the wrong track she told him so. Rivera liked her caustic wit and acute drawing, which he called "politely cruel persiflage."[37]

In 1932 she did her first group of lithographs—twelve sprightly prints that explored individual oddities of the Mexican bourgeoisie as well as the small sins of the American colony of diplomats and businessmen and their wives living in Mexico City. George Miller showed her the rudiments of the lithographic process. From Howard Cook she also learned the technique of etching but soon showed a preference for the direct lithographic process, where "you can see exactly what you are doing throughout."[38] Darío Mejía, who worked at the Senefelder Lithographic House in Mexico City, printed her Mexican series lithographs in 1932, which were then sent to Zigrosser's Weyhe Gallery.[39]

In these prints we see up-and-coming merchants drinking one too many at lunch, playing golf at the Mexico City Country Club, dancing the tango; their

wives confined to the house listlessly playing cards or being fitted for an elaborate gown. All are dressed fashionably and display what seems to be an almost desperate drive for social status. No one ever accused this emerging Mexican bourgeoisie of maintaining a low profile. Durieux's images of the Mexican middle class and the American colony were unique. Rivera and most of the great muralists concentrated on the historical drama of the peasants' struggle against the landowners, pictures that frequently teemed with politically inflammatory messages. For Durieux, the shops along the boulevards of Mexico City, the dance floors of new nightclubs, and the beaches in front of good, if not swank Acapulco hotels, along with other places only recently made accessible to the awakening middle class, were more interesting subjects, probably because they were closer to her memories of social-climbing activities in the middle-class Creole culture of New Orleans. In her own pithy words: "What marks the bourgeoisie everywhere is *what they own.*"[40]

And how did she make this point? With an ice-cold eye she picked out telling details of the human landscape: bird-like profiles, pinched mouths, eccentric hair styles, and furniture that knarls about the women and echoes their idiosyncrasies. Sometimes she featured outsized, full-figured women as in *Acapulco* (Fig. 9.10) and *Dressmaker,* where the mighty slopes and expanses of the thighs, breasts, and shoulders make attempts to cover these bodies seem ludicrous. Durieux repeats the strategy of taking a plausible situation, editing out the routine facts, exaggerating the posturing nonsense, and ending up with a bittersweet burlesque. Throughout these satires, the action generally remains inside—the legendary buildings, outdoor food markets, and gardens of Mexico City rarely form a backdrop much less compete for our attention. We enter humid rooms where perspiration crawls inside the snug dresses—shriveled quarters where hushed voices can barely be heard, and where a dozen little ritualistic dramas are being played out.

The American colony in Mexico City receives at least equal time. As the dutiful wife of a successful businessman, Durieux had access to the inner sanctum of the Baton Rouge Country Club and other haunts of the Americans, but she was in no way a status seeker herself. Rather, she was a sardonic critic of this Yankee subculture. With kindness toward none and malice toward most, she loved to size up the nightclubs. "Dancing," she once said, "offers strange individual movements, and many chances for preposterous, uncomfortable situations found in few other activities."[41] In *Bipeds Dancing* (Fig. 9.11), North American businessmen and their wives are shown swaying, grappling, lurching.

9.10. Caroline Durieux, *Acapulco*, 1932. Lithograph; 9 × 10¾ in. Courtesy of the Louisiana State Library.

9.11. Caroline Durieux, *Bipeds Dancing*, 1932. Lithograph; 8 × 8⅝ in. Courtesy of the Louisiana State Library.

One woman even winces with pain from her partner's misstep. In *Dancing With Vigor,* the slick, tuxedoed dandy with waxed moustache and hair moves his partner so swiftly that her hair stiffens from the motion. Facial expressions are understated. Anger, hate, lust, greed—the more dramatic passions—are seldom mirrored on the faces of Durieux's figures. But surprise, indifference, arrogance, bewilderment, slight vanity, and every known quiet expression are present in the common faces and body postures of the figures that people her satires.

Durieux's Mexican series was more traditional in technique than her subsequent lithographs. The blowsy draftsmanship, the resonant, subtle play of light and dark, was at least inspired by the example of Mexican revolutionary art as well as by her art-school training in the nineteenth century life-drawing tradition.[42] Bending over the grained stone, Durieux quickly learned the feel of its surface, its potential for blunt form or many varieties of tone. She preferred closely valued tonal modulations to the dramatic chiaroscuro of Daumier's urgent political lithographs. Her compositions were usually hierarchic: one or several major darkened figures (with spotlit faces) establish mastery over smaller and lighter figures and accessories. The rhymed and interlocking shapes and patterns move easily across the surface.

In 1936 she started a second series of lithographs on the Mexican milieu. These North American series prints, as she called them, were astringent scrutinies of international merchants. The hovering figure in the modern art gallery in *Preview* (Fig. 9.12) impinges on the viewer's space and generally sets our teeth on edge. In *Fish, Nice Men, Nice Women, Rugged Americans,* and *Los Diplomáticos* almost all warm details are purged from the surface: Durieux draws taut lines with the precision of a lens grinder, and the blunt, frontal images jolt the viewer and discourage any spectator empathy with the figures. These are unsweetened themes of disagreeable, repressed people. Narrative qualities are frozen out by the stark, blazing white light. Technical considerations played a part in this shift to a more reductive style. At the urging of George Miller, Durieux experimented in the North American series with zinc plates that were ground to simulate stone; zinc did not afford the artist opportunity for three-dimensional effects, and Miller cautioned her to work "linear."[43] The contemporary New Orleans artist George Dureau believes the "guarded, snappy, uptight" character traits common to women in the New Orleans Creole culture of the early years of this century played a part in Durieux's wire-thin style.[44] And, of course, the subject matter partly dictated the new style. Just as the solid, full-bodied drawing suited

9.12. Caroline Durieux, *Preview*, 1936. Lithograph; 13½ × 18. Courtesy of the Louisiana State Library.

the thick physiques and robust earthiness of the Mexican subjects, so the razor-edged drawing perfectly represented the pseudosophisticated North Americans.

Pierre Durieux grew gravely ill in 1938, and Caroline was forced to return to New Orleans. She would only do a few more Mexican subject satires, now from old drawings. By the late 1930s Hart no longer was traveling to Mexico, and Cook did not return after leaving Taxco in 1933. These three artists had been pioneers among American artists who were lured to Mexico. In their prints, they left a subtle, occasionally profound mix of satire, fact, and myth about different sides of the Mexican culture. They were not part of the great wave of Yankee tourist-artists which washed up on Mexican shores in the late 1930s and in the 1940s. As World War II neared, Mexico was in full vogue. Formal and informal groups of Americans met in Taxco, San Miguel Allende, Cuernavaca, Mexico City, Guadalajara, and Baja California. Wide public fanfare had accompanied the mural commissions of Orozco, Siqueiros, and Rivera in the United States in the 1930–35 period. American artists were anxious to see for themselves the land that produced these modern Giottos and Michelangelos. The mass-media—movies and hit-parade tunes—stimulated interest. The itch spread to go south of the border, or at least to have Mexican music, trinkets, and its art brought here. As Leslie Simpson remembers: "Painters, writers, and scholars swarmed in to breathe the invigorating air. ... They collected in bars and studios and talked endlessly. We were all writing, or intending to write; painting or intending to paint."[45]

Notes

1. A good brief discussion of the political developments is found in the late Senator Ernest Gruening's *Many Battles: The Autobiography of Ernest Gruening* (New York: Liveright, 1973), 107–35. Another participant in Mexican life during this extended period who wrote of the tangled relationship of Mexico and the United States was Anita Brenner, *The Wind That Swept Mexico: The History of the Mexican Revolution, 1910–1942* (New York: Harper and Brothers, 1943).

2. In his *File on Spratling: An Autobiography* (Boston: Little, Brown and Company, 1967), William Spratling writes of these enthusiasms. He established a salon of sorts in Taxco in the 1930s, where among the "extraordinary friends" who gathered were Hart Crane, Waldo Frank, John Dos Passos, William Faulkner, John Huston, Paulette Goddard, Caroline Durieux, Diego Rivera, Miguel Covarrubias, and José Clemente Orozco.

3. A fairly typical notice of one of these "schools" is found in the February 1941 issue of *Mexican Life:* "February will see the opening of the Winter seminar at the art school at San Miguel Allende, Mexico. The art colony at San Miguel takes on a gay and informal character during February and March. Diversions include horseback riding, swimming, natural hot springs pools, trips to Morelia, Patzcuaro, or Querétaro" (*Mexican Life,* February 1941, 4).

4. Jane Dixon, "Artist Knows Where Life is Easy on $10 a Week," *New York Telegram,* May 4, 1926.

5. See "Pop Hart to Boom Oaxaca with his Art," *New York Evening Post,* April 29, 1926, p. 52. Also George Biddle, *An American Artist's Story* (Boston: Little, Brown and Company, 1939), 233–34.

6. *New York World,* April 15, 1927.

7. James Rorimer, former director of the Metropolitan Museum of Art, confused Hart with the pop artists of the 1960s, according to Calvin Tompkins, who himself wrongly labeled Hart a "long-dead American folk artist" (Tompkins, *Off the Wall: Robert Rauschenberg and the Art World of Our Time* [New York: Doubleday and Company, 1980], 178–79).

8. Clinton Adams, *American Lithographers, 1900–1950: The Artists and Their Printers* (Albuquerque: University of New Mexico Press, 1983), 55–56.

9. Frederick James Gregg, George "Pop" Hart Papers, New York Public Library.

10. Biddle, *An American Artist's Story,* 56.

11. See John Palmer Leeper, Introduction to *Jules Pascin's Caribbean Sketchbook* (Austin: University of Texas Press, 1964), 8–9.

12. In his typical wry way, Hart once gave a partial explanation for the exaggerated size of the outstretched hands and feet of his Latin American peasants who were usually in the company of ducks, chicken and other eating fowl. "Don't you realize how big the hand of approach must look to a duck whose fate is sealed." Mergs O'Frost, "Women are Hell Says Noted Artist in Exile," *New Orleans States-Item,* April 15, 1926, p. 37. George "Pop" Hart Papers, New York Public Library.

13. See Ernest Gruening, *Many Battles.* Mexico in the 1920s was, Gruening notes, "a world of contrasts and paradoxes, of exquisite beauty and unbelievable squalor," 109. Nearly 85 percent of the population was illiterate, and a large majority of the children were undernourished.

14. Hart likened himself to Hearn, a New Orleans journalist who was well known for his adventures in the Caribbean and the Pacific in the 1870s, 1880s, and 1890s, in an interview with Lyle Saxon. Lyle Saxon, "Noted Artist Impatient for Return to Happiness in Wilds of Old Mexico," *New Orleans States-Item,* December 17, 1925, p. 43. George "Pop" Hart Papers, New York Public Library, n.d.

15. Pop Hart to Lyle Saxon, George "Pop" Hart Papers, New York Public Library, n.p.

16. *New York Times Magazine,* January 18, 1925, George "Pop" Hart Papers, New York Public Library.

17. *New York World,* April 15, 1927, George "Pop" Hart Papers, New York Public Library.

18. Allen S. Weller, Introduction to *Watercolor U.S.A. National Invitation Exhibition* (Springfield Art Museum, Springfield, Missouri, 1976), 16–18.

19. Harry Wickey, "The Genius of Pop Hart," *Prints* 6 (October 1935):23–24.

20. Joann Moser, *The Graphic Art of Emil Ganso* (Iowa City: University of Iowa Museum of Art, 1969), 8–9.

21. "'Pop' Hart, Creative American Genius and Philosopher, is Dead," *The Art Digest*, October 1, 1933.

22. Robert Rosenblum, *Nineteenth Century Art* (New York: Harry Abrams, Inc., 1984), 431.

23. *New York Herald Tribune*, September 10, 1933. In 1926, Hart lamented (in a perhaps half-serious way) that his romantic Mexico might not last: "I'll be hitting the trail south again as soon as I show my year's work up here and dispose of or hang my pictures. I've got to stop telling my fellow painters about the life down there, because so many of them want to try it out. The first thing you know Oaxaca will be a suburb of Provincetown and I'll have to move into the jungle farther along the Isthmus to get anywhere near the primitive." *New York Telegram*, May 4, 1926.

24. Robert Carleton Hobbs and Gail Levin, *Abstract Expressionism: The Formative Years* (Ithaca: Cornell University Press, 1978), 14.

25. Betty and Douglas Duffy, *The Graphic Art of Howard Cook* (Washington: Museum Press, 1984), 15–16.

26. Duffy and Duffy, *The Graphic Art of Howard Cook*, 21.

27. Spratling, *An Autobiography*, 60.

28. Carl Zigrosser, *The Artist in America: Twenty-Four Close-ups of Contemporary Printmakers* (New York: Alfred A. Knopf, 1942), 196. See also Howard Cook, "The Road from Prints to Frescoes," *Magazine of Art*, January 1942, 4–5.

29. Barbara Lathram, interview with author, April 5, 1982.

30. Janet Flint, in Duffy and Duffy, *The Graphic Art of Howard Cook*, 37.

31. Barbara Lathram, interview with author, April 5, 1982.

32. This is the theme of Zigrosser's essay on Cook in his *The Artist in America*, 192–201.

33. Janet Flint, in Duffy and Duffy, *The Graphic Art of Howard Cook*, 36.

34. Barbara Lathram, interview with author, April 5, 1982.

35. Caroline Durieux, "An Inquiry into the Nature of Satire" (M.A. Thesis, Louisiana State University, 1949), vii. The full quotation on her purpose is: "A satirical artist is one who feels detached from emotional involvement; who has an objective attitude toward life similar to that of the satirical writer or poet. Controlling his personal indignation, the artist-satirist is not disturbed by that which shocks other people, and is therefore able to probe the ills of society with the cold precision of a surgeon working on an interesting case. This power of emotional detachment makes possible an ironic attitude toward any life situation and explains the peculiar ability of the satirist to see and to inject an element of tragedy into his interpretation of the comic, and an element of comedy into his interpretation of tragedy."

36. Caroline Durieux, taped interview with author, April 30, 1977.

37. Diego Rivera, quoted in Zigrosser, *The Artist in America*, 127–28.

38. For more details on Durieux's technique see Richard Cox, *Caroline Durieux* (Baton Rouge: Louisiana State University Press, 1977), 8–13.

39. Ibid.

40. Durieux, taped interview with author, April 30, 1977.

41. Ibid.

42. Durieux studied art with New Orleans academic painter Ellsworth Woodward at Sophie Newcomb College/Tulane University and later with Henry McCarter at the Pennsylvania Academy of the Fine Arts (Carl Zigrosser, Foreword, *Caroline Durieux* [Baton Rouge: Louisiana State University Press, 1949]).

43. Durieux, taped interview with author, April 30, 1977.

44. George Dureau, quoted on "The Penetrating Eye: The Story of Caroline Durieux," television program on Louisiana Public Television, February 1982.

45. Simpson, quoted in William Spratling, *An Autobiography*, 58–59.

INDEX

ASPECTS OF AMERICAN PRINTMAKING, 1800–1950

was composed in 10-point Baskerville, with two points of leading, on a Linotron 202
by Partners Composition;
printed by sheet-fed offset on 60-pound, acid-free Glatfelter Natural Hi-Bulk,
bound over binder's boards in Holliston Roxite C,
with dust jackets printed in two colors,
by Braun-Brumfield, Inc.;
designed by Will Underwood;
and published by

SYRACUSE UNIVERSITY PRESS
SYRACUSE, NEW YORK 13244-5160